Approaches to Understanding Visual Culture

MALCOLM BARNARD

palgra

First published 2001 by
PALGRAVE
Houndmills, Basingstoke, Hampshire RG21 6XS and
175 Fifth Avenue, New York, N.Y. 10010
Companies and representatives throughout the world

PALGRAVE is the new global academic imprint of St. Martin's Press LLC
Scholarly and Reference Division and Palgrave Publishers Ltd
(formerly Macmillan Press Ltd).

ISBN 0–333–77287–3 hardback
ISBN 0–333–77288–1 paperback

The book is printed on paper suitable for recycling and
made from fully managed and sustained forest sources.

A catalogue record for this book is available
from the British Library.

Library of Congress Cataloging-in-Publication Data
Barnard, Malcolm, 1958–
 Approaches to understanding visual culture / Malcolm Barnard.
 p. cm.
 Includes bibliographical references and index.
 ISBN 0-333-77287-3 – ISBN 0-333-77288-1 (pbk.)
 1. Visual sociology. 2. Culture. 3. Art and society. I. Title.

HM500 .B37 2000
306–dc21 00-048318

10 9 8 7 6 5 4 3 2 1
10 09 08 07 06 05 04 03 02 01

Printed in China

To Stella, Gill, Meggie and Luke

Contents

List of Illustrations

Acknowledgements

My colleagues at the University of Derby, Alan Barnes, Robert Burstow, Mark Durden, Martin Farrell, Andy Jones, Stanley Mitchell, Giles Peaker, Janet Sleath, Josie Walter and Rhiannon Williams, as well as the staff of the Britannia Mill Learning Centre, have been their usual supportive selves and I would like to thank them for various suggestions and contributions. I would also like to thank the students of the BA(Hons.) Visual Cultures degree at the University of Derby – they will know who they are – on whom I first tried out many of the topics and approaches in the following chapters. Their help has also been invaluable.

Sally Edwards, at the Centre for Educational Development and Media, University of Derby, provided illustrations suitable for reproduction here.

From Leeds Poly days, Leon Hunt's and Wendy Leeks' lectures helped with the section on auteur theory and with the account of psychoanalysis respectively; Judy Attfield, Martin Barker, Ian Heywood and Chris Jenks all offered their support, encouragement and advice. I am very grateful to them all.

The author and publishers would like to thank the following for permission to reproduce the following illustrations: Figures 3.1 and 8.2, The National Gallery, London; Figure 3.2, the Vintage Motor Scooter Club; Figure 4.1, Robert Burstow; Figure 5.1, the Victoria and Albert Museum Picture Library, London; Figure 5.2, Harlow Museum, Harlow; Figures 7.2 and 7.3, Perfectly Formed Publications, Surbiton; Figure 8.1, the Uffizi Gallery, Florence; Figure 8.3, Ted Polhemus.

Every effort has been made to trace all the copyright-holders, but if any have been inadvertently overlooked the publishers will be pleased to make the necessary arrangements at the first opportunity.

MALCOLM BARNARD

Introduction

What is visual culture?

There is a case for saying that the idea of visual culture needs no intro-
duction, that its features and characteristics are already quite well
known. As Heywood and Sandywell point out in a book on the inter-
pretation of visual culture, since the late 1970s 'the visual field has
begun to be explored with a thoroughness and global understanding
unique in the history of human self-reflection' (1999: ix). W. J. T.
Mitchell's (1995a and 1995b) essays on visual culture, John A. Walker
and Sarah Chaplin's (1997) *Visual Culture: An Introduction*, Nicholas
Mirzoeff's (1999) *An Introduction to Visual Culture*, and even the
present author's (1998) *Art, Design and Visual Culture*, could be cited
as evidence of the plethora of books introducing, exploring, analysing
and critiquing visual culture. However, one consequence of this
profusion of books is that the sense of visual culture becomes fluid.
Each author proposes a slightly different definition, with different
emphases, inclusions and exclusions, from the previous authors. This
results in slightly different aspects, or versions, of visual culture being
studied. It might help if some clarification were made of this range of
meanings pertaining to the phrase 'visual culture'.

There seems to be a case for distinguishing a strong sense and a
weak sense of visual culture. Used in its strong sense it stresses the
cultural side of the phrase. It refers to the values and identities that are
constructed in and communicated by visual culture. Some books on
visual culture, then, will be interested in studying and understanding it

1

as one of the ways in which a cultural group produces and reproduces its particular character and individuality. Such books are concerned with the objects, institutions and practices of visual culture in so far as they are used to assemble and communicate cultural identity. They concentrate on the oppositional nature of the visual, the ways in which identity is defined in opposition to, or even in conflict with, other, different, cultural groups. Barnard (1998) attempted to introduce, describe, analyse and explain this strong sense, devoting chapters to the institutions of production and consumption and to how visual culture relates to the social process, for example. In his (1995a) and (1995b) essays, Mitchell is also concerned to stress the cultural functions of visual culture, proposing a syllabus that would cover 'institutions of the visible' and the ways in which cultures are ranked, or placed into hierarchies (1995b: 211). And the first chapter of Walker and Chaplin's (1997) book introduces the cultural element of visual culture in relation to social class, structure and conflict. The weak sense of 'visual culture' stresses the visual side of the phrase. It refers partly to the enormous variety of visible two- and three-dimensional things that human beings produce and consume as part of their cultural and social lives. Visual culture in this sense is an inclusive conception. It makes possible the inclusion of all forms of art and design, as well as personal or body-related visual phenomena, under a single term. Thus, all kinds of fine art (painting, drawing and sculpture, for example), all kinds of design (graphic, interior, automotive and architectural design, for example), and things like facial expressions, fashion and tattooing may be included under the title of visual culture. Many of the volumes appearing are content to use visual culture in its weak sense.

The present volume tends to use visual culture in the weak sense. Because it concentrates on the different approaches to understanding a wide variety of images and artefacts, it is less interested in visual culture as performing a set of cultural and social functions (unless explaining those functions is part of the approach, of course, as it is with the social history, Marxist and feminist approaches investigated in Chapters 5 and 6), and more interested in how different approaches to visual culture use the notion of understanding. And, of course, it is most interested in the strengths and weaknesses of these attempts to understand visual culture. (How art differs from design, and the methodological consequences of those differences, will be addressed as and when they occur as problems for particular approaches to the understanding of visual culture.) The notion of visual culture, even in its weak sense, however, is broader than that of either art or design,

encompassing both and including material that is often overlooked or ignored by the histories of art and design. Consequently, the following chapters will introduce as broad as possible a range of examples of visual culture. In the next chapter, extracts from authors attempting to understand a wide variety of visual culture will be used to ask the question: 'Who understands visual culture?' These extracts will relate to package design and interior design, as well as more traditional oil paintings. The chapters that follow will also investigate an extensive range of examples, from typography, architecture and body-art to painting, automotive design, textile design and comic books, in an attempt to give some idea of the scope of things that may be studied, and understood, as visual culture. The question of the scope covered by the phrase 'visual culture' brings this Introduction to the matter of who wants to understand visual culture.

Who wants to understand visual culture?

This question is really two questions, depending on whether the stress is placed on the 'who' or the 'wants'. The first concerns potential readers of this book and may be expressed as 'Who is interested in understanding visual culture?' The second asks after the motivations of those readers and translates as 'Why should anyone want to understand visual culture?' The answer to the first question should not be difficult to find. Given that the examples chosen to illustrate the approaches in the following chapters come from art, film, graphic-, architectural-, fashion-, interior-, automotive-, textile- and furniture-design, practitioners and students of these disciplines might be expected to be among those interested in understanding visual culture. Similarly, given that one of the claims made by proponents of these approaches is that they are useful in understanding many, if not all, forms of visual culture, students of art and design practices not mentioned here will also be interested in studying them. Over the last twenty years or so, it has increasingly become the case in the Humanities and Social Science departments of many colleges and universities that students of sociology, anthropology, the media, cultural studies and communications are also prompted to take an interest in the visual. They too might be assumed to be interested in understanding the visual as it permeates their concerns.

The second question is not difficult to answer either. A first response could be that one should want to understand visual culture

because the visual has developed into an important part of people's lives. One is more and more dependent on and subject to visual material. Unless that material is understood, and unless an account is given of how that understanding has been arrived at, that material's power and effectiveness operate without our knowledge, or behind our backs. At this fairly simple level, the study of visual culture provides an awareness of what is going on. A second response could be that, in newspapers, magazines and on television, one is presented with a series of other people's (critic's, commentator's) interpretations and explanations of this visual material. Without a knowledge of which traditions of thought these interpretations have come from, what their strengths and weaknesses are, there is little option for people but to either accept them unthinkingly or to realise that they have no means of challenging them. On this slightly more complex level, a study of visual culture can provide analytical and critical insight into the workings of our understanding of the subject. And a third response might be that, in understanding how the explanations and interpretations of visual culture that one encounters every day are produced, adopted and supported, one is actually understanding one's own cultural and social position, or identity. Following the hint provided by Heywood and Sandywell above, opinions concerning, and responses to, visual culture are part of what makes people the people they are and an understanding of these opinions and responses can generate a more sophisticated, self-reflexive and critical, understanding of the visual world and one's place in it. Here, the study of visual culture performs the relatively sophisticated function of self-enlightenment through providing an understanding of one's own role and position in the process of understanding visual material.

What this book is about

This book is about the different ways in which visual culture may be understood. Using a series of visual examples, it will describe and evaluate the various methods which have been proposed as providing the truest or most rewarding means of interpreting visual culture. In doing this, it will respond positively to a point made by W. J. T. Mitchell in 1995 when he said that, 'While the general study of visual culture may seem like an idea whose time has come, it is by no means self-evident how it ought to proceed' (Mitchell 1995b: 208). The following chapters are explorations of some of the ways in which the under-

standing of visual culture has been thought to proceed. And, while it is unlikely that, by the end of this book, any single method for the study of visual culture will have emerged from the scrum of competing candidates, it is intended that whatever strengths, weaknesses, truths and lacunae the methods possess will be fully revealed.

Indeed, given Mitchell's assertion that visual culture is itself an 'interdiscipline' (1995a: 540), the possibility of any one approach emerging as the single best approach is matched only by its desirability. To repeat, visual culture may usefully be thought of as an 'interdiscipline', 'a site of convergence and conversation across disciplinary lines' (ibid.), and it must, therefore, be studied by a number of different disciplines. This does not, of course, preclude individuals from finding that they have a preference for certain types of approach. The present volume intends to provide such favourites, generating enthusiasm for and energy within them, and suggest some reasons as to why they are favoured. There can be nothing wrong with having a certain sympathy for one approach, so long as one has some defensible idea as to why it is found sympathetic. The present volume intends to provide such defensible ideas by placing each approach within a tradition. The knowledge that a disciplinary approach is nourished by a tradition which favours explanations in terms of individual artists, for example, may help explain why other approaches which also favour the singular or the individual are also favoured.

This book is also about what sort of activities or processes understanding and explanation are. It aims to make a problem out of what we routinely take for granted: understanding, interpretation and explanation. What are we doing when we understand a piece of visual culture? How do we know when we have successfully explained a piece of visual culture? Do we understand visual culture in the same way as we understand natural phenomena? These questions are important because, if we cannot answer them, we cannot be said to know what we are doing when we study visual culture. They demand that we take a step back and ask questions about understanding, interpretation and explanation in general. Is 'understanding' something that we do, or something that happens to us? What is it that we do, or what is it that happens to us, when we understand something? What is an interpretation? Are there different types of interpretation? How are understanding and interpretation different from explanation? The answers to these, general, questions will give a better idea of what the understanding and explanation of visual culture are.

And this book is about the intellectual traditions which the different methods of understanding and explaining visual culture come from. It will be suggested that there are two basic sets of answers to all of the questions above. These are the two traditions from which stem all of the methods of understanding visual culture. These two sets of answers, these two intellectual traditions, will be referred to as the 'structural tradition' and the 'hermeneutic tradition'. As the name suggests, the structural tradition argues that understanding and interpretation work in terms of structures. Conceptual structures, class structures and gender or narrative structures, for example, are the basis of understanding and interpretation for this tradition. The word 'hermeneutics' is related to the Greek god Hermes, who was the messenger of the gods, relaying messages between the gods and also between the gods and humans. As Palmer points out,

> The Greeks credited Hermes with the discovery of language and writing – the tools which human understanding employs to grasp meaning and to convey it to others. (Palmer 1969: 13)

The hermeneutic tradition argues that understanding and meaning are the business of individuals; the different interests, positions, beliefs and values of different individual people are productive of understanding and interpretation for this tradition. Each of the methods to be studied in the following chapters will be explained in terms of which tradition, the structural or the hermeneutic, it belongs most securely within. Some methods, of course, will be found to inhabit both, taking insights and approaches from both structural and hermeneutic traditions.

Chapter outline

Consequently, Chapter 1 will introduce the idea of understanding visual culture as a problem. It will ask various questions concerning visual culture and understanding. Who understands visual culture? Can we tell when we understand a piece of visual culture? What sort of activity is understanding? Introducing these questions via a discussion of short extracts from four very different approaches, the chapter will ask which of the different authors understands visual culture. It will ask whether one of them understands the visual culture they have chosen better than the others. And it will ask what these authors are doing in their understanding of visual culture. Can we, as readers, tell that these

very different authors have understood their chosen examples? What is it that we do, or what is it that happens to us, when we understand visual culture? Having made the idea of understanding into a series of problems and having suggested some potential answers to these problems in Chapter 1, in Chapter 2 we will look at the differences between explanation and understanding. That is, we will consider the differences between the forms of understanding that are held to be found in the natural and social sciences and assess the implications of these different forms of knowledge for our understanding of visual culture. This is important because history, along with art history and design history, often conceived of themselves as forms of science. History, art history and design history presented the knowledge and understanding they could provide as scientific understanding. It is important to be aware of the kind of understanding that is being claimed by art history and design history, and to distinguish it from the kind of understanding (explanation) found in the natural sciences because unless we know this, we do not know what we are doing when we understand visual culture. It is important, then, because, unless we have some idea of what we are doing, or of what is happening to us, when we understand something, we can literally be said not to know what we are doing. This reflexive aspect of the study of visual culture will be followed up explicitly in Chapters 3, 5 and 6, where hermeneutic, feminist and Marxist approaches are explained.

The following chapters will each be devoted to an approach, or to a range of different versions of a larger approach. There are many versions of Marxism, structuralism, formalism and feminism, for example, and while chapters cannot and will not attempt to explain all the different varieties that are available, they will try to select the most useful and representative examples. Each chapter will also concentrate upon one or two aspects of visual culture. Again, chapters cannot and will not attempt to show how each approach applies to all types and kinds of visual culture. Rather, one or two examples will be used in each chapter to illustrate how a particular approach proposes understanding visual culture. The question as to whether an approach can successfully understand examples of visual culture that are not covered in detail in the chapter will be discussed in terms of the strengths and weaknesses of the approach. A separate section in each chapter will assess the ability of each approach to understand examples of types of visual culture other than those used in the main body of the text. So, Chapter 4 may use architecture to illustrate how a theory of expression might understand visual culture, but the chapter will also consider whether such an

approach is of any use in understanding other kinds of visual culture – graphic design, or other examples of 'anonymous' or unsigned design, for example (see Conway 1987: 10 for more on this concept). Similarly, the chapter on feminist approaches to understanding concentrates on design, and feminist design history, while the chapter on Marxist approaches concentrates on representational art and the social history of art, but both chapters consider how these approaches might or might not apply to other sorts of visual culture.

Consequently, Chapter 3 will begin to explore the hermeneutic tradition of understanding, which is based on a conception of the individual. The individual's own ideas, values and beliefs are the basis for understanding, according to this tradition. In terms of reflexivity, one is what one understands on this account. In order to explain this tradition, the chapter will look at Dick Hebdige's (1988) essay 'Object as Image: the Italian Scooter Cycle' (in *Hiding in the Light*), and Michael Baxandall's (1972) book *Painting and Experience in Fifteenth-Century Italy*. Here, it is the ideas of individual people, the ideas and beliefs that make up their familiar worlds, that provide the basis for understanding. Baxandall shows how an individual's knowledge of dancing and commercial arithmetic informed, or produced, an understanding of Renaissance paintings for fifteenth-century Italians. Hebdige shows how the meaning of the Italian scooter changes according to the individual who is doing the understanding: the scooter means something different to its designers, marketing personnel and to its users: Mods and Rockers, for example.

Still at the subject- or individual-based end of the spectrum, Chapter 4 will consider the productive individual's conscious and unconscious expression as a potential source of understanding of visual culture. This is probably the most popular way of accounting for how the understanding of visual culture is achieved. The popular prejudice that, to understand a piece of visual culture, it is most of all necessary to understand the individual's conscious expression will be explored in relation to the Einstein Tower, designed by Erich Mendelsohn and built in Potsdam between 1919 and 1921. Ernst Gombrich's work will be used to provide a more detailed and complex version of this approach and to outline the strengths and weaknesses of this account of understanding. Auteur theory will be used to show how the individual may be thought of as an author, and it will be used to understand film. And the psychoanalytic theory of the unconscious will be used to try to explain the idea of unconscious expression and show how it may be used to understand visual culture.

Chapter 5 will look at feminist or gender-based accounts of visual culture. It will study Cheryl Buckley's (1986) essay, 'Made in Patriarchy: Toward a Feminist Analysis of Women and Design' and Judy Attfield's (1989b) essay 'FORM/female FOLLOWS FUNCTION/male' to show how design and design history may be understood in gender terms; and at Penny Sparke's (1995) book *As Long As It's Pink* and Judy Attfield's (1989a) essay 'Inside Pram Town: A Case Study of Harlow House Interiors 1951–61', in order to illustrate how feminism proposes sexual and gender politics as the basis for understanding visual culture. In Chapter 5 of this volume, one's position as a gendered individual is held to produce and affect one's understanding of visual culture. In the chapter 'The Happy Housewife', Sparke explains domestic interior design, in both the UK and the USA, in terms of gender roles and gender politics. Supplementing her gender-based account with a notion of social class, Attfield draws on Bourdieu and Veblen and charts the ways in which women could negotiate and challenge the officially sanctioned rules of 'good design' after the Second World War. The way in which these gender-based accounts introduce the notion of consumption, and active consumption, into the understanding of visual culture will be explored here.

Chapter 6 will reprise the debates surrounding the scientific nature of our understanding of visual culture that were outlined in Chapter 2. It will refer briefly, in passing, to the 'scientific' status of, and claims made for, certain early Marxist accounts of society in terms of how they might be applied to culture and visual culture. It will also discuss the location of the Marxist account of visual culture in the structural and hermeneutic traditions outlined in Chapter 2. The theme of reflexivity will be continued here as the part played by social, or class, identity in the understanding of visual culture will be explored. The contribution of Gen Doy and Griselda Pollock to the Marxist tradition will be seen to lead into a discussion of postcolonial theory. Although he was never a classical hermeneutic theorist, Marx proposes the matter of understanding in classical hermeneutic terms when he asks how it is possible to 'aesthetically enjoy' (Marx 1977: 360) the art of societies in the past, but Marxism may also be located in the structural tradition in that it is the class structure of a society that is proposed by Marxism as the basis for understanding the visual culture of that society. This chapter will consider the social history of art as an approach to understanding visual culture. It will concentrate on the work of Hauser, Hadjinicolaou and Clark to explore this tradition. It will then consider the criticisms of Pollock

and Doy, pointing up difficulties in conceptualisation, and regarding gender and ethnicity.

Firmly within structural traditions, Chapter 7 will provide further illustration of Saussure's claim, introduced in Chapter 2, that semiology would be the 'science' that studies the life of signs in society. The chapter will explain the sign and show how visual culture may be understood as signs and structures; using the work of C. S. Peirce, it will explain the different types of sign (icon, index and symbol), and show how visual culture may be understood as such signs. And it will use the work of Barthes to show how visual culture may be understood in terms of denotation and connotation. Barthes' work on photography, fashion and advertising will be used here but the work on photography and advertising will be concentrated on in this chapter. Barthes' accounts of denotation, connotation and myth in his analysis of the 'Panzani' advertisement and the famous *Paris-Match* cover will be used here. Comic strips and cars will also be used to illustrate the workings of semiological concepts and methods, such as syntagm and paradigm, for example. Another example in this chapter will be taken from graphic design; typography will also be used to assess the claim that structure is the source of the understanding of visual culture.

Chapter 8 will illustrate and explain the strengths and weaknesses of the formalist attempt at understanding visual culture. It will do this by explaining the work of Wölfflin, Bell and Greenberg. Wölfflin proposed to understand the transition from Renaissance or Classical to Baroque art in terms of style and form: he devised five pairs of stylistic concepts with which to explain this transition. Bell defined and understood art as 'significant form', shapes, lines and colours. He also referred to Cézanne as the 'Christopher Columbus of a new continent of form'. And Greenberg explained the history of European art from the Renaissance to the twentieth century in terms of the formal characteristics of paintings. Other examples of people using the formal properties of visual culture to understand that visual culture include Hebdige and Polhemus. Hebdige's account of skinheads, Mods and Punks is made in terms of style. Polhemus understands the myriad youth styles since the end of the Second World War in terms of stylistic differences. The point will be made that the understanding of visual culture found in the work of Hebdige and Polhemus is not purely formal but contains some reference to gender, ethnicity and class, for example. This will be presented as a positive development, or a strength, of such an approach to understanding visual culture.

Despite the claims made concerning the interdisciplinary nature of visual culture and the methods used to study and understand it, the conclusion to this book demands some evaluation of the various approaches explained in the previous chapters. The conclusion will reconsider all of the approaches in the book in terms of their relation to the traditions identified above and developed in Chapter 2. It will suggest that all these approaches must have some element of structural and hermeneutic understanding. Taking them in turn, it will show how they cannot be simply identified as structural or hermeneutic. Rather, each will be shown to partake of both traditions. Each will be shown to contain elements of structural and of hermeneutic traditions. Taken together, these traditions will be seen to contribute to the reflexive self-understanding of the individual student of visual culture. Looking at the work of Paul Ricoeur, the way in which a structural understanding of visual culture is made possible by a hermeneutic understanding, and the way in which a hermeneutic understanding is made possible by a structural understanding will be explained. Ricoeur says that there is no hermeneutic understanding without structural understanding and vice versa: each exists as a moment of the other. The conclusion will evaluate each of the approaches in terms of this dialectic between, or 'mutual conditioning' of, hermeneutic and structural approaches.

Further reading

At the end of each chapter, with the exception of Chapter 1 and the Conclusion, there is a section containing suggestions for further reading. There are at least four reasons for proposing further reading in this way. The titles and authors that are suggested in these sections may be ones that the chapter did not have space to deal with but which are worth following up. Where the chapter concentrates on what might be termed 'classic sources', the further reading section may suggest more up-to-date references. It could also be the case that, where the main text of the chapter concentrates on art, for example, the further reading section shows how the approach covered in the chapter may be extended and applied to design. And, where the chapter introduces the approach, the further reading section can suggest more difficult material.

Chapter 1

Understanding Visual Culture

Introduction

Most, if not all, of the books recently published on visual culture presuppose that understanding is possible and that they know what it is. This chapter will raise various questions regarding the very possibility of understanding and the possibility of understanding visual culture. It is commonly taken for granted that understanding simply happens and that we know what understanding is. In everyday life, people do not tend to sit around wondering what understanding is, or what enables it to happen. In art and design history, the possibility of understanding visual culture is rarely questioned. This chapter intends to thematise the notion of understanding, yielding the prospect of exploring the different historical and philosophical traditions of understanding and of clarifying what it is we do when we understand visual culture. It will do this by looking at three or four approaches to the understanding of visual culture, using them to raise questions such as 'What is understanding?', 'What kind of activity are people performing when they understand?' and 'Do some people understand better than others?'

Understanding visual culture

Who understands visual culture? Can we tell when we understand a piece of visual culture? What sort of activity is understanding?

Consider the following extracts.

(1) She is Venus, the Italian one, the daughter of Jupiter, the sister of the Greek Aphrodite. The organ player gives her music lessons. My name is Love. Tiny, delicate, rosy, winged, I am a thousand years old and chaste as a dragonfly. The stag, the royal peacock, and the fallow deer that can be seen through the window are as alive as the pair of lovers strolling arm in arm in the shade of the promenade lined with poplars. . . . The young music teacher and I are not here to enjoy ourselves but to work . . . our task consists of kindling the lady's bodily joy, poking up the ashes of each one of her five senses till they burst into flame . . . that is how Don Rigoberto likes to have us hand her over to him: ardent and avid . . .

(2) The pages of the *Harlow Citizen* feature complaints from architects about 'windows heavily shrouded in net curtains' and from tenants that 'privacy is one of the things held in low regard in the town from the planner's point of view'. . . . Could it be that people were not interested in the status value of their houses in the way that was generally imagined? For women it was their place of work – their view was from the inside . . . we need to go back into that fifties interior, where functional and leisure areas blur into one, where front and back no longer meet neatly in the middle but on the stairs, and consequently the confusion caused by the lack of definition between public and private spaces which women experienced in a totally different way to men . . .

(3) The general arrangement, a horizontal array of tomatoes . . . punctuated by vertical celery and carrots, has stayed more or less the same. . . . The colors . . . are surely more vivid than they would be in conventional four-color reproduction, which has become a sort of standard for reality. Thus, there is something mysteriously compelling in this representation. . . . Even though the label is in large part a collection of required and regulated words and images, color breaks through these restrictions and makes a very powerful statement of its own on the shelf. . . . Color is the fundamental language of packaging, and this label tries to use it powerfully . . .

(4) Gradually, you start to realise that the forms are defined as much by the spaces surrounding them as by their own shapes. If you look closely at the figure on the left in the middle, you will see how carefully and precisely delineated is the triangle made by the upper part of his legs, his torso and his upper arms; similarly, the triangle made by the shadow from his feet to his buttocks and the underneath parts of his legs. Also, the space defined by his profile, his forearm, the brim of his hat and the line of the back of the man behind him. Then you see how little detail there is and how the texture is rudimentary . . .

Which of these authors understands their topic? Does one of them understand their topic better than the others? What are they doing when they understand pieces of visual culture?

The first extract is from Mario Vargas Llosa's novel *In Praise of the Stepmother* (Vargas Llosa 1990). It is written from the viewpoint of Love, or Cupid, as he appears in Titian's painting *Venus with Cupid and Music*. Vargas Llosa constructs an entire chapter around the story told by Cupid, an elaborate and dreamlike story, which includes all the characters in the paintings, as well as some, like Don Rigoberto and his wife Lucretia, who are not in the painting. In the story, Don Rigoberto has instructed Cupid and Music to prepare 'his lady', Venus/Lucretia, for his arrival. They are to play music and persuade her until she is 'ready to receive him and entertain him'. The 'lady' of Cupid's story is sometimes Venus, who is seen in the picture, lying on her left side with Cupid stroking her breast and whispering into her left ear, and sometimes the beloved Lucretia, who is described as an 'obedient', if somewhat 'reluctant' wife (1990: 69–77).

The second extract is from Judy Attfield's essay 'Inside Pram Town: A Case Study of Harlow House Interiors, 1951–61' (Attfield 1989a: 219–25). In this essay, Attfield is concerned with the interior design of houses in Harlow new town between 1951 and 1961. The interiors of the houses are described and explained in terms of a number of themes. One theme is the difference between what might be called the 'official' or 'professional' taste of the architects and planners and the 'unofficial' or 'amateur' taste of the tenants and women. Another theme relates to the way in which the houses are presented as containing places that are traditionally considered private (upstairs and bedrooms, for example), and places that are considered public (downstairs and hallways, for example). A third theme is connected to the distinction between work and leisure: whether work in the house counted as 'proper' work, or merely as 'housework' (see figure 5.2). And overriding them all is the most important theme, that of gender, the construction of the differences between men and women. Men and women are said to experience or understand space in different ways.

The third extract is from Thomas Hine's book *The Total Package: The Evolution and Secret Meanings of Boxes, Bottles, Cans and Tubes* (1995: 215–16). In this extract, he is concerned with the presence and impact generated by the graphic design employed in the packaging of V-8 vegetable juice. More accurately, he is concerned first with the use of

layout, the ways in which elements of the illustration on the can use verticals or horizontals. Secondly, he is concerned with the way the graphic designer uses colour. He is looking at the workings of the illustration itself, at the things that he can see in it, like the horizontal and vertical energies of the layout, and like the use of colour.

And the final extract is from Mary Acton's book *Learning to Look at Paintings* (1997: 67). In the chapter from which the extract is taken, Acton is describing and explaining Georges Seurat's painting *Bathers at Asnières*, painted in 1884. Like Hine, she too is concerned with the workings of the image itself, with the things she can see within the painting. She is almost wholly preoccupied with the artist's use of shape and line. More precisely, she is concerned with Seurat's use of form, with the ways in which shapes relate to, or create, the spaces around them as much as they do to the things they enclose. There is the hint of a concern with Gestalt phenomena, such as the way in which background and foreground can reverse: the shapes between things here can become as significant as the things themselves. And there is the beginning of a concern with the texture of the paint as it has been applied to the canvas. Again, these are things which Acton can see in the painting.

So, who understands visual culture?

It would be very difficult to argue that none of these writers understands the pieces of visual culture they are engaged with. It would be quite difficult to argue that one of these writers had understood visual culture and that the others had not. But it would be relatively easy to argue that one or more of them has understood it partially, incorrectly or poorly. The present volume is not interested in claiming that nobody understands visual culture, or that understanding is not possible. Nor is it interested in arguing that some people do, and other people do not, understand visual culture. What it is interested in is looking at a variety of different ways in which visual culture can and has been understood. It is also concerned with the strengths and weaknesses of these different ways. All of the different approaches will offer partial understandings of visual culture. They will be partial in that they will favour one set of concerns over another, for example, and they will not necessarily be able to account for, or understand, all visual culture.

Can we tell when we understand a piece of visual culture?

If you go to the sources of these extracts, you will find that the authors construct elaborate, reasoned, sometimes scholarly, well-read, and more or less consistent and coherent cases for their readings of these pieces of visual culture. These features are often signs that someone has understood something. Alternatively, you may ask yourself, 'Have I learned anything from these people's work?' If your answer is 'Yes', then you may suspect that, not only have the writers understood the pieces of visual culture, but that they have also communicated that understanding to you. Even if your answer is 'No', it could be argued that you, and they, have a similar level of understanding of the pieces. Understanding is not always the sort of thing that can be tested for in the way that the question presupposes. It presupposes that understanding may be tested for in the same way as alkalinity, or the presence of starch, may be tested for in chemistry. The different approaches to the understanding of visual culture that will be found in the following chapters will all offer different things as understanding. Even if it were not a completely inappropriate thing to do, it would still be extremely difficult, and time-consuming, to provide a comprehensive test for the presence of understanding for each one.

What kind of thing are we doing when we understand a piece of visual culture?

The extracts above have been chosen because they each exemplify a different approach to understanding visual culture. If it is accepted that they all understand the examples they have chosen, then the authors have all understood their examples in different ways. In the first extract, Vargas Llosa has understood the painting in an imaginative way. He has imagined himself to be one of the characters in the painting and has written about the relationships he has with the other characters in the painting. He has also imagined the relationships to some characters who do not appear in the painting but who have something to do with it. And he has understood the painting in something like a factual way: the reclining nude woman in Titian's work does indeed represent Venus, who is, in fact what Vargas Llosa says she is, the daughter of Jupiter, and so on. This synthesis of sympathetic imagination and art-historical fact is what Vargas Llosa is doing when he understands this piece of visual culture.

In the second extract, Attfield is doing something different from Vargas Llosa when she understands the piece of visual culture she is concerned with. She is not imagining herself to be one of the women tenants of the houses in Harlow. Rather, she understands the interiors of the houses in Harlow in terms of gender, the cultural differences between men and women. The interiors of these houses are explained in terms of how women and men relate differently to those interiors, the ways in which they do different things to, and in, those interiors. She uses a series of paired concepts, men/women, public/private, inside/outside, leisure/work and official/unofficial, for example, in order to understand these interiors. Moreover, the terms making up these pairs are valued differently as they relate to the main pair, men/women. On the 'side' of the 'men', and highly valued in the society she is describing, are 'official' and 'work', for example. And on the 'side' of 'women', accorded lower status in this society, are 'unofficial' and 'leisure', for example. What Attfield is describing here is a structure, a system of interrelated ideas, which neither she, nor the inhabitants of 'pramtown', have created but which determines the understanding of the interiors they are all concerned with.

Both Hine and Acton, in the third and fourth extracts, are concerned with things 'inside', or 'intrinsic' to, the pieces of visual culture they have chosen to explain. They do not relate their examples to external conceptual or social structures, organised concepts in terms of which their examples are meaningful. Nor do they imaginatively reconstruct the experiences of the artists, graphic designers or characters in the paintings and illustrations they are dealing with. Rather, they study the paintings and designs in terms of 'formal' characteristics, things like layout, for example, the way in which the shapes, colours, lines and textures of the works relate to one another. They are also concerned with colour, shape and the use of texture in themselves. Their understanding of these pieces of visual culture is based on the formal properties and characteristics of the works.

What is understanding?

The extracts illustrate a variety of different approaches. The variety is so wide that the question can be raised as to whether they are in fact all offering a form of understanding. Studying the shapes and textures of a piece of visual culture is not the same sort of activity as investigating the social, gender and conceptual structures that that piece

exists within. Therefore, it could be claimed that the formal approach is not offering an understanding of the piece. Or it could be claimed that it is offering a different sort of understanding from the structural approach. Similarly, it could be argued that the imaginative reconstruction of the opinions and point of view of a character in a painting does not offer an understanding of the painting at all. These are all problems for the definition of understanding. If there is only one definition of understanding, then it seems plausible to suggest that not all of the above approaches offer an understanding of visual culture. If all these different approaches lead to an understanding of visual culture, then understanding cannot be one single thing, or activity. The present volume favours the second argument, that understanding cannot be one single activity. It will argue that there are many ways of understanding visual culture, each with its own strengths and weaknesses.

Conclusion

Having made the idea of understanding into a problem, the following chapter will consider how understanding has been thought about in the natural and social sciences. By looking at the history of how the natural sciences developed an idea of understanding, how the social sciences wanted to emulate the successes of the natural sciences in understanding their parts of the world, and at how art and design history, as social sciences, thought that they could be part of this success as well, the next chapter will prepare for the different approaches to understanding visual culture.

Chapter 2

Explanation and Understanding: Visual Culture and Social Science

Introduction

This chapter is about the sort of thing understanding is and what sort of understanding is going on when we understand a piece of visual culture. It will look at the differences between explanation and understanding in the natural and social sciences and assess the implications of these different forms of knowledge for our study and understanding of visual culture. This is important because for a long time the study of visual culture, in the form of the disciplines of art history and design history, has conceived of itself as some form of science. Following many other social, or human sciences, like history, art history and design history have presented the knowledge and understanding they could provide as scientific knowledge and understanding. What Anthony Giddens has called the 'sensational illumination and explanatory power' (1976: 13) of the natural sciences were exactly what many people working in the social and human sciences dreamed of achieving and possessing in the nineteenth and twentieth centuries. Many people working in the study of art and design have also wanted to emulate this illumination and explanatory power. Now, the present volume is not committed to the idea that the study and understanding of visual culture is scientific, in the same sense that the natural sciences are scientific. This chapter will address the lure and the attraction of such 'scientific' knowledge. It will explain what sort of knowledge and understanding these early theorists thought science could provide and it will ask to what extent this sort of

knowledge and understanding is appropriate to the human sciences in general and to the understanding of visual culture in particular. The following sections, then, will address the differences between approaches to natural phenomena, social phenomena and to visual culture.

This chapter will also provide philosophical and historical contexts for the approaches of the following chapters. It will suggest that there are two basic approaches to the study and understanding of visual culture, a phenomenological and hermeneutic subject-based one and a structural, object-based one. The hermeneutic, or phenomenological, approach stresses the role of the individual consciousness in understanding. Here understanding is either something that individuals do, or something that happens to individuals: either way, it is the product of specific, intentional, historically and spatially located individual awarenesses. The structural approach stresses the role of structure in understanding: understanding is the product of structures, in that structures provide the dichotomous concepts through which reality is ordered. So far from being individual- or subject-based, there is a sense in which individuals are themselves the products of structures, rather than pre-existing essences.

These two basic approaches will be explained in terms of hermeneutical and phenomenological traditions on the one hand and structural traditions on the other. Hermeneutical and phenomenological traditions will be contrasted with structural traditions. The work of Wilhelm Dilthey and Hans-Georg Gadamer, for example, will be used to illuminate phenomenological and hermeneutical traditions on the nature of understanding. And the work of Giambattista Vico and Claude Lévi-Strauss, for example, will be used to illuminate structural traditions on the nature of understanding. The approaches in subsequent chapters will be explained in terms of how closely they approximate to these two basic approaches. The sort of understanding that the human sciences, history, art history and design history, believe they provide will be made clear through either a structural or a hermeneutic explanation of understanding. This is important to the project of the present volume as the approaches to the understanding of visual culture that are described in the following chapters will be characterised as belonging more or less strongly to one or other of these traditions. Eventually, it will be possible to propose arguments evaluating the effectiveness of these methods based on the methods' relations to the two traditions.

Explanation and understanding: science and social science

Reference has been made above to the 'sensational illumination and explanatory power' perceived to be possessed by the natural sciences in the late eighteenth and the nineteenth centuries (Giddens 1976: 13). The sustained and logical study of nature, in any sense that modern western cultures would recognise as scientific, really only began after the work of philosophers like René Descartes and Francis Bacon (1561–1626) broke away from the Aristotelian and medieval traditions of thought about the world in the seventeenth century. Descartes's *Discourse on Method*, first published in 1637, is one of the earliest methodological treatises to propose a deductive, or rationalist, investigation of the natural world. According to this account, which separates the knower, or mind, from the known, or nature, it is on the basis of ideas existing innately in the mind that knowledge of the external and objective world may be constructed. Bacon's *Novum Organon*, published in 1620, suggests a more inductive approach. As Larrain points out, Bacon 'emphasises the role of positive science and its observational character' (1979: 19). John Locke (1632–1704), writing in 1689, intended his empiricist *Essay Concerning Human Understanding* to be of ground-clearing benefit to the great scientists of his day – Boyle, Sydenham, 'Huygenius' and 'the incomparable Mr Newton' (Locke 1975: 9–10). On the empiricist account of knowledge and understanding, all human knowledge is produced from sense experience. The scientific investigation of nature and the material world went hand in hand with the development of increasingly empirical philosophy during the seventeenth century. It is also worth pointing out that many of these philosophers and scientists were very interested in the visual: Jay notes that Spinoza was a lens grinder, while Leibniz was 'fascinated by optical instruments' and Huygens built telescopes (Jay 1993: 64ff). The development of empirical science, the philosophy of scientific knowledge and a consuming interest in the visual are all closely connected in the seventeenth century.

In the eighteenth and nineteenth centuries, of course, the progress of science was astonishing. Antoine Lavoisier (1743–94) is often credited with being the founder of modern chemistry, devising the modern method of naming chemical compounds, distinguishing elements from compounds and, with Joseph Priestley (1733–1804) going some way to describing the contents of the air we breathe. Michael Faraday

(1791–1867) conducted research into the condensation of gases, electrolysis and the relations between electricity and magnetism and between light and magnetism. John Dalton (1766–1844) first described colour-blindness, kept a detailed meteorological diary and proposed a version of the atomic theory of matter. In physics, James Watt (1736–1819) built a steam engine in 1769 and designed a steam locomotive in 1784: George Stephenson's 'Rocket' was built in 1829. Benjamin Franklin, James Maxwell and André-Marie Ampère, amongst others, continued the work on electricity and various electromagnetic effects. Carl Linnaeus (1707–78) developed a system of botanical classification, classifying plants according to genus and species. Jean Baptiste Lamarck (1744–1829) worked on the theory of evolution before Darwin and also worked on invertebrate zoology. Charles Darwin (1809–92) proposed natural selection as the explanation of evolution, applying the theory generally to species in 1859 and specifically to humanity in 1871. The explosion of experimentation, the enormous growth in knowledge and the corollary, the increase in useful applications of this knowledge, technology, can only have been breathtaking to behold during this period.

Perhaps unsurprisingly, the social sciences (including sociology, anthropology, history and economics, for example) wanted to be like the natural sciences. Practitioners of these social-scientific disciplines wanted to emulate the successes of the natural sciences. They too wanted to deal objectively with observable facts to produce truths and useful knowledge and the way they thought they could do this was by using the same methods as the natural sciences. Among those proposing that the social sciences should reorganise themselves along the same lines as the natural sciences were Auguste Comte (1798–1857) and John Stuart Mill (1806–73). In his work *Cours de philosophie positive*, Comte, who had a great effect on the methodology of sociology through the work of Emile Durkheim (1858–1917), notes the founding of disciplines such as physics, chemistry and biology and calls for a 'social physics' (quoted in Giddens 1978: 241). As Bauman points out, Comte and Durkheim both believed that facts were 'things', existing independently of individual experience, objectively 'out there' in the world and waiting to be discovered by diligent researchers using the proper methods (Bauman 1978: 15). For Comte, people's behaviour could be explained objectively, in terms of causes and effects, after careful observation and measurement of that behaviour. Mill, in his *System of Logic*, published in 1843, argues something rather similar. For him, explaining human behaviour is also a matter of

'establishing causal sequences' and subsuming them under 'laws' of human nature and society (Winch 1958: 67, 70). These 'laws' of human nature and society are apparently to be regarded as being the same kind of things as the laws of nature. As Winch points out, for Mill

> there can be no fundamental logical difference between the principles according to which we explain natural changes and those according to which we explain social changes. (Ibid.: 71)

The methodology of the social sciences is, therefore, the same as that of the natural sciences for Mill.

The desire to emulate the successes of the natural sciences can be found in the social sciences generally, then, through the nineteenth and early twentieth centuries. This desire can be found in history in particular. As E. H. Carr points out, the nineteenth century 'was a great age for facts', citing Mr Gradgrind in Charles Dickens' novel *Hard Times* and the historian Leopold von Ranke as evidence for the positivist adoration of facts, showing 'how it really was' (Carr 1961: 8–9). One of the clearest statements of the thesis that history is a science was made by J. B. Bury in 1903: 'History is a science', he said, 'no more and no less' (quoted in Walsh 1960: 34). Although Carr's position is not as simple to categorise as it might at first appear, he is concerned with all the accoutrements of science. Chapter 2 of his *What is History?*, published in 1961, concerns the historian and 'his facts', chapter 3 deals with history, science and morality and chapter 4 looks at the concept of causation. While he is concerned with facts, as the natural sciences are concerned with facts, Carr is aware that the historian's facts are not 'things' objectively existing in the world. He posits some form of dialectic between facts and interpretation, each 'reciprocally' acting on the other (1961: 30): there are no facts without interpretation and there can be no interpretation in the absence of facts. Similarly, he is aware that talk of 'laws' of society is as old-fashioned as it is presumptuous, but still wants to be able to talk of 'principles', even if these 'principles' are supported by 'facts' which are themselves only facts according to the 'principles' by means of which they have been selected (ibid.: 58–9). The lure of scientific knowledge is evidently so strong here as to overcome doubts concerning the 'circularity' of the arguments.

W. H. Walsh is also keen to establish the correct relation between history and the natural sciences, devoting chapters 2, 3, 4 and 5 of *Philosophy of History* to the question as to whether or not history is a science. Again, the answer is not clear cut. In chapter 2, history is

said to be a science in that it follows a method 'of its own' (Walsh 1960: 37), but it is not scientific in that it does not consist of 'a body of general truths' (ibid.: 36): 'general truths' being understood as akin to the 'laws' of the physicists (ibid.: 39). On the matter of explanation, Walsh is keen to differentiate history from a simple positivism, as supported by Comte, for example, but he also wants to conclude that history is 'not so different from natural science . . . as some would have us believe' (ibid.: 71). On the matter of truth and fact in history, Walsh eschews the (positivist) idea that facts and theory are entirely independent of each other, with a fact simply existing, 'whether or not anyone takes any notice of it' (ibid.: 77). And he agrees that facts are only facts in the context of some theory. But he will not accept the (relativist) consequence that this means that all historical facts are unconnected with reality (ibid.: 88). The question of the 'objectivity' of historical knowledge, Walsh suggests, is, finally, central to the matter of whether or not history is a 'genuine science' (ibid.: 95). Again, Walsh struggles heroically and strenuously against perspectivalism and scepticism but is forced to conclude that objectivity must remain little more than a 'pious aspiration' (ibid.: 118). And again, the lure and the attraction of the perceived benefits of the natural sciences, along with the desire to establish one's discipline as at least having something in common with the natural sciences, are irresistibly strong here.

The disciplinary focus of the social sciences gets closer as it moves in from history to art history: as Gombrich says, 'the art historian must be a historian' (1979: 133). So, getting ever closer to the concerns of the present volume, the desire to be scientific can also be found in art history. In the nineteenth century, for example, Giovanni Morelli (1816–91) believed that he could make artistic connoisseurship 'scientific' by studying the ways in which artists tackled details like ears and fingers in their paintings. He believed that such features of paintings were 'objectively verifiable' data. In *Italian Painters*, published in 1890 (and excerpted in E. Fernie (ed.) 1995), Morelli describes the 'method' in the form of a fictional dialogue between 'Ivan Lermolieff', a Russianised version of himself, and 'the Italian', who has devised the method. The Italian despises both art historians and their sources – books. He prefers to look at the paintings themselves, the evidence, existing 'out there'. Rather, he prefers to observe

> the forms peculiar to each great master . . . only by gaining a thorough knowledge of the characteristics of each painter – of his forms and of his colouring – shall we ever succeed in distinguishing the genuine works . . . from those of their pupils . . . or even from copies. (Fernie 1995: 110–11)

Consequently, he appeals to Botticelli's characteristic way of painting hands: 'bony fingers – not beautiful, but always full of life' (ibid.: 113). Other hands are described as 'northern', or as having thumbs uncharacteristic of Raphael. It is as if these characteristics are objectively in the paintings, independent of any theory, to be observed. In this sense, the approach bears resemblances to the empirical method noted above, emphasising the role of observation, independent of the interpretation supplied by theorists in their books. Morelli's ideas were taken up in the twentieth century by his pupil, the art historian Bernard Berenson (1865–1959), and by other, later, formalist critics who were similarly interested in making art history more scientific, intellectually and academically a more respectable discipline.

Roland Barthes (1915–80) was one of the people who believed Ferdinand de Saussure (1857–1913) when he said that semiology was, indeed, the 'science that studies the life of signs within society' (Saussure 1974: 16). During the 1960s, Barthes wrote two of his more 'scientific' works, *Elements of Semiology*, published in France in 1964, and *The Fashion System*, published in France in 1967. In the Introductions to both of these works, which deal, in their ways, with design, he refers to the scientific nature of his projects. In the former, he says that, although Saussure's 'ideas have made great headway, semiology remains a tentative science' (1967: 9), and in the latter he says that the method to be followed was 'originally inspired' by Saussure's idea of a 'general science of signs' (1983: ix). Among other things, *Elements of Semiology* is an attempt to begin to explain visual culture in the terms of a scientific semiology. Barthes refers to cinema, advertising, comic strips and press photography, for example, in the Introduction to the work (1967: 10) and gives glimpses of how the ideas may be applied to architectural design (58–9), automotive and furniture design (28–9) and fashion design (25–6). *The Fashion System* is probably the most 'scientific' of Barthes's works – its 'Contents' pages alone struggling to make the enterprise appear systematic, objective and as much like a natural science as possible, with its references to 'Species', 'Genera', 'Variants of Existence' and so on. The content of the work is similarly set up to appear as objective and systematic as possible, with diagrams, matrices and what appear to be mathematical equations. Barthes, of course, later admitted that he had been misled by a 'euphoric dream of scientificity' (*Tel Quel*, no. 47 (1971) p. 97, quoted in Larrain 1979: 236).

The ideal of scientific knowledge and understanding is something that many anthropologists and cultural theorists have wanted to

pursue. Clifford Geertz has proposed the idea that there is something scientific about the methods and results of anthropology. Anthropology is itself another social science which has influenced the study of visual culture (see Walker 1989: 125–8, for example). The very idea of there being a plurality of cultures that were visual cultures, as opposed to literary or material cultures, for example, would be difficult to conceive were it not for the influence of anthropology. Geertz argues that the fact that thought consists in the 'traffic in significant symbols . . . makes of the study of culture a positive science like any other' (Geertz 1973: 362). This is stating the case in the strongest terms. The reference to 'positive science' is a direct reference to the work of Comte, with his facts and inductive methods. However, Geertz suggests earlier in the book that the study of culture is not quite like any other positive science. He says that

> believing, with Max Weber, that man is an animal suspended in webs of significance he has himself spun, I take culture to be those webs, and the analysis of it to be therefore not an experimental science in search of law but an interpretive one in search of meaning. (Ibid.: 5)

This has the effect of 'softening' Geertz's claim that anthropology is a 'positive science', leaving social science the hermeneutic tasks of interpretation.

This book is about the different ways of understanding visual culture. It will argue that the social sciences are not and cannot be like the natural sciences in certain crucial respects. To follow and then to quote Giddens: those in the social sciences, including art history, design history and the study of visual culture, who are waiting for a figure like Newton, 'are not only waiting for a train that won't arrive, they're in the wrong station altogether' (1976: 13). The study of visual culture is not the same sort of thing as the study of Newtonian mechanics or physics. The following paragraphs will argue that the objects and phenomena of natural science are not the same kind of things as the objects and phenomena of social science, that they cannot be studied in the same way and that visual culture is best studied and explained by means of social-scientific traditions.

Something this chapter must do first, then, is to investigate what understanding is: What is it that we do, or what is it that happens, when we understand something? In order to begin the investigation of understanding, this section will contrast it with explanation. One way of introducing the differences between understanding and explanation, and between natural science and social science, is to look at the

differences between two types of phenomena and at what counts as an explanation of these two types of phenomena. The following paragraphs will develop an example first proposed by Gilbert Ryle (see Geertz 1973: 6), by considering two different phenomena, blinking and winking, in the attempt to investigate what counts as an explanation of blinking and what counts as an explanation of winking.

At one level, there is very little difference between these two activities: they are both visual phenomena and both may be described, or explained, as the closing of the eyelid over the eyeball. As soon as the explanation gets any more complicated, however, the differences start to emerge. Blinking is explained as the reflex or involuntary closing of the eyelid over the eyeball. It enables the eyeball to be cleaned and lubricated by means of tears, the tear glands and ducts and the membranes of the eyes. Most people blink about twenty times a minute, the exact frequency being determined partly by the temperature, humidity and dust content of the atmosphere and partly by the emotional state and general health of the individual. The explanation of winking, however, is slightly different. Winking is not a reflex or involuntary action; it is deliberate, or intentional, and done for a purpose. It has no physiological function, neither cleaning nor lubricating the eye. Winking may be used to communicate many different things, in a way that is significantly different from the way blinking might be said to communicate. A wink may signify friendship, collusion between two people or an intention to deceive or mock a third party (see Geertz 1973: 6 for more on this). And it will communicate these things in a way that is different from the way that a blink 'communicates' that the eye is dry, or in need of cleaning.

It will be noticed that the sorts of things produced here as an explanation of blinking are slightly different from those produced as an explanation of winking. The sorts of things produced as an explanation of blinking tend to be the sorts of things that are either correct or incorrect, independent of what anybody thinks about them. The things said about blinking are objectively either true, or false. Moreover, they are the sorts of things that can be repeatedly observed and measured in order to ascertain their truth or falsity. Thus, it is either true or false to say that, under certain circumstances, a person will blink twenty times per minute. It is either true or false to say that tears flow at a rate of one litre per hour. One may observe a person blinking and count the number of times they blink in a minute in order to ascertain the truth or falsity of the claim. One may control and vary the temperature, humidity and dust-content of the air to observe what

effect it has on blink-rate or the flow of tears. This is not the case with the things produced in the explanation of winking. Whether a wink communicates friendship, collusion, deceit or mockery is not independent of what the people involved think about the wink. A suspicious person might well interpret a friendly wink between two friends as mocking him or her, for example. Thus, what is said about a wink is not objectively true or false in the same way as what is said about a blink may be. Nor can one repeat the winking episode indefinitely in order to observe the effects of minor changes in the circumstances; the context in which the winking takes place is unique. One cannot request a person to repeat a conspiratorial wink: it stops being a conspiratorial wink and becomes something else as soon as the request is made. What is said about a wink cannot, therefore, be tested in the same way as what is said about a blink. The social phenomenon cannot be repeated and observed, in an experiment, as a natural phenomenon can.

Blinking and winking, then, are different sorts of things. They elicit different sorts of explanations. Briefly, blinking is the object of natural science while winking is the object of social science. Blinking may be explained by biology, physiology and chemistry, for example. Winking is more appropriately understood by disciplines like psychology, philosophy (see Ryle's account, referred to in Geertz 1976: 6), and anthropology. The things that are proposed in the explanation of blinking are either facts or they are not facts: they are either true or false. The things that are proposed in the explanation of winking are not facts in the same way: they are not true or false in the same way. What is different, it is argued, is that winking requires understanding, as well as explanation. Understanding of the purpose, intention and deliberate nature of winking is required in order to give an explanation of it. Understanding of the context in which winking takes place is also required in order to explain it. Winking is both a social and a visual phenomenon. Blinking is a natural phenomenon. As Bauman says,

> social phenomena . . . demand to be understood in a different way than by mere explaining. Understanding them must contain an element missing from the explaining of natural phenomena: the retrieval of purpose, of intention, of the unique configuration of thoughts and feelings, which preceded a social phenomenon. (1978: 12)

While it cannot be argued for in any great detail here, there is a case for saying that the distinctions between the phenomenological and structural traditions to be discussed below are in fact suggested

by the discussion so far. Reference has already been made, above, to the types of concerns and activities that will count as understanding according to these two traditions. The first is easy to explain. There has been reference to the intention, purpose and deliberate nature of social phenomena. This aspect of social phenomena seems to be most appropriately discussed by hermeneutic and phenomenological methods, which begin from the idea of the individual consciousness. The second is less easy to explain. There have, however, also been references to various differences. There was the difference between blinking and winking: an act was one or the other. Similarly there were differences between different sorts of winking: there were conspiratorial winks, deceitful winks, winks that established or strengthened friendship and so on. A wink was one or other of these. This aspect of social phenomena seems to be more appropriately studied by structural methods. The structure here is one of difference, what structuralists call paradigmatic difference. A paradigmatic difference is the difference between things that could replace one another, as one can imagine a friendly wink being replaced by a deceitful wink. Structural accounts seem as unhelpful in understanding individual intentions as phenomenological accounts are in understanding conceptual and impersonal structures. It may be, as Paul Ricoeur suggests, that structural and hermeneutic or phenomenological methods depend in some way upon each other (Ricoeur 1974: 56). Consequently, the following sections will explore both structural and phenomenological traditions as potential sources for the understanding of visual culture. And the following chapters will point out to which traditions the approaches most clearly or strongly belong.

Hermeneutic traditions

Giddens points out that the differences noted above between these phenomena and the differences between the sorts of explanation and understanding appropriate to them are versions of distinctions made by earlier hermeneutic theorists. In the nineteenth century, Freidrich Schleiermacher and Wilhelm Dilthey distinguished the study of human activity from the study of natural phenomena. According to Giddens, they held

> that the former can (and must) be *understood* by grasping the subjective consciousness of that conduct, while the latter can only be causally *explained*, 'from the outside'. (Giddens 1976: 55)

As Hans-Georg Gadamer says, however, even these two do not represent the beginning of the tradition of hermeneutic thought (Gadamer 1975: 157, and 1976: xii–xiii, 7). Hermeneutics has its origins in the explaining or clarifying of obscure or contradictory religious texts. Where there were different versions of the Christian Bible, or conflicting copies of the Christian Gospels, for example, produced as a result of a succession of more or less diligent, conscientious and accurate scribes copying the texts by hand, there was a need for an authoritative version to be arrived at. The true meaning of the Bible, or the Gospels, the authoritative version of the text, needed to be ascertained and hermeneutics was simply the tool by means of which the true meaning, the authoritative version was arrived at (Bauman 1978: 7).

According to Bauman, however, by the end of the eighteenth century, hermeneutics was no longer seen as a neutral tool by means of which problems concerning correct understanding were solved: it began to generate problems of its own. These problems were at least partly produced by developments in the world of art and design. In the fourteenth, fifteenth and sixteenth centuries, 'artists' were regarded as 'artisans' or craftsmen: these craftsmen did what they were told by wealthy patrons who were not interested in the personal views or opinions of the people they had employed. As Bauman says, these artisans were bound by the 'anonymous rules of the Guild' and there was no interest in their intentions or 'private feelings and visions' (Bauman ibid.: 8, see also Barnard 1998: 61–5). Even for Johann Winckelmann, writing as late as 1764, 'the history of individual artists has little bearing' on the historical understanding of art (quoted in Fernie (ed.) 1995: 72). With the development of capitalism, however, the Guild system began to break down as traditional markets like the Church, the Court and the aristocracy declined and new markets, in the form of new social classes, developed. Finally, at the end of the eighteenth century, the philosophy of Kant, with its emphasis on the active and constitutive role of the subject in perception and understanding, proved critical. It was critical in many ways. Bauman suggests that this emphasis on the constitutive role of the individual in cognition 'was soon followed by the discovery of the artist behind every work of art' (1978: 9). This lead to W. H. Wackenroder's idea, crucial to the development of hermeneutics, that, in order to find the meaning of a piece of art, 'one has to contemplate the artist rather than his products' (ibid.).

With these developments, the problem set for hermeneutics has subtly shifted and hermeneutics has itself become part of the problem.

The original problem concerned how best to clarify obscure and anonymous works. It then changed to ascertaining the meaning of anonymous works. And then, after Kant, at the end of the eighteenth century, it becomes one of how to understand the individual artist's intentions in the work. It is the role of the individual's intentions that makes hermeneutics part of the problem. It becomes part of the problem because the interpreter, as well as the artist, is now thought of as having intentions that complicate the process of understanding. These intentions may be thought of as the thoughts of the individual, the beliefs, hopes, fears and desires about the world and its contents that an individual has at any one time. Clearly, these thoughts are going to change from individual to individual. They are going to change and be different according to where and when that individual lives. For example, the fears of a fourteenth-century male English peasant are likely to be quite different from those of a twenty-first century female American university lecturer. The 'horizons' or the 'life-worlds', as phenomenological theory calls the collection of beliefs, hopes, fears and so on of these individuals, are likely to be utterly different.

Consequently, the problem for hermeneutics is considerably more complex. The process of understanding is now itself a problem. Moreover, the intentions of the interpreter, the beliefs, hopes, fears and so on, are now seen as obstacles in the way of understanding the meaning of works. As David E. Linge points out, for Schleiermacher the differences between the interpreter's life-world and that of the author (the fact that they have different intentions, that their world-views are different) are now the source of misunderstanding: 'intervening historical developments are a snare that will inevitably entangle understanding unless their effects are neutralised' (Linge 1976: xiii). The beliefs of the twenty-first century female American academic are problems, obstacles in the way of understanding the life-world of the fourteenth-century peasant, on this view. The ideas possessed by a modern academic must be neutralised in order that the world and the meanings of the peasant may be fully revealed. Linge argues that this neutralising, or 'purging', of the interpreter's own position is to make of hermeneutics a 'method' and to identify understanding with a scientific understanding. It seems that even hermeneutic theory was unable to resist the lure or the promise of achieving apparently scientific knowledge in the nineteenth century, and it was the scientific turn of the theory that Gadamer was to resist in the twentieth century. However, for Schleiermacher and Dilthey, the ill-effects of

the interpreter's own horizons, the interpreter's own life-world, must
be systematically and methodically 'neutralised' in order to gain
access to the author's intentions. Linge also argues that Dilthey takes
this process further, wanting to make this methodologically effective
hermeneutics the basis for all the human sciences. For Schleiermacher
and Dilthey, he says,

> the knower's own present situation can have only a negative value. As the
> source of prejudices and distortions that block valid understanding, it is
> precisely what the interpreter must transcend. (Ibid.: xiv)

As noted, Gadamer does not think that the sort of understanding
arrived at by hermeneutics is scientific. Nor does he think that
hermeneutics is a method, especially not a scientific method, as sci-
entific method has commonly been understood (Gadamer 1975: xi ff).
Hermeneutics is not a method for Gadamer because our immersion
in history is not something accidental that could be neutralised, our
immersion in history is what makes us what we are. Following the
German philosopher Martin Heidegger, Gadamer thinks that our
situatedness in the life-world in which we find ourselves is what we
are. In a sense (and it does sound odd), we *are* our understanding of
the world in which we find ourselves. It is here that the self-reflexiv-
ity that was proposed in the introduction becomes pertinent. One of
the things that Gadamer is doing here is describing the philosophical
situation interpreters of visual culture find themselves in. Such inter-
preters are constituted by their understanding of visual material: it is
one of the things which make them what they are. Among the conse-
quences of Gadamer's argument is the idea that no method, no
'scientific' technique, can or will extricate us from that life-world.
This means that the interpreter is stuck with the intentions that make
up the view of the surrounding world that in turn make the interpreter
the person that he or she is. As Linge explains,

> any [scientific] ideal of understanding that asks us to overcome our own
> present is intelligible only on the assumption that our own historicity is an
> accidental factor. But if it is an ontological rather than a merely accidental
> and subjective condition, then the knower's own present situation is
> already constitutively involved in any process of understanding.
>
> (Linge 1976: xiv)

The 'horizons' in which we always already exist, the beliefs and
expectations concerning the world that we always already have as his-
torical beings, then, are not accidental and cannot be methodologi-
cally neutralised. They are our understanding of the world and they

make us what we are. Gadamer calls them 'prejudices' (Gadamer 1975: 235ff). He does not use the word in its everyday sense, where prejudice is the source of unjustified, untrue and unattractive opinions. As he says, prejudices are not necessarily unjustified, and in fact, 'in the literal sense of the word, constitute the initial directedness of our whole ability to experience' (1976: 9). Were it not for these prejudices, we would experience nothing and understand nothing: they open the world up to us 'in the first place'. So, the assumptions about the world that make up the twenty-first-century female academic are what make it possible for her to have any insight at all into the world of the fourteenth-century peasant. He, too, had a set of assumptions, constituting a 'way in' to his world, his horizons. The 'horizons' she inhabits, her 'life-world', are not obstacles to her understanding, they are the starting points of her understanding.

Understanding on Gadamer's account, then, is not reconstructing or duplicating the world of the past or the intentions of the other in the head of the interpreter. Nor is it reconstructing oneself as, or trying to be, the fourteenth-century peasant, for example, in order to understand the pronouncements of that peasant. Rather, it is a mediation, or a fusing of the horizons of the interpreter and of the past (1975: 272–3). So, understanding is not the move from a single, closed horizon of the present into the single, closed horizon of the past (ibid.: 271), it is the fusion of horizons into a wider 'superior vision' (ibid.: 272). Prejudices, therefore, have a productive power on Gadamer's account and, as Linge says, the admission of such a productive power 'seems to place Gadamer in explicit opposition to the scientific ideal of prejudiceless objectivity in interpretation' (Linge 1976: xvii). This, then, is a version of the hermeneutic tradition's explanation of understanding. It is based on the individual, although it would be true to say that it describes something that happens to the individual, rather than something that the individual does and is in complete control of. It also describes a tradition that ends up, with Gadamer, explicitly distancing itself from the project laid out by the sciences, and by those social sciences which conceive of themselves too positivistically.

Structural traditions

Fredric Jameson describes structuralism as the study of the

> unconscious value system or system of representations which orders social life at any of its levels, and against which the individual conscious acts and events take place and become comprehensible. (Jameson 1971: 101)

He is suggesting that, so far from being the source of understanding, as on the hermeneutic account, the individual, along with its acts and intentions, is to be thought of as a product of that understanding. He continues by saying that, for structuralism, 'all conscious thought takes place within the limits of a given model and is in that sense determined by it' (ibid.). For structuralism, the individual consciousness is itself a product of structures. A structural approach to understanding, then, would appear to be something like the exact opposite of a hermeneutic one.

Given this, it may come as a surprise to learn that structural accounts of what sort of thing understanding is start, as did the hermeneutic traditions above, with the notion of science. Early thinkers in the structural tradition also look to the natural sciences for a model of what should be the proper understanding employed by the human or social sciences. It is instructive that Giambattista Vico (1668–1744) calls his work of the early eighteenth century *New Science*. He intends this account of humanity to be scientific and, as H. A. Hodges says, 'complementary to the natural science of which Galileo and Bacon and Descartes were the exponents' (Hodges 1969: 440). He wants to be scientific, to provide or generate new knowledge, and he wants to do for the social or human sciences what he perceives Bacon and Galileo to have done for the natural sciences. Vico has a particular sense of the word 'science' in mind, of course, it being an account of neither a 'blind concourse of atoms', nor a 'deaf [inexorable] chain of cause and effect' (Vico 1968: 102, par. 342; references are first to page and second to numbered paragraphs). Also, Vico's science was carried out under the nose of the Inquisition (see Bierstedt 1978: 23), and divine providence is the ultimate guarantee of the science's truth (Vico 1968: 104, par. 349).

Although Vico uses the phrase, a 'physics of man' (Vico 1968: 112, par. 367), it is clear that he wishes to distinguish his enterprise from the kind of physics found in the work of Newton. According to Werner Stark (1969: 298), Vico conceived the social order not as an artefact, as Descartes had done, nor as a natural datum, as Comte had done. Rather, the social order was something that had to be developed. It was not mere extended matter, existing objectively, out there. Nor was it just a thing. Isaiah Berlin supports Nicolini's idea that Vico was 'particularly opposed' to Descartes's *Discourse on Method*, with its attempt to apply the mathematical or geometric method, for example, to areas to which it was not appropriate (Berlin 1969: 372). For Vico, the mathematical method was not appropriate to the social order. The

social order was something that had to be, and was, developed. Vico's account is of the movement of humanity, through stages. Vico writes of three ages, the age of the gods, the age of heroes and the age of men (Vico 1968: 69, par. 173). During the age of gods, men are ruled by gods; in the age of heroes, men are plebeians and live under the rule of patricians; and in the age of men, men form their own governments and monarchies. Similarly, each of these stages has elements, characteristic sets of opinions, for example, which read rather like early versions of ideology.

Vico refers to something he believes to be true beyond all question. This is

> that the world of civil society has certainly been made by men, and that its principles are therefore to be found within the modifications of our own human mind. (1968: 96, par. 331)

He refers to 'the world of nations, or civil world, which, since men had made it, men could come to know' (ibid.). The natural world, which has been made by God, is not to be known in the same way by humans. Edmund Leach argues that, while he is not aware that Lévi-Strauss ever refers to Vico, nor that Vico directly prefigures Lévi-Strauss, Vico is concerned with the same problems as later structural anthropologists and that he 'encounters what Lévi-Strauss would . . . refer to as "structural" data' (Leach 1969: 313–14). Here Leach has something like the characteristic poetry and myth of a people in mind: both Vico and later structural anthropology are interested in what myth has to tell modernity about old civilisations (Vico 1968: 116ff, par. 375ff).

Tom Bottomore and Robert Nisbet argue that Vico's work may be called structuralist for three reasons. The first is that, in *New Science*, Vico is trying to find 'recurrent patterns or structures of events' (Bottomore and Nisbet 1978a: 563). So, for example, Vico suggests that 'all nations, barbarous as well as civilised . . . keep these three human customs: all have some religion, all contract solemn marriages, all bury their dead' (Vico 1968: 97, par. 333). These customs are not accidental or incidental to one society, they may be described as structural. If there is society, then there are these customs. Secondly, Vico is looking for the 'principal and recurring stages or phases through which peoples' histories tend to pass' (Bottomore and Nisbet 1978a: 564). These common stages are the product of the relation between the human mind and the institutions in which those ideas are formed, and 'the order of ideas must follow the order of institutions' (Vico

1968: 78, par. 238). And thirdly, Vico is interested in the mythology of different peoples and in the 'poetic imagination' they employ to make sense of their worlds (Bottomore and Nisbet 1978a: 564–5). He says that the first peoples were poets, by which he means that they were creative – they 'made' their world as they 'made' their poetry (Vico 1968: 117, par. 376). Such poetry and myth were made up of 'imaginative genera', which served as categories with which to interpret the world (ibid.: 22, par. 34).

This latter point accords with Jameson's account of what structuralism is. According to Jameson, structuralism is the

> explicit search for the permanent structures of the mind itself, the organisational categories and forms through which the mind is able to experience the world or to organise a meaning in what is essentially in itself meaningless. (Jameson 1971: 109)

Meaning here is something which must be 'organised', it is the result, or product, of a place in a structure, an organised set of elements. Such an account of meaning is completely different from the hermeneutic account of meaning, where meaning is a product of individual intention.

It also accords with later structuralists' accounts of what structuralism is. Vico's pronouncement, noted above, to the effect that 'the order of ideas must follow the order of institutions' (Vico 1968: 78, par. 238) would not look out of place in the work of Karl Marx (1818–83), for example. Marx might be presented as a sort of structuralist, arguing that social life is to be understood in terms of the structure that is class society. Class, that is, would be the structure in terms of which actions and human history were to be seen as meaningful and understandable, on a Marxist account. This is not to suggest, of course, that Marx was ever directly influenced by Vico (see Eugene Kamenka 1969: 137–9, for example). It is merely to note a compatibility between the approaches. Similarly, the work of Emile Durkheim (1858–1917) has been acknowledged as structuralist. Bottomore and Nisbet claim that, prior to Claude Lévi-Strauss, Durkheim must be regarded as 'the pre-eminent structuralist in French sociological thought' (1978a: 565). They cite his treatment of the 'categories of the mind', ideas of causation, space, time and so on, in terms of which the human mind orders and produces sensory experience, as evidence of this. Durkheim's criticism of Kant, who proposed that such ideas have such a role in his *Critique of Pure Reason*, written in 1787, is that the content of these ideas is not the same in every society or at all times.

Each of these ideas is found in a larger context, or structure, of ideas 'which are closely woven into the life of the people' (ibid.: 568). Durkheim's case is that, if one is to understand a society, one must take these ideas, in their place in such a structure, into account. Here, understanding is a product of structure, not of individual intention. In this sense, Durkheim makes Kant more structuralist than he was in the first place (see Ricoeur 1974: 33 for more on this).

Someone who was profoundly influenced by Durkheim and who was, like Vico, concerned with the nature and use of so-called 'primitive' language and mythology in understanding the world was Claude Lévi-Strauss, (1908–). In *The Savage Mind* (1966), Lévi-Strauss refuses to draw a distinction between 'primitive', or 'pre-logical' thought and non-primitive and 'logical' thought. He argues that

> [t]he savage mind is logical in the same sense and the same fashion as ours, though as our own is only when it is applied to knowledge of a universe in which it recognises physical and semantic properties simultaneously. (1966: 268)

What he is trying to explain here is that the mind, whether 'savage' or not, works structurally, associating physical and semantic properties of the world. He continues to say that the mind 'proceeds through understanding . . . with the aid of distinctions and oppositions' (ibid.).

It is in language that these distinctions and oppositions are to be found. Each culture's language will provide sets, or a structure, of distinctions and oppositions. And these distinctions and oppositions will be used to construct and understand a world. Consequently, when anthropology wants to understand another culture, it must do so structurally, paying attention to the distinctions and oppositions of the language. In his book on Lévi-Strauss, Edmund Leach uses the example of the 'often bizarre rules' which govern the behaviour of Englishmen towards animals. Animals are classified semantically, in the English language, according to the following:

> (i) wild animals, (ii) foxes, (iii) game, (iv) farm animals, (v) pets, (vi) vermin.
> (Leach 1973: 40)

He then suggests that if the following linguistic categories are also taken into consideration, they will be found to be 'homologous':

> (ia) strangers, (iia) enemies, (iiia) friends, (iva) neighbours, (va) companions, (via) criminals. (Ibid.)

All non-human animals have been categorised by the terms found in the language. A structure has been constructed. A set of distinctions and oppositions between things found in the (natural) world, has been established by means of language. Similarly, the humans that an Englishman is likely to encounter have also been categorised by the terms found in the language. Another structure, or set of oppositions and distinctions between things found in the (cultural) world, has also been established, again by means of language. And, so long as one does not object too strongly to the idea that one might eat one's friends, a homology has been found to exist between the two structures. Consequently, if one wishes to understand the culture, one must understand the structures which that culture sets up and in terms of which it in turn understands the world.

On such a view, it is structures that are productive of understanding. The mind, savage or not, operates in terms of categories. These categories, sets of distinctions and oppositions, form structures. These structures may be used to understand the external world. Consequently, they may also be used to understand the culture that is itself using them. These categories, these structures, are not under the control of individuals. They are a product of mind, or consciousness, but they are not the products of individual minds or consciousnesses.

Conclusion

In the attempt to account for what it is we are doing when we understand visual culture, this chapter has examined two accounts of what is meant by understanding. It has tried to explain two different traditions of understanding, the hermeneutic and the structural. In spite of some striking similarities, understanding has been seen to be quite different in each of the traditions. Those similarities included finding a source in the sixteenth-century desire to put the natural sciences on a secure footing. Both structural and hermeneutic traditions in the social or human sciences were seen to be born of the desire to emulate the successes of the natural sciences in understanding and explaining the world. However, it was seen in the account of the hermeneutic tradition that understanding was a different activity from explaining.

The chapter has established, not entirely intentionally, a distinction between structure and intention. Intention proved to be what the

hermeneutic tradition conceived understanding to begin from. And the structural tradition posits structure as the source of understanding. It may be that this distinction between structure and intention leads to, and to that extent justifies, the interest in structural and hermeneutical approaches respectively. Meaning is more appropriately understood and explained in terms of structures. Intention is more appropriately explained and understood in terms of phenomenology. Hence, to this extent, these traditions are both appropriate to the study of visual culture. The approaches studied in the following chapters, which will be located in one or other (and sometimes both) of these traditions, will be assessed in terms of whether they are appropriate to the study of visual culture. While it is not something that can be pursued here, these traditions are not to be thought of as entirely separate. Ricoeur (1974: 60) argues, for example, that each approach should be thought of as supplementing or complementing the other. It should, perhaps, be said that the distinction is made for analytic purposes only.

Further reading

There is not much further reading on the topics covered in this chapter: that is partly why the present volume includes this chapter. However, Gombrich's essay 'Art History and the Social Sciences', in his (1979) *Ideals and Idols* (London: Phaidon), is crucial further reading. Gombrich considers many of the topics covered here – the relation of art history to history, the nature and role of explanation and interpretation in history – in terms of the concerns and procedures of the social sciences. The work of Algirdas Julien Greimas is also highly relevant to the concerns of this chapter. He begins his essay 'On Scientific Discourse in the Social Sciences', for example, by pointing out that 'it might appear naive or even misleading to use the word "science" when speaking about our knowledge of human beings' (1990: 11). He also studies the credentials of structuralism's claim to scientific status in the essay 'The Pathways of Knowledge'. Neither of these essays is exactly introductory, but they do provide further commentary on the matter of the scientific nature of the sort of understanding that is to be found in the social sciences, including the history of art and design. Both of these essays are collected in Greimas's (1990) *The Social Sciences: A Semiotic View*, Foreword by Paolo Fabbri and Paul Perron, translated by Paul Perron and

Frank H. Collins, published by the University of Minnesota Press, Minneapolis.

John Mepham's essay 'The Structuralist Sciences and Philosophy', in D. Robey (ed.) (1973), *Structuralism: An Introduction* (Oxford: Clarendon Press), provides a useful, interesting and complex philosophical treatment of many of the issues covered in this chapter. Concentrating on Marx, Freud and especially Lévi-Strauss, he considers the differences between the human and the natural sciences and the theoretical, or structural, construction of experience and 'the facts'. Finally, he considers the implications of the arguments that make up these issues for Lévi-Strauss's distinction between 'bricolage' and science. Finally, from a non-visual perspective, chapter 3 of Malcolm Williams's (2000) *Science and Social Science* (London: Routledge) discusses whether social science is scientific. Earlier chapters present the development of both the natural and social sciences and consider the nature of scientific method.

Chapter 3

Interpretation and the Individual

Introduction

Previous chapters have raised questions regarding the nature of understanding and introduced two different traditions, or explanations, of understanding. Chapter 1 raised the question as to what sort of thing, or activity, understanding is and considered whether there were different forms of understanding. Chapter 2 proposed that the two main traditions were the hermeneutic, which stressed the role, active or passive, of the individual, and the structural, which minimised the role of the individual and proposed that structures of concepts were productive of understanding. This chapter will begin to explore the ways in which the hermeneutic, subject-based tradition of understanding may be used to investigate and understand visual culture. In order to do this, it will look at Dick Hebdige's (1988) essay 'Object as Image: the Italian Scooter Cycle' (in *Hiding in the Light*), and Michael Baxandall's (1972) book *Painting and Experience in Fifteenth-Century Italy*. Hebdige shows how, during the 1950s and 1960s, the scooter was understood in different ways by different groups of people. Baxandall shows how the middle-class Italians of the Renaissance would have understood the paintings surrounding them by relating the paintings to those people's social skills, religious beliefs and commercial practices. In their different ways, these works illustrate how the beliefs, the hopes, desires and fears about the world, what Gadamer would call the 'horizons' of their interpreters, change the meaning of the images and objects the interpreters are surrounded by. The work of Hebdige

enables this chapter to explain how different life-worlds, or 'horizons', as Gadamer would have it, produce different interpretations of the same object. The work of Baxandall enables the chapter to explore how the horizons of present-day spectators need to be expanded, or 'fused' with those of the fifteenth-century Italians, in order to understand the works as they would have done.

As well as various strengths, there are various problems and potential weaknesses involved in the hermeneutic account of understanding. This chapter will explain these potential weaknesses as well as the strengths. It will use the examples above to discuss Dilthey's question as to how we can be sure that modern spectators, from specific times and places, understand the visual culture of different times and places in the way that the original spectators did. The question of whether this is either desirable or possible, also needs to be considered. The matter of relativism, whether it is not the case that every spectator, or interpreter, generates a different and equally valid interpretation, will also be addressed. And the question will be raised as to whether each interpretation does not simply understand the past only, or simply, in terms of the present. Gadamer's response, that the prejudices of the present are a condition of understanding, rather than an obstacle, will be explained.

Fifteenth-century Italy: a 'church-going business man with a taste for dancing'

Baxandall's book is about much more than the life-worlds of fifteenth-century Italian men (and it must be noted that, for the most part, he does refer only to men). It covers more than the hermeneutic concern with the differing beliefs, hopes and fears of the interpreters and the ways in which these factors affect the interpretation of images. As he says, '[a] fifteenth century painting is the deposit of a social relationship' (1972: 1). To begin with, there is a painter, a patron and a contract between them. The relation between the painter and the patron may be of various kinds: it may be a formal contract, written and signed by both parties. It may be that the painter lives in the patron's house, or is paid a salary, it may be that the patron is not an individual, but a social institution, like a cathedral. These relationships are themselves social institutions, governed by rules and conventions. For Baxandall, they affect the production and reception of paintings. There are numerous other institutions and conventions, 'commercial, religious, perceptual, in the

widest sense social' (ibid.) conventions and institutions, all of which influence the production and reception, or interpretation, of paintings at this time. However, a significant part of Baxandall's account is to do with what the previous chapter explained in terms of 'horizons', or 'life-worlds'. It is about the ways in which the beliefs, hopes, fears and desires of fifteenth-century, affluent, middle-class Italians produced their inter-pretations of the paintings they saw. For Baxandall, it is also about the ways in which these beliefs, hopes and so on produced the paintings themselves. However, the following sections will explore how these 'horizons' may be used to investigate the production of interpretations of these paintings. They concern how understanding is explained in terms of the horizons of individuals.

Baxandall begins his account by noting the workings of the eye. He explains how light enters the eye, is focused by the lens onto the retina, and how the resulting information is transferred by the rods and cones to the brain (ibid.: 29). 'It is at this point that human equip-ment for visual perception ceases to be uniform' (ibid.). Now the brain must 'interpret' this information, using skills, some of which are 'innate' and some of which are learned from experience. Given that everyone will have had a slightly different set of experiences, every-one will have slightly different knowledges and interpretative skills. Therefore everyone will process the information from the eye with different 'equipment' and the interpretations of the information are in turn likely to be slightly different (ibid.). Most of the time, of course, as we know from our own experience, the differences will be minor, passing unnoticed, or at least unremarked. But sometimes, as Baxandall says, the differences can take on a 'curious prominence' (ibid.). Many of the examples in the book do indeed show how the differences between the interpretative skills and abilities possessed by fifteenth-century Italians and modern people from any country take on this curious prominence.

Baxandall introduces three respects in which the horizons of indi-viduals are likely to differ. These respects may be thought of as three sets of basic beliefs about the world and its contents which will vary from culture to culture and which will determine how an interpreter interprets a painting. First, understanding a painting, picture or diagram requires that the interpreter understand the convention that marks, lines and shapes on a two-dimensional ground represent some-thing in the world. An interpreter has to know that an image has 'been made with the purpose of representing something' (ibid.: 30). More specifically, with regard to painting,

> understanding the picture depends on acknowledging a representational
> convention, of which the central part is that a man is disposing pigments
> on a two-dimensional ground in order to refer to something three-
> dimensional. (Ibid.: 33)

This is not a very complex requirement, but it is a requirement: it is
something that a person must know, it is something that must be
within their life-world. As Baxandall says, unless the convention
(that what one is looking at is a representation, one thing standing
for another thing) is within the interpreter's culture, 'as it is within
ours' (ibid.: 30), the interpreter will not know how to understand
the image.

The second set of beliefs and knowledges that a potential inter-
preter must possess consists in the 'kinds of interpretative skill . . . that
the mind brings' to a picture or a painting (ibid.: 34). Baxandall is
thinking of the 'patterns, categories, inferences [and] analogies' that
an interpreter can either see or not see in an image. If the interpreter
does not possess a certain interpretative skill, then they will not be
able to understand a painting in terms of that skill. There are various
capacities upon which rests the possibility of understanding. For
example,

> if he is skilled in noting proportional relationships, or if he is practiced in
> reducing complex forms to compounds of simple forms, or if he has a rich
> set of categories for different kinds of red and brown, these skills may well
> lead him to order his experience of Piero della Francesca's 'Annunciation'
> differently from people without those skills. (Ibid.)

The bottom half of Piero's *Annunciation*, for example, contains a wide
range of reds and browns. The painting also requires a fairly sophisti-
cated understanding of how complex three-dimensional figures are
rendered in simple two-dimensional shapes. Without these skills and
categories, without these ideas and beliefs, the understanding of the
painting would be quite impoverished. Knowledges, ideas and beliefs
may also be irrelevant to a painting. Someone with skills only in
anatomy, for example, someone who knows the surface musculature
of the body, 'would not find much scope on the "Annunciation"'. They
would not find much to understand the painting in terms of.

Thirdly, according to Baxandall, 'one brings to the picture a mass
of information and assumptions drawn from general experience'
(ibid.: 35). The two examples that Baxandall gives are again related
to Piero's *Annunciation*. He imagines how the image would be
understood were one to

remove from one's perception ... the assumption that the building units are likely to be rectangular and regular and ... knowledge of the Annunciation story. (Ibid.)

As noted above, the complex three-dimensional structures of the buildings are rendered in two-dimensional forms. If one did not know that this was the case, one might suppose, according to Baxandall, that the 'picture space abruptly telescopes into a shallow little area' (ibid.: 36). If this knowledge was subtracted from a modern, western set of presuppositions, the picture would be understood quite differently, as showing events happening in a very shallow space indeed. These pre-suppositions are part of the life-world, then, in relation to which the picture may be understood. Another more or less familiar horizon from which the painting may be successfully understood is the Christian story of the Angel Gabriel and Mary. If one did not know this story, one might suppose, as Baxandall says, that the two central characters are addressing a Corinthian column. Knowledge of per-spective and of the Christian Bible, then, are just two examples of the kind of ideas and beliefs, the conceptual horizons, required to under-stand Renaissance paintings, on Baxandall's account.

There are many other ideas, beliefs, hopes and fears which would have affected fifteenth-century Italians' understanding of the paint-ings they saw, and Baxandall's book is mainly an account, in some detail, of them. There are a few which it is worth pursuing here, in order to get a more concrete idea of how these horizons function in the production of understanding on a hermeneutic account. These ideas may be subsumed into horizons which may be termed the reli-gious, the commercial and the social. First, as Baxandall points out, these paintings are religious paintings (ibid.: 40). The life-world inhab-ited by the earlier interpreters of these paintings is likely to have been very different from that inhabited by most modern western inter-preters. One way in which this difference manifests itself is on the matter of 'visualisation'. Baxandall points out that the Renaissance painter 'was a professional visualiser of the holy stories', and that 'each of his public was liable to be an amateur in the same line'. The modern, western interpreter of these paintings is not likely to be so skilled. Baxandall quotes the 'Garden of Prayer', a handbook of prayer, written for young girls in 1454 and explaining at length the need for 'internal representations' of the story of the Passion. It recommends visualising a town, one's home town perhaps, in which the Passion could be set. It then suggests imagining the houses and

buildings of that town, and the rooms in those buildings, where the scenes might happen. And it suggests using people one already knows to 'play the parts' of the central characters, Jesus, Pilate, Judas and so on. As Baxandall says,

> This sort of experience, a visualising meditation on the stories particularised to the point of perhaps setting them in one's own city and casting them from one's own acquaintance, is something most of us now lack.
>
> (Ibid.: 46)

Consequently, 'most of us' will understand the paintings quite differently from the fifteenth-century girls to whom the handbook was addressed. It is unlikely that we will share the beliefs, hopes and fears of these people and thus it is unlikely that we will understand the images in a similar fashion to them.

The commercial horizon of the fifteenth-century gentleman is also liable to be one that many modern western interpreters will not share. Baxandall explains this horizon in terms of the mathematics that a boy would learn in school: 'it was a commercial mathematics adapted to the merchant, and both of its principal skills are deeply involved in fifteenth century painting' (ibid.: 86). One of these skills was to do with gauging and one was to do with the 'Rule of Three'. Gauging was necessary to the business man because there were no standard sizes in fifteenth-century Italy. A bale of straw, or a barrel of wine in one part of the country could be quite different in size and volume from a bale and a barrel in another part of the country. Consequently, a merchant needed to be highly skilled in gauging, or estimating accurately, the volume in a non-standard bale or barrel. Piero della Francesca even produced a mathematical handbook on gauging for use by merchants and, as Baxandall says, 'the skills that Piero or any painter used to analyse the forms he painted were the same as Piero or any merchant used for surveying quantities' (ibid.: 87). The Rule of Three was more advanced mathematics and applied to working out proportions. According to Baxandall, problems of proportion included 'the adulteration of commodities, barter [and] currency exchange' (ibid.: 96).

Consequently, Baxandall argues that painters reduced 'irregular masses and voids to combinations of manageable geometric bodies' (ibid.: 88–9). Spectators would use their gauging skills to estimate the relative size, capacity and proportion of these geometric shapes. This would also have the effect of impressing the lessons learned from the paintings more forcefully in the memory of the spectator (ibid.: 87).

Among the examples Baxandall provides of paintings that may be interpreted in this way are Piero's *Annunciation*, the *Madonna del Parto* and Uccello's *The Battle of San Romano*, where Niccolo da Tolentino's hat provides a stern test of any gauger's geometric abilities (see Figure 3.1). Cisterns, columns, paved floors, towers, pavilions and other features of the paintings were also fair game for the gauger's skills. And Piero's *Annunciation* is also full of mathematical problems regarding the Rule of Three and proportion (ibid.). Clearly, few people in twenty-first century western countries will possess such skills. They will not be looking at the works from within such a horizon. And they will not share the life-world of those fifteenth-century merchants and gentlemen. Consequently, either they will not understand why the paintings look the way they do, or they will understand them quite differently.

In addition to the skills necessary for learning the Christian stories and conducting a profitable business life, the fifteenth-century gentleman also needed various social skills. Chief among these were the understanding of gesture and dancing. Baxandall shows how many paintings are influenced by popular dances of the time. He also illustrates the ways in which gesture can inform an understanding of the paintings. There are religious and profane gestures, for example (ibid.: 70), and an interpreter would need to know the difference, as well as the meanings of such gestures. In Botticelli's *Primavera*, for example, Venus's hand gesture is not asking us to 'look over here', nor is she beating time to the dance of the three Graces. Rather, she is inviting the spectator into 'her kingdom' (ibid.). Baxandall also suggests that the dance of the three Graces in *Primavera*, and the image of Venus in Botticelli's *Birth of Venus*, may both be understood as representing a dance called 'Venus', composed by one of the Medicis in the 1460s (ibid.: 78). As he says, 'both the dance and the picture of Venus were designed for people with the same habit of seeing artistic groups' (ibid.: 80). The social skills involved in interpreting gestures and in dancing were called upon by artists for the interpretation and enjoyment of their paintings. Again, if one does not know the gesture, or if one does not know the dance, the interpretation and understanding of the painting are likely to be compromised. The ideas and knowledges of the individuals are again producing an understanding of the images. And the absence of those ideas and knowledges are preventing the understanding of the images.

Baxandall suggests that, on the basis of the description thus far, Quattrocento man might be caricatured as 'a church-going business

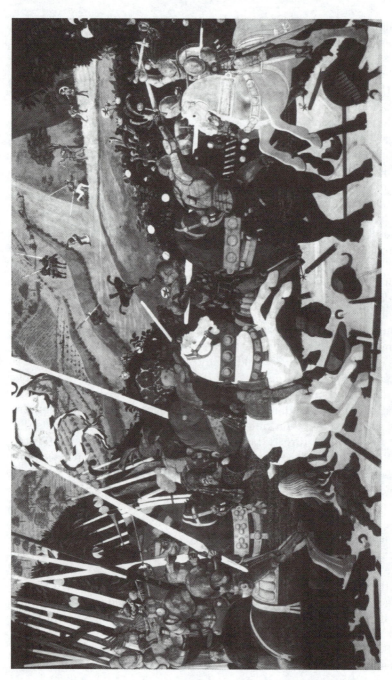

Figure 3.1 Paolo Uccello, *The Battle of San Romano*

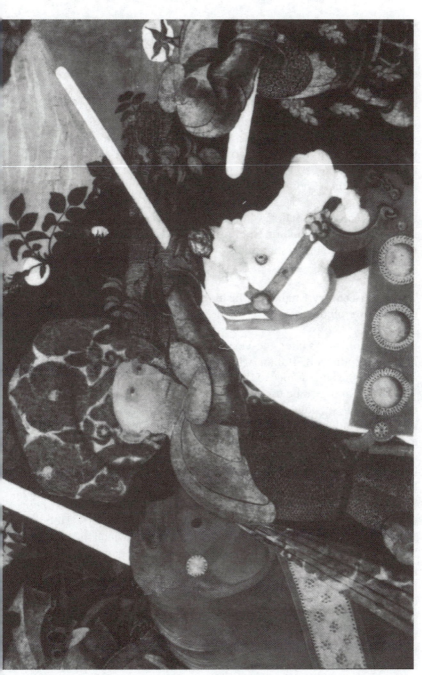

Figure 3.1 Detail from *The Battle of San Romano*

man, with a taste for dancing' (ibid.: 109). However, the account does show how the individual consciousness of interpreters can affect the understanding of paintings. It is the set of beliefs and ideas that are specific to an individual that may be seen to inform the interpretation and understanding of fifteenth-century paintings here. Despite the undoubtable fact that the interpreters mentioned here are male, middle class and Italian, it is the individual intentions, the religious, social and commercial beliefs, hopes and fears, that generate the understanding of the images on this account. The fact that more modern, although still western, interpreters do not necessarily think in terms of these religious, social and commercial ideas and beliefs indicates that those ideas and beliefs are indeed productive of under-standing. The next section will examine another example of how the life-worlds of individuals, the individual intentions, thoughts and beliefs, generate understanding.

Twentieth-century England: a fashion-conscious pansy with a taste for violence

Five hundred years later, the Vespa and Lambretta motor scooters are also the products of Italian artistry (see Figure 3.2). Dick Hebdige's account of the appearance of the Italian motor scooter after the Second World War may also be used to show how the different life-worlds, the different sets of beliefs and ideas about the world and its contents inhabited and possessed by different individuals, may be used to explain the understanding of visual culture. As with Baxandall, there is more to Hebdige's account than the description of the contents of indi-viduals' consciousnesses in the 1950s and 1960s and their relation to the understanding of the meanings of these products. It is significant that Hebdige begins his account with a discussion of the role of structure in understanding, and this point will be returned to in Chapter 9 (Hebdige 1988: 85ff). The structuralist's notion of totemism, in which the relations between objects are made to represent the relations between people or groups of people, is used to present the scooter in terms of its relation to the motorcycle. On this structural account, the scooter is feminine and the motorcycle is masculine. The message about the relation of the scooter to the motorcycle is expressed in terms of the message about the relation between masculinity and femininity. However, within, or alongside, this structural account there is an account of how the under-standing and interpretation of these items of visual culture is generated by individual consciousnesses, with their own ideas, beliefs, hopes and

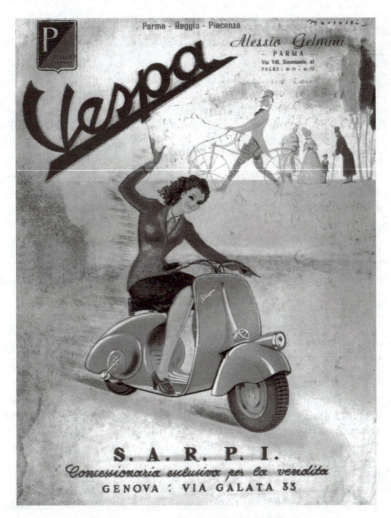

Figure 3.2 Vespa advertisement, 1960s

fears concerning the world. It is this latter that the following paragraphs will concentrate on.

The first category of people to be considered here for whom the post-war scooter was meaningful are the Italian engineers and design-ers of the late 1940s. Although Hebdige is not especially concerned with the intentions and the life-worlds of these people, their inter-pretations of the scooters may be reconstructed from the things he reports. The 1946 Vespa and the 1947 Lambretta are, on this level,

the products of a set of problems, a collection of demands, technical limitations and specifications. The meaning of the scooters for the engineers and designers will, then, at this level, be that of a response to these problems, demands, limitations and specifications. (Parenthetically, the following discussion might be usefully compared with Baxandall's treatment of the Forth Road Bridge project in his book *Patterns of Intention* (1985: 12–40)). In the most general terms, the problem posed for the engineers and designers of the Piaggio and Innocenti companies was that of developing a

> 'popular' commodity capable of translating the . . . inchoate desire for mobility and change – a desire associated with the re-establishment of parliamentary democracy . . . – into a single object, a single image.
>
> (Hebdige 1988: 90)

This desire would have been one of the intentions in the minds of the engineers and designers: the Vespa and Lambretta scooters can be seen as being meaningful, as being interpreted and understood, in terms of this desire.

There are also less general and more specifically technical problems which faced the designers and engineers of post-war Italy. The scooter had to make the best use of the plant that was not destroyed by Allied bombing and it could only be designed and produced by the personnel who remained. It had also, as Hebdige says,

> to fill a gap in the market, supplying the demand on the part of consumers deprived during the war years of visually attractive, inexpensive luxury goods, for a cheap, stylish form of transport. (Ibid.: 88)

And, if that were not enough, it had to be capable of 'negotiating Italy's war-damaged roads' (ibid.). So, for example, the size of wheel, how the wheels were to be fitted to the frame, what sort of frame was to be constructed and many other questions would have to be answered within the parameters established by these general and particular demands. Again, these demands, abilities and limitations would have been present in the minds of the engineers and designers as they planned, sketched and costed their machines. As present in the minds of the designers and engineers, these intentions are productive of those engineers' and designers' understanding of their machines. For these people, these intentions would have been the way they understood the machines they were making. These desires, and the solutions to the problems, would have been the meaning of the scooters they were designing. The objects may be understood as looking the way they do,

for example, because of the intentions in the minds of the designers and engineers. The intentions were concerned with the political, technical and mechanical demands and specifications described above.

The second group of people for whom the scooters were meaningful were the advertising and marketing departments of the Piaggio and Innocenti companies, respective producers of the Vespa and the Lambretta. What this section is trying to establish is that the advertisers and marketers had a series of ideas and beliefs about their products and that they saw their machines as meaningful in terms of, or as a result of, those intentions. Their strategy was to get the public to understand the products in terms of those intentions. Understanding here is a product of individual intentions existing in the minds of the advertisers and marketers. According to Hebdige, Piaggio and Innocenti set out to display the scooter's

> versatility and range, its resilience, its androgynous qualities ('feminine' and sleek but also able to climb mountains, cross continents . . .). (Ibid.: 95)

These properties may be seen as intentions in the minds of the marketers and advertisers: this is how they intend the machines to be understood. The understanding of the machines is, therefore, based on these intentions, these thoughts and ideas in the minds of the advertisers. Hebdige identifies four general 'public representations' of the scooter, four characteristic ways in which it was presented to the public or four ways in which it was intended by the advertisers to be understood by the public (ibid.).

The first concerns the 'dematerialisation' of the object. This involves removing the brute materiality of the machines, the machinic nature of the products, with all their petrol and oil and their hot, smelly, moving and fallible dirty parts. And it involves turning the scooter into an item of consumption, clean and convenient (ibid.: 96). Innocenti's strategy stressed the notion of convenience, setting up an 'international network' of mechanics and service stations, where the machines, which had themselves been made easier to service by means of stub axles and engine layout, could be serviced and repaired by people other than the rider. As Hebdige points out,

> the sheathing of machine parts placed the user in a new relation to the object – one which was more remote and less physical – a relationship of ease. (Ibid.)

This encasement tended to 'accentuate the boundary between the human and the technical' and helped the scooter appear even more

'ideal' (ibid.: 96–7). The second concerns the linking of the scooter to the worlds of femininity and fashion. The advertisers and marketers intended the scooters to be associated with femininity and fashion: that is how they wanted the machines to be understood. Consequently, when Innocenti exported Lambrettas to New York, they were often displayed in the windows of 'exclusive "ladies" fashion shops' (ibid.: 99). The Lambretta newspaper, *Lambretta Notizario*, contained regular features on what women should be wearing that season on their scooters. And *Picture Post* in an article in 1954 showed the latest shoes, 'headkerchiefs' and sweaters to be worn (ibid.).

The third representation related to international tourism and the fourth centred around the actual image of the Innocenti factory in early Lambretta advertisements. These images need not be pursued in detail here. The important point is that in all of these characteristic representations, it is the intentions in the minds of the advertisers and marketing people that are providing the basis for the interpretation of the products. These ideas and beliefs which the advertisers and marketers have about the scooters are the ways in which they intend their product to be understood. They are, therefore, productive of the understanding of the scooters. It is a set of ideas and beliefs in the minds of the advertisers that is the basis for the public's understanding of the Vespa and Lambretta scooters.

Finally, the third group of people whose intentions regarding the Lambretta and Vespa scooters are to be considered here are the Mods of 1960s England. Hebdige suggests that the 'first wave of modernist youth emerged in or around London in the late 1950s' (ibid.: 112). The Dean, a character in Colin MacInnes's novel *Absolute Beginners*, which was published in 1959, was, according to Hebdige, 'a "typical" (i.e. ideal) early modernist' (ibid.: 110). The Dean, like Mods generally, was obsessive about his clothes. They had to be just right and preferably Italian or American:

> . . . neat white Italian rounded-collar shirt, short Roman jacket very tailored (two little vents, three buttons) no turn-up narrow trousers with seventeen-inch bottoms . . . pointed white shoes, and a white mac. (Ibid.)

The scooter appealed to Mods because it was clean, it was stylish and Italian, and because it was fashionable. Jimmy, the Mod hero of The Who's 1969 'opera' *Quadrophenia*, linked the two when he sang about riding a 'GS scooter' with his hair cut 'neat'. It fitted in with their desire to look immaculate. Of course, Rockers, who represented different tastes and tendencies (ibid.: 113), disagreed. Rockers typically rode motorcycles and wore leathers and jeans. They characterised the

Mods as 'pansies' and said they were 'soft' (ibid.). For whatever reason, Mods and Rockers clashed throughout the summer of 1964 in violent confrontations along the seafronts of Margate and Brighton. Again, it is the wishes and beliefs in the minds of the Mods which form the basis for understanding the scooter in this way, as stylish, clean and, precisely, 'mod'. It is within the Mod life-world, where maintaining an appearance of affluent consumption, the ability to dress 'to the letter', is of such importance, that the scooter takes on the meaning that it had for them. This world, this set of horizons, then, is the basis of the understanding of the scooter.

The strengths and weaknesses of the hermeneutic account

Having looked at two examples of the hermeneutic account of understanding, of how individual intention may be used as the basis of understanding, the following sections must assess the strengths and weaknesses of such an account. In other words, the use of notions such as 'life-world', 'horizon' and 'intention' in explaining how understanding visual culture works, must be assessed by judging what is good about such an account and what is not so good. The following paragraphs must also examine what the account leaves out, or cannot explain, as well as any logical, or philosophical, discrepancies it may have.

1 The fusion of horizons

One question to be asked concerns how the above accounts may be explained on the basis of the fusion of horizons. The above sections may have showed how it is the intentions of individuals that provide the basis for the interpretation of visual culture, but they do not necessarily do it in terms of the fusion of horizons mentioned in the previous chapter. Horizons were explained as sets of ideas, beliefs, hopes and fears about the world and its contents that made up the individual. Clearly, different individuals, existing in different times and places can be expected to have different sets of horizons, different sets of beliefs about the world and the things in it. The most serious question that arises concerning understanding conceived in this way is about the very possibility of that understanding in the first place. It is argued that, if understanding is based on the intentions and life-worlds of people from other times and places, and given that, by definition, one is not of those times and places, then one cannot have those intentions or life-worlds and understanding must be impossible. The most serious form of this

question denies the possibility of understanding anyone else at all, let alone those from other times and places. Given that one is not any other person, the argument goes, one cannot have the intentions and beliefs and so on of another person. Understanding is therefore impossible. Another question that arises from this conception of understanding regards whether the interpreter is fusing their horizons with those of the producer of the visual culture, or whether the interpreter is simply seeing the piece of visual culture from the perspective of their own horizons. If it is the latter case, then the interpreter is simply imposing their view of the world on that of the artist or designer, and this can hardly be called understanding.

In considering the examples above, then, the arguments may be made that understanding the visual culture used by Mods from the 1960s is no more possible than understanding the visual culture familiar to middle-class business men of the 1460s. The idea is that, given that one is no more likely to share the outlook, the ideas, beliefs and so on, of any one of the Mods than those of the fifteenth-century business man, understanding the visual culture of the Mods is just as impossible as understanding that of the business man. This is an extreme version of this argument, but it does carry it to its furthest point, at which the argument is that nobody can understand anyone else. One simple way of meeting such an argument is to point out that an understanding of the visual culture of the Mods and of the Quattrocento (and, indeed, of other people) is in fact reached. Understanding must, therefore, be possible. Matters are not as clear cut as these arguments imply.

Another, related, question, one which begins to show in what ways matters are not so clear cut, regards the level of difficulty of fusing one's horizons with those of the artist or designer that one is trying to understand. The question is whether it is more difficult to understand a piece of visual culture, or an artist or designer from many years ago and another culture, or one from one's own time and place. Baxandall's response to this problem is to assert that:

> Our own culture is close enough to the Quattrocento for us to take a lot of the same things for granted and not to have a strong sense of misunderstanding the pictures. (Baxandall 1972: 35)

The implication here is that it is relatively easy for 'us' to understand the visual culture of five hundred years ago; the implication seems to be that 'our' horizons are much the same as those of fifteenth-century business men who knew their New Testament. It is possible to dispute

these implications. One may wonder, who is this 'us' that Baxandall constantly refers to? Who is this 'we' that is presupposed? If you are the twenty-first-century female academic mentioned in the previous chapter, or if you are a Muslim African-American, or if you are a working-class mature student, you may well wonder whether you are included in this 'us' and this 'we'. Which horizons do the academic woman, the black Muslim and the working-class student have in common with the middle-class, white European business man?

Stated in this fashion, the problem of how understanding can consist in the fusion of horizons seems insurmountable. Stated like this, the implication is that these people can have nothing in common with, and can therefore not understand, the visual culture of the Quattrocento. Even when the visual culture is only a few decades distant, as the visual culture of the 1960s is from Hebdige, writing in 1988, it is possible to argue that, because the time and place are different, it is impossible to understand it. It is possible to argue that even this temporal distance establishes horizonal differences that cannot be overcome. Here, though, the counter claim that 'our own culture' is close enough to the 1960s for 'us' not to have a strong sense of misunderstanding, seems to be more plausible. After all, it might be argued, 'we' are listening to styles of music which were developed in the 1960s, 'we' wear fashions that derive from 1960s styles and the world 'we' live in is a direct product of the social and cultural changes that took place in the 1960s. According to this counter claim, the differences between the horizons are not so great that they cannot be negated, overcome, or exchanged: there is a sense in which 'we' are the products of the times, and horizons, 'we' are seeking to understand.

However, as Gadamer says, these horizons are to be fused. They are not to be exchanged or negated. It is not that the black Muslim, or the woman academic, or the working-class student have to become a fifteenth-century Christian business man, or even to take on his outlook, in order to understand the visual culture he would have been familiar with. For Gadamer, the problem is not quite as Schleiermacher and Dilthey envisaged it. For the latter, understanding was possible only if the obstacles of the interpreter's own, and different, world-view, the interpreter's own different horizons, could be overcome. As Linge points out, for Schleiermacher and Dilthey, the meaning of a piece of visual culture is identified with the artist's or the designer's intentions (Linge 1976: xiii). This meant negating the intentions of the interpreter, somehow removing them, in order that they did not interfere with access to those of the artist or designer to be understood. On this view,

the intentions, the life-worlds, of the interpreter represent a handicap, something that prevents understanding happening, because they deny access to the intentions and the life-world of the artist or designer to be understood. On this view, understanding meant in some sense 'becoming' the people to be understood.

For Gadamer, however, as was seen in the previous chapter, understanding the meaning of a piece of visual culture is a fusion of the interpreter's horizons and those of the artist or designer to be understood. Understanding is not the negation of the interpreter's intentions or life-world, nor is it the simple reconstruction of those of the work or artist/designer, it is the mediation or fusion of horizons (ibid.: xvi). So, the question as to how the female academic, the black Muslim and the working-class student are to understand the world and the visual culture of a fifteenth-century Christian business man may now be re-approached. It can be suggested that, having an idea of a supreme being, of a moral order based on the teachings of a religion and of the son of a supreme being having been made flesh and walking the Earth, a Muslim has plenty of horizons to fuse with those of the fifteenth-century Christian business man. Or it may be suggested that, experiencing life as a woman in the twenty-first century, with its demands, stereotypes and possibilities, the female academic has some insight into the role of femininity, and hence of the Virgin, in fifteenth-century paintings. And it may be suggested that the working-class student has an insight into the world of the Quattrocento artist, doing exactly what a more or less insensitive and uncaring employer says, chasing that employer for payment and so on. In these cases, it is not that the ideas, the beliefs, hopes, fears and desires, of the interpreters are being negated, or erased. Nor is it that the world of the past is being reconstructed. The ideas, the life-worlds of the interpreters are fusing with those of the artists and designers to be understood.

These intentions, these ideas, beliefs, hopes and fears about the world, which go to make up the life-worlds of the interpreters are not to be thought of as obstacles, or as preventing access to the intentions of the artists and designers one is seeking to understand. The differences are not thought of as things that need to be overcome. On Gadamer's view, they are starting points, places from which to begin to understand the intentions and life-worlds of those artists and designers. Gadamer's horizons may be thought of as 'ways in', or 'entrances' to the horizons of other people and thus to the visual culture produced by other people, no matter how distant in time or space. A horizon which shares a religious idea may be seen as a 'way in' to a horizon from a different religious tradition: what they have in common is something 'reli-

gious'. It may be something as general as the idea that there is a creator god, or that mercy is important, but it is argued that this kind of element of a horizon will function as a way in to the horizon of another culture. For Gadamer, of course, what is formed by the fusion of horizons is not one horizon taking in the other horizon, but the formation of a further, more accommodating horizon, in which the particularity and limitations of the interpreter's original horizon have been lost. This is why it is probably not a good idea to stress for too long the idea of elements or 'bits' of horizons operating as 'ways in' to other horizons: it tends to lose the Gadamerian stress on fusion.

These issues and arguments are analogous to those which will be examined later, in Chapter 4 (where the idea that individual expression is the basis for the understanding of visual culture is examined), and in Chapter 7 (where Panofsky's account of visual culture in terms of iconology and iconography explicitly raises these questions). The approaches to be examined in those chapters admit of the same objections. For example, when Panofsky is describing what he calls 'iconological interpretation' (Panofsky 1955: 64ff), it seems that either one has to be of the time that is being interpreted, or one has to have that time 'reconstructed' for one, by sensitive and specially attuned interpreters (ibid.). Panofsky's responses to these issues and arguments will be addressed in Chapter 7.

2 The object of interpretation

Another set of problems concerning hermeneutical approaches to understanding visual culture relates to the kinds of visual culture which are available to such interpretation. The following paragraphs must examine the claim that certain examples of visual culture are amenable to hermeneutic interpretation while others are not. It is part of the strengths and weaknesses of hermeneutic approaches, then, that they are applicable to some items of visual culture and not to others. Cheryl Buckley presents one version of this sort of problem in her (1986) essay, 'Made in Patriarchy: Toward a Feminist Analysis of Women and Design'. She points out that 'design is a process of representation' and argues that to concentrate on the individual designer's intentions as the basis of understanding is to simplify the process out of recognition (1986: 10). This means that the designer's intentions are not paramount in the understanding of design objects: there are meanings encoded in design objects that are 'decoded by producers, advertisers and consumers' (ibid.). There are the advertisers and the consumers to be considered in this process, as well as the

intentions of the designer. In a sense, this has been raised by Hebdige, but not as a problem. Buckley is raising it as a problem for this approach to understanding. On Buckley's argument, then, even when the intentions of the designer are known, they are not a basis for understanding the designer's production as there are other factors, other people, involved in the design process.

A further problem concerns what is to form the basis of understanding when the individual designer is not known: when the designer is unknown, or anonymous, what then is to form the basis for interpretation? After all, it seems clear that an approach to understanding visual culture which is based on the idea of individual intention cannot approach, or understand, any example of visual culture where individual intentions are either unavailable or non-existent. Where the intentions, the life-world, the horizons with and within which a producer produced a piece of visual culture are absent, for whatever reason, the project of understanding seems doomed to fail. How, after all, can the hermeneutic project succeed when individual intentions are unavailable, based as it is, precisely on the workings of individual intentions?

This is a serious problem for the understanding as many pieces are anonymous, they are not attributed to individual artists or designers. Some pieces are simply not signed by, or even attributed to, an individual artist or designer at all. This is slightly different from saying that a piece of visual culture is attributed erroneously and it is different from pointing out that other pieces of visual culture are signed by forgers, who are not the individual artists and designers they claim to be. In both the latter cases, there is, somewhere, an individual to whom the piece can eventually be attributed. In these cases there is the possibility that an individual will be found and his or her individual intentions interpreted. In the former case, the piece is anonymous and while there clearly has to be, somewhere, an individual to whom it can be attributed, that individual is not known. Here, it is more difficult to see where the individual intentions on which an interpretation could be based will be found.

Much of what is called 'design' is anonymous in this sense (Conway 1987: 10). Graphic design, wallpaper, the layout of a newspaper, websites, birthday cards and computer game graphics are all usually anonymous. There is rarely a signature at the end of a roll of wallpaper, at the foot of the newspaper page, website, or in the computer game, for example. Similarly, most furniture is not signed by the carpenter, or the designer. Every day, millions of people, in villages, towns

and cities all around the world, pass by buildings designed by people whose name they will never know. Few people know the name of the person, or more likely the design team, who designed, or styled, their car or motorcycle. One's shaver, television, computer zip drive, hairdryer and kitchen utensils are also anonymous. Product design, while undoubtedly what one would want to call visual culture, is anonymous. Fashion design is slightly different: it is often linked to an individual's name, even if that individual did not in fact design that particular garment. However, most of the clothing bought in most High Street stores by most people most of the time will not be linked to the name of a designer: it is unlikely that the consumer of J. Crew or BHS clothing will know the name of the person who designed their underwear. So, graphic, automotive, computer, furniture, architecture, fashion and product design are all anonymous in the sense that there is often no person linked by name with particular products, nor is there, for the most part, the possibility of finding out who such an individual might be.

Does this mean, then, that graphic design, automotive design, computer design, furniture design, architecture, fashion design and product design, for example, are all out of bounds for visual culture? Does it mean that, because there is usually no known individual designer linked with them, these sorts of design cannot be interpreted and understood? The most obvious response to these issues and arguments is to say that of course they are not out of bounds and that of course they may be interpreted and understood. People have been studying these items of visual culture, interpreting and understanding them, writing their histories, for many years. However, that is not to say how they have been studying them, interpreting and understanding them and writing their histories, for all those years. If one is committed to the idea that interpretation and understanding operate in terms of individual intention and if one is persuaded by the idea that individual intention is often absent from many forms of design, then one has to consider two possibilities. The first is that these forms of design are understood in a way that is not hermeneutic. The second is that these forms of design must have their individual intentions reconstructed in order that they can be understood hermeneutically.

The former possibility, that design is better studied, interpreted and understood using approaches other than the hermeneutic, is eminently arguable. The following chapters will look at approaches, like those which involve the formal properties of visual culture, or structural elements like class and gender, which might seem much more

appropriate to design than a hermeneutic approach. The latter is effectively what Hebdige does in his essay on Italian scooters. The presentation of his essay concentrates on reconstructing, from press cuttings, advertisements and comments of the people involved at the time, what those people's intentions must have been. Although the Vespa and the Lambretta scooters are not entirely anonymous, in the sense used here (Hebdige tells us, for example, that the Vespa was originally designed by Corriando D'Ascanio), there are few individuals named to whom one could appeal personally for their intentions. For the most part, the account is reconstructing intentions, the life world of the Mod, for example, from anonymous quotes and generalisations.

It is also what Baxandall is doing much of the time in his account of fifteenth-century paintings. There are a few individuals whose names are known, and whose comments are quoted verbatim. Piero della Francesca's account of the Rule of Three is quoted at length (Baxandall 1972: 95), and related closely to his paintings. But for the most part, Baxandall reconstructs what he thinks must have been in people's minds when they produced and responded to these paintings. Lorenzo de' Medici, for example, is imagined in his bedroom, contemplating Niccolo da Tolentino's hat in Uccello's painting (Figure 3.1) *Battle of San Romano*. Lorenzo 'would have . . . accepted it as a sort of serial geometrical joke' (ibid.: 89). The horizons of Lorenzo's world, the fact that he 'would have' appreciated both ways of seeing the hat, first as a 'round hat with a flouncy crown', and secondly 'as a compound of cylinder and . . . polygonal disc' (ibid.), are reconstructed and the painting understood within them.

Conclusion

Hermeneutic approaches, then, may be used to understand those examples of visual culture which, for whatever reason, are anonymous. Where individual intentions are clearly discernible, there is presumably no problem in presenting understanding as the fusion of horizons. This is the case with all live artists and designers, and with many dead ones, where records exist, for example. Where there are no discernible individual intentions, as in the case of much design, intentions and life-worlds may be reconstructed. As Panofsky implies, however, this is not always easy, it may involve much hard work and the 'synthetic intuition' he calls upon in this task is as often found in a tal-

ented layman as in a scholar (Panofsky 1955: 64). It remains the case, however, that this approach is open to the charge that one cannot be sure that these were the intentions of people from other times and places: Gadamer's account of the fusion of horizons may always be refused and the problem re-described in terms of the negation or reconstruction of horizons. It may always be argued, that is, that what Hebdige and Baxandall, for example, are doing here is not fusing their horizons with those of the past, but attempting to cast themselves into the horizons of the past. It may always be argued that they are trying to negate the negative effects of their own life-worlds and to think themselves into those of the 1460s or the 1960s. What the present account has assumed is that understanding here could be described as Gadamerian fusion. Whilst this is not the place to do it, the above discussion of Hebdige and Baxandall could profitably be re-cast in the terms of negation and reconstruction.

The next chapter will consider a very closely related approach to the understanding of visual culture. It will look at understanding as the product of personal or individual expression and consider the claim that visual culture may be understood as the expressing of private feelings, thoughts and emotions.

Further reading

Nicholas Davey has written an excellent essay on Gadamerian hermeneutics; it is called 'The Hermeneutics of Seeing' and is collected in I. Heywood and B. Sandywell (eds) (1999), *Interpreting Visual Culture: Explorations in the Hermeneutics of the Visual* (London: Routledge). Paul Crowther's (1983) essay 'The Experience of Art: Some Problems and Possibilities of Hermeneutical Analysis', in *Philosophy and Phenomenological Research*, vol. XLIII, no. 3, is also very useful. Another central, although not introductory, text here is Martin Heidegger's essay 'The Origin of the Work of Art' in his (1971) *Poetry, Language, Thought* (New York: Harper and Row). Other authors whose work in this area is generally worth investigating include Gianni Vattimo and Mikel Dufrenne. Vattimo's (1988) *The End of Modernity* (Cambridge: Polity Press) and Dufrenne's (1966) *The Phenomenology of Aesthetic Experience* (Evanston, Ill.: Northwestern University Press) would be good places to start.

Chapter 4

Expression and Communication

Introduction

Still at the individual-based end of the spectrum of approaches, this chapter will consider expression and the role of the individual in understanding visual culture. It is apparently on the basis of an account of Leonardo da Vinci, in Vasari's *Lives*, that the idea of expression is first conceived as a way of understanding visual culture. During a lull in the production of *The Last Supper*, Leonardo explains to the Duke of Milan that

> men of genius really are doing most when they work least, as they are thinking out ideas and perfecting the conceptions, which they will subsequently carry out with their hands. (Vasari 1963: 161)

Leonardo is expressing the idea that there is something going on in the artist's or designer's head, some idea or conception that is being thought out and developed, which will later be expressed outside that head in the work of art or design. This chapter will consider the productive individual's consciousness as a potential source of understanding of visual culture. This is probably the most popular way of accounting for how an understanding of visual culture is achieved. Many people believe that, to understand a piece of visual culture, it is necessary to understand the creative individual's conscious expression. One may speculate that it is this idea which is behind the practice of interviewing art and design students before making them offers of places at art schools and universities, and of interviewing famous

artists and designers for magazines and television programmes. There is little point in interviewing such people if one does not believe that their work is the expression of something going on in their heads and that one will understand their work better if one knows what they were or are thinking about.

This chapter will also consider the idea that the unconscious mind of individual artists and designers may be used as a basis for understanding their work. This is the idea that there are unconscious, or subconscious, thoughts and desires which are informing the production of visual culture. It is the idea that the expression of these unconscious and subconscious thoughts and desires may be used to help understand that visual culture. Psychoanalytic theory will be examined in order to explain how the idea of the expression of the unconscious may be used to understand visual culture. The idea that the unconscious of the individual spectator, as well as that of the artist or designer, can be used to understand visual culture must be examined here. The role of notions of desire, pleasure, scopophilia, voyeurism and exhibitionism in understanding visual culture will be explained. The understanding of the producer and the spectator, or user, of visual culture may be explained in terms of their unconscious thoughts and desires, and in terms of the structures and 'mechanisms' of the unconscious.

And the chapter will explore auteur theory in relation to the understanding of film and television. It will present auteur theory as a form of explanation that depends upon notions of expression and individual personality. This theory holds that films and television programmes may be understood in terms of the personality of an individual, whether that individual is the director, the producer or even the writer. The theory proposes that, when a film is described as a 'Mike Leigh film' or a 'Dennis Potter television play', the audience has some idea of the sort of film or programme they may expect. Having said that the concerns of the chapter are at the subject-based end of a spectrum running from individual subjects to apparently impersonal structures, it should be pointed out that some versions of auteur theory involve the operation of structure. They look for recurring structures in works, rather than the presence of a personal or individual vision.

The weaknesses of and problems involved in basing an understanding of film and television on the individual 'auteur' will also be covered here. These weaknesses include the ideas that the theory cannot account for all aspects of film, that the very notion of the

auteur, as distinct from a talented director, is difficult to make sense of and that some 'auteurs' made films that inhabit very different genres. Another problem involved in suggesting that visual culture in general may be understood on the basis of individual expression is that much mass-produced visual culture, graphic design images, such as in advertising or packaging, is not usually seen and experienced as an expression of individuality. Graphic design, press photography and packaging are all examples of visual culture and they are all things that a study of visual culture would want to understand, but they are not all equally open to analysis and understanding in terms of individual expression. Finally, the notion of the unconscious, explored by psychoanalysis, is itself a powerful critique of the notion of conscious expression, placing in doubt the idea that the conscious expression of the individual is all there is to be understood in a piece of visual culture. The chapter will begin the account of expression by looking at the work of the architect Erich Mendelsohn. It will then consider Julian Bell's and Ernst Gombrich's contributions before moving on to Auteur theory, psychoanalytic accounts and the strengths and weaknesses of this approach to understanding visual culture.

Expression

In Leland M. Roth's (1993) book *Understanding Architecture*, Erich Mendelsohn's 'Einstein Tower', built near Potsdam in Germany between 1919 and 1921, is described as an example of 'expressionist' architecture (see Figure 4.1). Roth says that 'progressive architects in Germany and Italy' around this time were interested in 'inventing bold sculptural forms expressive of the modern fascination with movement' (Roth 1993: 485). Mendelsohn had studied in Munich, which was the centre of pre-war German expressionism and the 'Blaue Reiter' group, led by Wassily Kandinsky. It was here, suggests Roth, that Mendelsohn 'learned to think of the function of architecture as the symbolic expression of inner human emotions realised in physical form' (ibid.). Here are two senses of 'expression', then. The first, and surely most challenging, sense is that in which the architect attempts to express a concept like 'movement' in something that will not move. The second refers to using buildings to express inner emotional states of human beings. The tower was intended to house an observatory and a laboratory in which the latest, and radical, theories

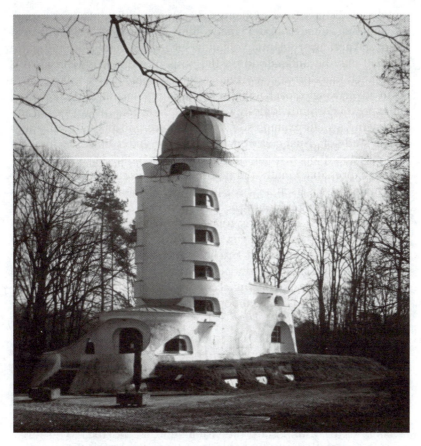

Figure 4.1 Erich Mendelsohn, Einstein Tower, 1919–21

of Albert Einstein concerning the relation between energy and matter could be tested. In addition to the shapes and lines of the building, Mendelsohn thought that the material the tower was to be built from, reinforced concrete, should also express the forces and the modernity of the project. For Mendelsohn, reinforced concrete was expressive of the potential and novelty of the early part of the century (ibid.: 487). Roth also suggests that the support for the central tower, being made from a 'heavy mass', was expressive or symbolic of the 'Promethean power' of the nuclear energies being investigated by the scientists in the laboratory (ibid.).

Again, the two senses of expression may be seen. First, the awe-inspiring energy of nuclear power, a concept, is expressed in the material mass of the central support. And, secondly, Mendelsohn's feelings concerning modernity and its potential are to be expressed in the use of concrete to construct the building. As regards understanding, it is clear that on this kind of account one must understand what is happening in the architect's head in order to understand the building. The architect here has feelings and emotions concerning the materials he is using, or would like to use, and they are being expressed in the shapes, lines textures and materials of the building he designs and builds. Similarly, the architect is trying to express something of what he feels concerning abstract concepts, like 'the new century', or 'movement', in building materials. In order to understand these materials and buildings, one needs to have some idea of the emotions and feelings of the architect. What Roth is doing in his account of Mendelsohn and the Einstein Tower is presenting the architect's feelings and emotions as the key to understanding the work. In understanding the former, one understands the latter: although Roth does not say what it is, there is some kind of relation between feeling and physical object.

In his book *What is Painting?*, Julian Bell considers painting in terms of expression and he helps to develop the definition of expression begun above in Roth's account of Mendelsohn. Bell proposes 'expression' as 'the most respectable job description for painting' (Bell 1999: 133). Expression is what painting does. It is the 'job' of painting to 'express'. He says that expression is the 'translation' of invisible states of mind into the visual and that the 'focus' or source of these invisible states of mind is 'the painter' (ibid.). This is 'expression' in the second sense noted above. The 'invisible states of mind' may be taken to be emotions and feelings and expression 'translates' them into two-dimensional painting. This represents an advance on Roth's account in that Bell tells us what the relation between emotions and physical objects is: it is one of 'translation', or 'transmutation' (ibid.: 134). It is as if one language, that of emotion and feeling, is being 'translated', or 'transmuted', into another, that of two-dimensional shapes, lines, colours and textures. Indeed, the *Encyclopaedia Britannica*, which is quoted by Bell, explicitly refers to a 'visual language' (ibid.: 133). Regarding understanding, the implication is plain. In order to understand a painting, one must understand the artist's invisible states of mind, his or her emotions and feelings. One must translate, or transmute the shapes, lines, textures and colours of paint-

ings into emotions and feelings, in order to understand those paint-ings. It seems that the artist translates or transmutes thoughts and feel-ings into physical objects and then the spectator translates or transmutes the lines, colours and other formal properties of the objects back into thoughts and feelings.

Using the 'philosopher's table', Bell identifies, elaborates and tries to clarify four main senses in which 'expression' may be used. The first is the sense in which someone who is drawing a table is trying to 'express' what the table is like. The second is the sense in which someone tries to tell us in words what a table is like: unable to find the right words, they are unable to 'express' their meaning. Thirdly, there is the sense in which a squeal of pain expresses one's feelings, on having knocked one's knee on the table. And there is the sense in which, carving one's initials on the table, one expresses oneself (ibid.: 135). These senses are conceived as existing along a scale, from 'intrin-sic quality', through 'meaning' and 'feeling' to 'self', all of which refer to expression. What they all have in common, however, is that they all involve something within (a quality, a feeling, a meaning, or a self) becoming without, an ex-pression. Something else that they all have in common follows from the action, or relation of 'translation' or 'transmutation', which exists between the thing that is within and the outward expression of it. Bell suggests that 'we are not like the print-ing machine that puts out exactly what is put in' (ibid.: 134). This trans-lation and transmutation involves a change: in Bell's language, what comes out is different from what goes in. This point relates to what Barthes says about the possibility of a 'message without a code' (Barthes 1977; see Chapter 7, pp. 149–50) and it will be important later in this chapter, when the problem of the meaning of these expressions is discussed.

Bell pursues this account of painting as expression, suggesting that painters have sought out and developed 'aspects of painting that were particularly personally expressive' (Bell 1999: 144). These aspects are the 'manner' and the 'content' of paintings. The manner of a painting involves the 'way' things are seen in it and (for Bell) refers to the use of colour. The content of a painting refers to the artist's memory and imagination and thus to the artist's 'mind' (ibid.). Manner and content, then, are the ways in which painters express themselves in a painting on Bell's account. Colour is 'primary', for Bell, meaning that it is that from which forms are 'picked' (ibid.: 148). It is associated 'automati-cally with feeling', the 'blues' referring to depression, and anger being said to be 'red' (ibid.: 146). Bell cites Van Gogh as one of those to have

done the most to develop the expressive use of colour and refers to his 1889 painting *The Artist's Bedroom at Arles*, in which each colour is associated with an emotion (ibid.: 151). It is the Romantics, in the nineteenth century, who are cited as having done most to develop the role of memory and imagination in painting. William Blake, for example, uses line as 'the track of the active spirit, creating and evolving visibly out of its own continuous movements' (ibid.: 154). Alternatively, some artists 'direct the viewer towards what cannot be painted' (ibid.). Tivadar Csontváry and Wassily Kandinsky are proposed as examples of artists painting in a 'climate in which the spiritual . . . had taken on a new centrality' (ibid.: 156). The works of these artists are related directly to something going on in their heads, to their innermost thoughts and feelings, to something which Bell does not hesitate to call 'spiritual'. The understanding of their use of line and colour, as well as their memories and imaginations, is related, via expression, to the 'mind' of the artist, on this account. Line, colour, memory and imagination, then, somehow translate, or transmute, memory and imagination, the contents of the artist's mind.

While he is not as interested in the 'spiritual' as Bell is, Gombrich is interested in the expressive use of line, colour, texture and other formal properties of paintings. Gombrich also emphasises the role of the Romantics in the development of the idea that art is 'the language of the emotions' and sets out to explore this idea along with its 'main misconceptions' (Gombrich 1963: 56). He begins with what he calls the 'theory of natural resonance' of Roger Fry. Fry believed that the message of a work of art was communicated, as though it were a radio signal, from transmitter to receiver. (It is not insignificant for this chapter that the message of the work of art is described by Fry as 'a whole mass of experience hidden in the artist's subconscious' (ibid.). Conscious or unconscious, the matter is still that of expression, and unconscious expression will be dealt with below.) On Fry's account, the receiver or spectator must be 'more or less in tune' with the artist or transmitter in order to understand the message, the work of art, and it is likely that understanding, or reception, is more or less 'crude' or 'elementary' as people are 'imperfect receiving instruments' (ibid.). The metaphor may or may not let Fry down eventually, but Gombrich argues that it illustrates the basic expressionist assumption that 'forms or tones are analogues of feelings and will therefore convey a specific emotional experience' (ibid.: 57). He goes further and says that this basic assumption includes the idea that 'expression is somehow rooted

in the nature of our minds and . . . in no need of conventional signs' (ibid.). Understanding on this kind of account, then, is entirely natural and in no need of conventions which must be learned in order to be effective: forms and tones express feelings naturally and those feelings are naturally 'picked up' by the receiver.

Gombrich uses the work of C. E. Osgood to elaborate this theory. Osgood has investigated the ways in which people order, or 'equate', sensations, sights and sounds according to whether they are perceived as 'friendly' or 'hostile'. On the 'friendly' pole he locates 'gay' moods, 'warm' temperatures and 'light' things, 'bright' and 'red' colours are also said to be 'friendly', as are 'fast', 'loud' and 'high' sounds. Along the 'hostile' pole are 'sad' moods, 'cold' temperatures and 'heavy' things. 'Dark' and 'blue' colours are located on this pole, as are 'slow', 'soft' and 'low' sounds (ibid.: 58). For Gombrich, this 'natural code of equivalences' represents the 'core of the expressionist argument', the idea that 'every colour, sound or shape has a natural feeling tone just as every feeling has an equivalence in the world of sight and sound' (ibid.: 59). Thus, on this account, it is natural to dress in dark colours, maybe blues, and play low, slow music at sad occasions, and one would naturally understand that an occasion was sad if one saw and heard such sounds and colours. As Gombrich says, the same theory could be used to account for shapes and lines. Pointy, angular shapes (and maybe thin, sharp lines) would be located on the cold and hostile pole while round shapes and undulating lines would be located on the friendly and warm pole (ibid.). Pointy and angular shapes would be naturally understood as hostile, for example, and rounded, undulating lines would be naturally understood as friendly, on this account of understanding.

However, as Gombrich points out, this 'natural code of equivalences', along with Fry's resonance theory, 'lets us down immediately' (ibid.: 60). These 'equivalences', if that is what they are, are either coded or they are natural: the idea of a natural code, like that of a 'private language' (to which it is not unrelated), is quite contradictory. It is also unable to account for the things which artists do with shapes, lines and colours. If the theory were true, Gombrich says, an artist would select from their palette the shade that exactly matched their mood and apply it to the canvas. The spectator would see the canvas and experience exactly the mood the artist had experienced. The problem is that artists do more complex things than this in their paintings, they also play around with the formal properties of brushstrokes,

shapes, lines, colours and textures. They may use shapes that do not 'fit in' with the colours they have used, for example. As Gombrich points out, the painter who has painted a uniformly blue, and therefore melancholy, canvas may either reinforce the effect of sadness by using a 'heavy downward brushstroke' or may counter it by lightly 'dabbing' the paint on (ibid.: 64). All the other formal qualities may be used in these ways to complicate and undermine the theory of natural resonance.

The most serious shortcoming of this theory, however, is its failure to account for 'structure'. The understanding of the blue canvas as melancholy is undermined if it is known that the only colour the artist possessed was blue: as Gombrich says, the artist will

> select from his palette the pigment from among those available that to his mind is most like the emotion he wishes to express. (Ibid.: 62–3)

There is a structure here, a range of colours from which the artist must choose. It is the choice from the structure that produces the meaning, not a natural property of the pigment. Similarly, the artist knows that, in a work of undulating shapes, a sharp and spiky line will create a tremendous charge. It is the choice of shapes from a range and the juxtaposition of them that creates the emotional charge here, not the natural resonance of shape. In music it is the range from which notes and volumes are chosen, that creates the meaning, not the natural meaning of those notes or volumes. The loudest moments of a string quartet are likely to be drowned by the quieter moments of a large symphony orchestra: one does not, however, experience the loudness of the quartet as expressing feelings that are less powerful than those expressed by the orchestra (ibid.: 62). Gombrich notes that it is not the chord itself that we find sad, 'it is the choice of chord within an organised medium to which we so respond' (ibid.): it is the experience of a chord chosen from a range of chords, and its place within a structure, that is moving. Similarly, it is the experience of a choice of shapes, lines, colours from a range and their place in the structure that is the painting, which affects a spectator, rather than a merely natural response to a colour.

Gombrich illustrates this point by using typography. We are invited to consider the words 'ping' and 'pong'. 'Ping', it is implied, tends towards the lighter, while 'pong' tends towards the heavier. 'Ping' would be in a light colour, 'pong' in a darker colour. Gombrich also invites us to play this game using bold and plain type. '**Pong**' would 'obviously' have to be printed in **bold**, while 'ping' would be in 'plain'

or medium print (ibid.: 65). A series of unsuspected subtleties can be achieved in this system, or structure, which are unavailable to the theory of resonance, by printing 'pong' in plain print and '**ping**' in **bold**. Some heaviness has been added to the original lightness, the original effect has been modified, but not enough to make the 'ping' into a '**pong**'. Similarly, other possibilities may be added, other parts of the structure may be added: one may print in either gothic or *italic*. Here the 'tendency' might be to use a **bold** typeface for gothic. But again, a plain gothic might strike one as 'unexpected and subtle' (ibid.). Here, the work of a structure, and of the use of choice from within that structure, has clear expressive effects, enabling unexpected and subtle effects that cannot be envisaged within the simple natural resonances of Fry's original theory.

The understanding of these typefaces is more complicated than the theory of 'natural equivalences' suggests. It is more complicated because it is code-based: one must understand the differences between the **bold** '**ping**' and the **bold** '**pong**', and also that the **boldness** of the **bold** '**ping**' is not the same **boldness** as that of the **bold** '**pong**', in order to understand the meanings of these types. One must, as Gombrich says, understand the structure. The expressionist account of understanding will

> never yield a theory of artistic expression unless it is coupled with a clear awareness of the structural conditions of communication. (Ibid.: 62)

This conclusion is not incompatible with that reached by Bell. As noted above, Bell is committed to the idea that paintings are a form of expression; as he says, expression is their job (Bell 1999: 133). He does, however, follow this idea to its conclusion and argues that, in so far as they are not 'mechanical transmission', paintings are not communication (ibid.: 170). He thinks that there will always be something in a painting that escapes the work of structure and which means that there will always be something about a painting that is forever expression and therefore indeterminate and uncommunicative. While both begin from an account based on the notion of expression, Gombrich argues that understanding paintings is possible, and Bell argues that it is not.

These matters bring the concerns of this chapter very close to those of Chapter 7. The ideas of structure, of paradigmatic choice and syntagmatic sequence, as well as those of denotation and connotation, are all relevant here and the reader may care to revisit this chapter having read Chapter 7.

Auteur theory

It was noted above that Bell identified the Romantics, of the nineteenth century, as having done most to develop the role of the creative individual's memory and imagination in painting. William Blake was produced as evidence of the way in which the artist could use line to track the 'active spirit' in painting (Bell 1999: 154). Bell presents the Romantics as putting forward the idea that visual culture is an expression of a creative individual's inner emotional life. Gombrich was also seen to emphasise the role of the Romantics in the development of the idea that art is 'the language of the emotions' (Gombrich 1963: 56). Both, then, locate the account of visual culture as expression, with the Romantics, in the nineteenth century. The auteur theory in film history and theory may be seen as the continuation of a tradition of romantic thought that was, by the 1950s, when André Bazin, Eric Rohmer and François Truffaut were writing early auteur theory essays in *Cahiers du Cinéma*, over a hundred years old. The idea of the Romantic artist, expressing his or her inner emotional life through their chosen medium, eventually became one of the ways in which film could be understood. John Caughie quotes Alexandre Astruc, writing in 1948, who says that

> the cinema is . . . becoming a means of expression . . . it is gradually becoming a language . . . a form in which and by which an artist can express his thoughts, however abstract they may be. (Ibid.: 9)

Caughie argues that auteur theory represented the

> installation in the cinema of the figure who had dominated the other arts for over a century: the romantic artist, individual and self-expressive.
> (Ibid.: 10)

Three elements, or characteristics, of auteur theory are identified by Caughie. The first characteristic of auteur theory is 'that a film, though produced collectively, is most likely to be valuable when it is essentially the product of its director' (ibid.: 9). Despite the obvious fact that, with film, there are producers, writers, actors and various technical personnel, who all play a part in the creation of the final product, auteur theory understands a film as 'essentially the product of its director'. Accounting for film in this way is different from accounting for paintings, for example, in terms of expression. The second characteristic is that,

in the presence of a director who is genuinely an artist (an auteur) a film is more likely to be the expression of his individual personality. (Ibid.)

This characteristic introduces a distinction that is not used in accounting for paintings in terms of expression: that between the 'genuine' artist, or auteur, and the non-genuine artist or mere '*metteur en scène*', who may be highly competent at making films but who does not consistently demonstrate his or her personality in their films. And the third characteristic is 'that this personality can be traced in a thematic and/or stylistic consistency over all (or almost all) the director's films' (ibid.). This characteristic is perhaps the most familiar from the expressionist account of painting: much art history is concerned with an artist's style, with the way in which they handle line, colour or texture, for example. Style will also be investigated in Chapter 8.

Thus Bazin reports how some directors are considered auteurs while others are not; on this account: 'Nicholas Ray is an auteur, Huston is supposed to be only a *metteur en scène*' (in Caughie (ed.) 1981: 45). The difference is explained in terms of the auteur being 'always his own subject matter . . . he always tells the same story, or . . . he has the same attitude and passes the same moral judgements on the action' (ibid.). The *metteur en scène*, no matter how talented, does not do these things. Telling the same story, beings one's own subject matter and possessing the same attitude are what is meant by the idea of 'thematic consistency': stories, subjects and attitudes may all be thought of as subject-matter. Peter Wollen uses the work of John Ford to show how the heroes of *My Darling Clementine*, *The Searchers* and *The Man Who Shot Liberty Valance* demonstrate this thematic consistency. Wyatt Earp, Ethan Edwards and Tom Doniphon, the respective heroes of these films, 'all act within the recognisable Ford world' (Wollen, in Caughie (ed.) 1981: 139). This world is made up of a set, or a structure, of paired concepts, or themes: 'garden versus wilderness, plough-share versus sabre, settler versus nomad, European versus Indian' and so on (ibid.). What is happening here, then, is that specific films, and a body of work produced by a director, are both being understood from the perspective of the expressive and creative individual. The films express a director's set of concerns, or themes, Wollen has identified some of those themes in the essay quoted here, and it is in terms of those themes that the films are to be understood in auteur theory. Reference was made above to the structure of the paired concepts and it is worth noting that Wollen is considered

representative of what is called 'auteur-structuralism' (see Caughie
(ed.) 1981: 121–95). While there is not room here to investigate
further, the reader is referred to Chapter 7, where structural accounts
of how visual culture may be understood are explored in more
depth.

While the work of Alfred Hitchcock was eventually acknowledged
as the work of an auteur, rather than of a *metteur en scène*, and while
his work is also a good example of thematic consistency, the follow-
ing paragraphs will use his camera-work as an example of stylistic con-
sistency. In general, where what might be called classical Hollywood
cinema tries to hide the work of the camera, Hitchcock will draw
attention to it. It is as if the camera had an intelligence and a will of
its own. Classical Hollywood cinema will hide the camera-work for
the sake of realism. It wants the spectator to be taken in by the film.
Hitchcock will often use the work of the camera to draw attention to
the constructed nature of the film. When classical Hollywood film
makers, for example, had stopped using back-projection, in favour
of more 'realistic' methods, Hitchcock will continue to use back-
projection. Sandy Flitterman relates Raymond Bellour's account of
Hitchcock's camera-work in the film *Marnie* to show how the camera
presents the point of view of the male viewer (in Caughie (ed.) 1981:
242–50). In a complex essay, which also draws on the work of Laura
Mulvey (1989), one episode may be picked out from Flitterman's
account. In the scene where Marnie walks away from the camera
along a hotel corridor, Hitchcock emerges from a doorway on the left.
He looks to his left, watching the disappearing figure of the woman,
then turns and looks into the camera, at the spectator. This scene
underlines Hitchcock's 'power as image-maker'. It

> makes explicit the fact that the film is ... proceeding from somewhere ...
> that he has delegated the look to his fictive surrogates.
>
> (Flitterman, in Caughie (ed.) 1981: 247)

This is only one example, but it is clear that the use of the camera may
be taken as a 'stylistic consistency' and used to explain the work of a
director as an auteur. The film is said to be 'proceeding from some-
where': that somewhere is the director. It is the director who is using
the film to express a personal vision. This is in addition to the 'the-
matic consistency' that Caughie identified as an element of the auteur
theory. And it could be argued that Hitchcock's use of camera-work,
his particular way of organising how cameras move, which characters
they show, how they show them, the lighting and so on, at times

becomes a thematic as well as a stylistic consistency. Flitterman's essay, like those of Mulvey and Bellour, on which it draws, is concerned with the role of the male spectator, his control of women, and the pleasure that is to be got from Hitchcock's films. In all these examples, the films are being understood in terms of their being the expression of a single director's vision. It is the emotional and inner life of the director, along with its pleasures which is being expressed in the films of Hitchcock, for example, and it is this which is being concentrated on by auteur theory.

Psychoanalysis: unconscious expression

The auteur theory of film may be used to introduce the next concern of this chapter, the ways in which visual culture may be understood as unconscious expression. Peter Wollen, who was referred to above as an 'auteur-structuralist', looks at film in this way. He considers expression to reflect the structures of the unconscious that are explored in psychoanalysis. (The work of the structural anthropologist Edmund Leach is also instructive here. He has explained Michelangelo's work on the ceiling of the Sistine Chapel in terms of these unconscious structures; see his essay (1977) and Chapter 7.) Wollen argues that the structure which underlies a film and shapes it

> is associated with a single director, an individual, not because he has played the role of artist himself or his own vision in the film, but because it is through the force of his preoccupations that an unconscious, unintended meaning can be decoded in the film.
> (Quoted in Buscombe, 'Ideas of Authorship', in Caughie (ed.) 1981: 30)

The following paragraphs will consider the understanding of visual culture in terms of this unconscious and unintended meaning.

The notion of the unconscious is commonly associated with the name Sigmund Freud (1856–1939), and his version of psychoanalysis. In his essay on Michelangelo's sculpture of Moses, Freud compares his own method, the 'technique of psychoanalysis', to that of the nineteenth-century art critic Giovanni Morelli, who was discussed in Chapter 2. Morelli was interested in the significance of minor and apparently unimportant details like the way an artist drew fingernails or earlobes in a painting. Freud says that Morelli's method is 'closely related' to that of psychoanalysis, explaining that psychoanalysis is also 'accustomed to divine secret and concealed things from despised

or unnoticed features' (Freud 1985: 265). Psychoanalysis, and the
notion of the unconscious, call into question some of the most cher-
ished beliefs of western society, including many that were discussed
above in the account of understanding visual culture. The concept of
individual subjects, who express their internal feelings and emotions
through their art and design, for example, is radically challenged by
the notion of an effective unconscious that is made up of unknown
and repressed emotions and structures. Most people believe, for most
of the time, that they are 'autonomous and unitary' individuals,
marked off distinctly from other people (Freud 1963: 3). They also
believe that they have free will, are free to make their own choices
and decisions, and that their thoughts, feelings and beliefs are their
own. These are some of the beliefs and ideas that are presupposed by
the idea that visual culture may be understood in terms of the expres-
sion of those thoughts, feelings and beliefs.

They are also the very ideas that are undermined by an awareness
that there are thoughts, feelings and beliefs that are socially un-
acceptable and which must be repressed from consciousness. This is
the notion of the unconscious. Freud found that many of his patients
had wishes and desires that they knew nothing about and that they
were not conscious of, but which he could detect from the other things
that they did and said. These unconscious yearnings were socially
unacceptable in that they were directed towards people and things
which were thought inappropriate, or in that they were directed in
ways that were said to be perverse, for example. Indeed, these long-
ings were so unacceptable that Freud's patients could not permit
themselves to think consciously about them and such thoughts were
expelled from consciousness, or, as Freud says, repressed. The energy
and structure of the libidinal desires which had been repressed he
called the unconscious. However, Freud believed that he could see
these energies and structures having an effect in the things his patients
said or did. So, for example, he was interested in the dreams that his
patients recalled and which they narrated to him; he was interested in
people's slips of the tongue and in the puns that people made without
realising. And he was interested in symptoms like nervous ticks and
obsessions, phobias and so-called 'hysterical' reactions to events, reac-
tions such as losing the use of a leg for no apparent reason. Freud
thought that all these phenomena were evidence of these repressed
desires and wishes trying to break into consciousness. It is as if these
unacceptable longings had slipped through the repressive apparatus

of consciousness by being disguised as something else, an obsession, a pun, or a weak arm and so on.

Among the consequences of these ideas for the understanding of visual culture is the idea that, if all humans have these unconscious and repressed appetites which keep breaking through into our conscious lives and work, and which are looking to be satisfied, then the understanding of visual culture must take account of them. The understanding of visual culture must see it as the product of these appetites, and of the satisfactions that they engender, and must recognise the fact that the spectators and students of visual culture, as well as the artists and designers who produce it, have these unconscious desires and that those desires may be being satisfied in visual culture. On this account of understanding, then, both the producers and the spectators of visual culture may be thought of as receiving pleasure from the satisfaction of their unconscious desires. It might also be the case that to persist in writing books about visual culture, or to persist in reading books about visual culture, is to display similar unconscious motivations and to receive pleasure from the satisfaction of those motivations. Another serious consequence of these ideas is that the conscious expression of artists, designers or writers is not the only way of understanding visual culture. The products of artists and designers will have meanings that those artists and designers are unaware of, which come from their unconscious. These products cannot, therefore, be understood only in terms of the artist's and designer's conscious expression. Visual culture must also be investigated for the unconscious expression it is the product of. Pieces of art and design must be questioned as to which unconscious desires they are expressing and satisfying. Similarly, the spectators of, and writers about, visual culture, will receive pleasures that they are unaware of from spectating and writing about visual culture.

Now, Freud also thought that these unconscious sexual drives were not peculiar to any one individual. It was not the case that each individual had their own individual set of repressed desires. Rather, these desires and their repression arose from the structure of the family and society that people were part of. So, certain choices of sexual object were unacceptable, and repressed, not because the individual found them repugnant, but because the structure of the family and society deemed them unacceptable. Incest, for example, is one such sexual possibility which the structure of society and the family regards as unacceptable and which it rigorously curbs. For the psychoanalyst,

every child begins life by wanting union with its mother. Part of social-isation according to the psychoanalytic account is to learn that this is unacceptable (what is regarded as a 'normal' family life and the rules of kinship would be impossible to follow if there were no taboo on incest) and to repress it. So, there are certain structures, or patterns, of desire as well as its repression that are common to all members of a society. This means that clues to the existence of drives considered inappropriate by a society will appear in the visual culture of that society. The following paragraphs will consider two of these structures of desire which are part of western society, scopophilia and what is called the Oedipus Complex.

The word 'scopophilia' is made up of two Greek words, *scopos*, which is to do with looking and seeing, and *philia*, which is to do with a love of, or pleasure in, something. Scopophilia is therefore to do with the love of, or pleasures that are received from, looking and seeing. Given that the present volume concerns visual culture, this idea may be expected to be of some use. On the psychoanalytic account, one need not be aware of possessing the desire to look, or of receiving pleasure from looking. If these are part of the structure of repressed desires that form the unconscious, one will necessarily be unaware of them. Both John Berger (1972) and John A. Walker and Sarah Chaplin (1997) use the example of Jacopo Tintoretto's *Susannah and the Elders*, painted around 1560, to explain scopophilia. In this work, two old men watch Susannah as she dries herself after bathing. They are explained as getting pleasure from looking at her. Susannah is also looking at herself in a mirror and Walker and Chaplin suggest that she 'is also taking pleasure in looking' (1997: 101). And, of course, the spectator of the painting is looking at Susannah, taking pleasure from 'gazing at Susannah's body' (ibid.). In the Dannimac advertisement (see Figure 4.2), the same concept is being illustrated but here it is even more likely that it is being illustrated unconsciously. In the adver-tisement, the layout of the two photographs makes it look as though the young man is staring at the young woman's legs as she moves off to the left. This may be the result of an unconscious desire of the designer. While it is not easily verifiable, it may be that the situation of looking at women's legs is a source of pleasure for the graphic designer who produced the advertisement. It may also be that the designer is expressing an unconscious desire to look at women's legs, through showing someone else doing so.

Scopophilia may be one of the structures of desire, and it may some-times operate unconsciously, but it cannot always be said to be taboo,

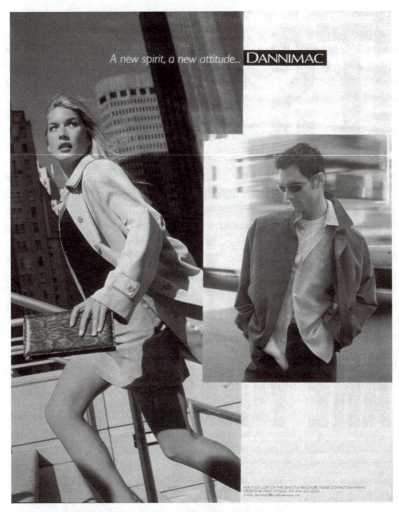

Figure 4.2 Dannimac advertisement

or unacceptable to society. Social rules may discourage men from staring directly at women's legs in such a way that the woman notices and feels uncomfortable, for example, but the desire to look at women's legs is hardly forbidden in the same way that expressing the desire to kill one's father and marry one's mother is forbidden. This, of course, is part of the account of desire that the Oedipus Complex attempts to explain. Laurie Schneider Adams provides a number of

examples of how this story may be used to understand visual culture. She presents Freud's rendering of the Oedipus Complex as something that happens to children between the ages of three and five years (1996: 183). Essentially, the little boy desires an exclusive attachment to his mother. This will require the elimination, or murder, of his father. Consequently, the boy is jealous of his father, who possesses his mother, and he also fears retaliation from his father. In the boy's understanding of the situation, retaliation will take the form of castration: the father cutting off the boy's penis. There is also a 'negative' version of the complex, in which the boy identifies with his mother and desires to be the object of his father's attentions (ibid). When the positive complex is dominant, the boy will grow up to be heterosexual, and when the negative is dominant, the boy will grow up to be homosexual (ibid.: 183–4). The story as it applies to little girls is slightly different, although no less problematic. Little girls originally desire their mothers. However, when they realise that they do not have a penis, the little girls are disappointed, both with themselves, for not having a penis, and with their mothers, for not giving them a penis. They then begin to desire their fathers, who possess a penis. On realising that this desire cannot be satisfied, little girls must then return to their mothers, ensure some form of identification with their mothers and look for a substitute for the father's penis, which they can never possess. This substitute takes the form of men (husbands) who are not their fathers, and babies, 'given' to them by those men.

According to Adams, these dramas can be seen working themselves out in art history. She appeals to the genealogies of Pliny and Vasari to back this claim up, proposing that 'when Giotto surpasses Cimabue, he symbolically defeats his father' (ibid.: 184). The account can be widened to all of visual culture. It can be claimed that all of visual culture is about killing off, or negating, what comes before. Each artist and designer has to deal with, kill off, surpass or supersede what has preceded them in the history of art or design. Modern art may be seen as a constant replacing of one style, or school, by another. This could be understood metaphorically as the elimination of the father. There are lines of descent in art and design, and these lines are often stressed in accounts of art and design. The great fashion houses, for example, give rise to much interest, in the press, as to who is likely to replace whom in the succession. In recent years, John Galliano has replaced Yves St Laurent as 'head' of the Dior fashion house. St Laurent, of course, originally replaced Christian Dior on the death of the latter.

Adams suggests that the statues relating the story of David and Goliath which were made by Michelangelo, Donatello and Bernini may be understood in terms of the Oedipus story. On one level, Adams says that David

> can be read as the young boy who eliminates the father in order to win a woman and become rich . . . [while] Goliath . . . represents the dangerous aspect of the father . . . [and] David's decapitation of Goliath is read . . . as castration. (Ibid.: 187)

On another level, Adams looks at the differences between these artists' treatments of David. Donatello's David is 'effeminate' and reveals the 'erotic quality of the boy's relation to his father' (ibid.: 188–9). Michelangelo's David is hewn from a block of marble known as 'the Giant' and Michelangelo thus defeats his own 'giant' – the abusive father who 'beat him for his ambition to be a sculptor' (ibid.: 191). And Bernini's active and determined David reflects his enlightened and non-retaliatory father (ibid.: 191–2).

Strengths and weaknesses

Some problems internal to the account of expression have been pointed out above. This section will consider some more general strengths and weaknesses involved in this kind of account of how understanding works. It may be a strength of this sort of account that most people are fairly comfortable with it. It offers a 'common sense' account of how understanding visual culture works: if you want to understand the work, you must understand what the individual who made it was trying to express. However, as with all common sense, it is not so common. One might argue, from a Marxist point of view, that it pushes an ideological view of the individual, that the individual it promotes as the source of expression and understanding is the bourgeois individual of capitalism, alienated from and unconnected with the historical, social, political and class structures that produce the notion of individuality 'in the first place' (see Barthes 1977: 143, and Swingewood 1986: 115ff, for example). This point reprises that made above concerning what Gombrich calls the 'structural conditions of communication' (Gombrich 1963: 62ff). Explaining the understanding of visual culture as the expression of individual artists and designers cannot work unless that account includes an explanation of the role of structure and of the codes needed to understand the signs that are part of the structure.

A second weakness of this account of understanding stems from the fact that much of the visual culture that is seen every day, in magazines, on television, in the home and on the street, does not admit of being understood in terms of the expression of a conscious individual. Journalistic and documentary photography, in newspapers and magazines, for example, is rarely understood as the production of an individual. This is because such media are usually anonymous. It is also because the communicative function of the media is more important than its role as a vehicle for the expressive personality of the artist or designer. One does not usually glance at the sports photograph and wonder what the photographer wanted to express in it. The informative and communicative function is more important here. Press photography, packaging, wrappers, advertisements, and typefaces and layouts, for example, are not usually signed by the photographer or designer who produces them. One has to do some research to find the graphic designer or typographer who is responsible for the layout and typefaces of the *New York Sunday Times* or the English *Guardian*, the wrappers of 'Snickers' bars are not signed by the designer who designed them and advertisements rarely bear the name of the photographer or copywriter responsible for them. Only when graphic images begin to be thought of as art and graphic designers to be thought of as artists, does it seem appropriate to think of graphic images in terms of individuals and the expression of their personalities. The advertising of Tony Kaye, the Mondrian-inspired packaging of L'Oréal haircare products or the book illustrations of Edward Ardizzone, might be produced as examples of design becoming, or being made into, art. Tony Kaye has campaigned regularly to have his work exhibited in serious art galleries and Ardizzone has been shown in galleries. The case of L'Oréal is more marginal: it is unlikely that anyone seriously considers the packaging to be art, but it does use a highly recognisable motif of modern art to sell itself on both High Street and Main Street.

Only in certain cases, that is, where the designer becomes well-known, is the mass-produced image or package seen and understood as some form of individual expression. Raymond Loewy's redesign of the Lucky Strike cigarette packaging, or Philippe Starck's designs for bottles of water, for example, have been understood as the products of an expressive individual. Adrian Forty quotes Loewy saying that the white of the new package looks 'clean', and has connotations of 'freshness and immaculate manufacturing' (Forty 1986: 243). Loewy's thoughts have been deemed worthy of being sought out and written

down in this case. Similarly, Thomas Hine presents the bottle that Starck designed for 'Glacier' water in terms of its 'distinctive', 'pure, clear form'. The bottle has, he says, 'one of Starck's trademark dangerous-looking pointed forms visible on the inside' (Hine 1995: 200). Again, the bottle is understood as the expression of Starck, as though it were a work of art. The 'trademark' characteristics are seen as forming part of the understanding of this particular product, almost as if it were a version of auteur theory. And similar phenomena may be observed in the worlds of fashion, furniture and typographical design (where designers like Alexander McQueen, Ettore Sottsass or Neville Brody are treated as though they were artists, their names becoming known and their individuality becoming interesting to a general public).

Cheryl Buckley discusses this approach to understanding visual culture in her (1986) essay 'Made in Patriarchy: Toward a Feminist Analysis of Women and Design'. Pointing out that the idea of the designer as the source of meaning, and therefore understanding, in design has been imported from art history, where the figure of the artist is all-important, she argues that the idea that the meaning of design objects is 'determined' by the designer is 'simplistic' (ibid.: 10). She says that designs,

> as cultural products, have meanings encoded in them which are decoded by producers, advertisers and consumers according to their own cultural codes. (Ibid.)

In order to understand design products, it is not sufficient to only consider the designer. The cultural codes according to which the designer, and everyone else in the design process, can first understand the object must be understood. As the present chapter has found, the notion of a code, or a structure, is necessary in order to understand visual culture. The focus on the individual designer or artist as the source of understanding, 'as the person who assigns meaning', is 'seriously challenged' by developments in the field of film studies, for example, where the notion of the author as a 'fixed point of meaning' has been challenged (ibid.: 11). These criticisms also apply to the notion of the artist and designer's intentions being considered as the source of meaning, as was explained above in Chapter 3.

The weaknesses of the auteur theory of film and television production might be raised by the example of the director Howard Hawks, who is well known for making films that are considered exemplary of many different genres of film. A similar problem arises in the

case of the writer Roald Dahl who, in addition to writing children's stories, has also written the scripts for such different films as *Chitty Chitty Bang Bang* and *You Only Live Twice*. The weakness is that auteur theory's claims that individual directors, or authors, may be understood in terms of a characteristic set of stylistic or thematic concerns might lead people to think that they know what to expect from a 'Howard Hawks film' or a 'Roald Dahl script'. The diversity of films and scripts produced by such directors and authors casts doubt on the idea that one knows what to expect from them. It has also been suggested that auteur theory ignores or plays down the social, political and historical contexts, for example, of film and television production, and that these contexts are essential to the understanding of these examples of visual culture. The social, political and historical context of any film or television programme cannot be ignored in attempting to understand that film or programme. The question may be asked, for example: How is one to understand films such as *Guess Who's Coming to Dinner* and *Mississippi Burning* without some idea of the context of ethnic relations at various points of American history?

Another problem associated with auteur theory is that it cannot account comprehensively for all films. There are some aspects of one's understanding of a film or television programme that cannot be explained solely in terms of authorship. It makes a difference to that understanding whether one is watching a western, a thriller or a film noir, for example. It also makes a difference to one's understanding that one knows the star of the film. Notions of genre, then, and of the star system are both ignored by auteur theory. A strength of auteur theory, however, is that it can account for pleasure. The pleasure of the viewer is taken into account by those versions of auteur theory that are influenced by psychoanalysis, which is also good at accounting for pleasure. The major weakness of the psychoanalytic account of understanding visual culture is that it is untestable. As noted in Chapter 2, there is no way to run an experiment to test one's experience of visual culture. This untestability of the theory is shown up above in the example of the Dannimac advertisement. The claims that it looks the way it does by accident, as a visual slip of the tongue, as it were, are completely unsupportable. One either likes the story and thinks that it helps one understand the picture, or not. The other main weakness of psychoanalytic accounts of visual culture is that they are usually heavily gendered. The account of scopophilia given by Walker and Chaplin (1997) and Berger (1972), for example, is an account of

the male point of view from a male point of view. The Oedipus complex and its exemplification in visual culture is also notoriously weak at explaining a woman's experience of these matters. Many feminist and psychoanalytic critics have argued that a woman's point of view is possible and desirable.

Conclusion

In conclusion, it appears that the attempt to explain the understanding of visual culture in terms of individual expression, either conscious or unconscious, is popular but wrong. It needs an account of the sign, and of the structures within which signs are meaningful, to be a more useful account of understanding. The general weakness of the explanation, that it ignores the social, historical, political and other contexts within which visual culture is produced, may be re-stated as the idea that the explanation in terms of expression ignores structure. As Gombrich argues, the community of sign-users must understand the structures in which shapes, lines, colours, textures and typefaces, for example, exist, in order to understand the individual expressive artist's use of those shapes, lines, colours, textures and typefaces. As with the explanation of understanding in terms of interpretation, in the previous chapter, some dialectic between the individual and the structural seems to offer a more plausible account of understanding visual culture than either element alone. This discussion will be continued in the following chapters and in Chapter 9.

Further reading

The matter of artistic intention, as opposed to expression, has not been covered here. However, the Introduction to John Roberts (ed.) (1994), *Art Has No History!* (London: Pluto Press), introduces the main themes of the discussion and recommends reading the philosophers Donald Davidson and Roy Bhaskar (Roberts 1994: 20ff). Further reading on the matter of expression in design may be found in Sherwin Simmons's essay 'Expressionism in the Discourse of Fashion', in *Fashion Theory*, vol. 4, issue 1 (2000). This essay discusses German fashion of the first two decades of the twentieth century in terms of expression and in relation to Lacanian psychoanalysis, notions of masquerade and gender. It does not concern itself explic-

itly with the terms of the debate about whether expression is possible only on the basis of structure, covered above.

Further reading on psychoanalysis is not hard to find. Arnold Hauser, who comes from a Marxist, or social history of art, background and who is discussed below in Chapter 6 devotes a chapter to psychoanalysis in his (1958) *The Philosophy of Art History* (London: Routledge and Kegan Paul). More recently, Laurie Schneider Adams's (1993) *Art and Psychoanalysis* (New York) would be a good place to start. Freud's own essays on art have not been covered in any detail here, mainly because, ironically enough, they are not central. The essay on Leonardo da Vinci (in Freud 1985) is interesting although, as Fernie has pointed out (1995: 355), it lacks knowledge of the iconographic tradition Leonardo was working in. The work of Lacan has also not been covered here, mainly because it is too difficult: it is not introductory. The Lacanian feminist Julia Kristeva has written on Giotto's and Bellini's treatment of motherhood. Claire Pajaczkowska has written an interesting essay, 'Structure and Pleasure', which uses some Lacanian ideas and offers a commentary of Kristeva's work, in *Block*, no. 9 (1983) pp. 4–13. For the female gaze, see L. Gamman and M. Marshment (eds) (1988) *The Female Gaze: Women as Viewers of Popular Culture* (London: The Women's Press).

On auteur theory, the work of Andrew Sarris and V. F. Perkins is central. Roland Barthes's (1977) *Image, Music, Text* contains the essay 'The Death of the Author' and Michel Foucault's (1977) *Language, Counter-Memory, Practice* contains the essay 'What is an Author?', both of which are central to the discussion of authorship and auteur theory in film and cinema studies.

Chapter 5

Feminism: Personal and Political

Introduction

Feminism, like Marxism and psychoanalysis, is unlike many of the other approaches to understanding visual culture covered in this volume in that it makes the nature or position of the person doing the understanding a problem. The previous chapter showed how psychoanalysis involves the artist's and the spectator's unconscious desires in the activity of understanding, and Chapter 7 will show how Marxism argues that the understanding of visual culture is not above or beyond the subject's class position. For psychoanalysis and Marxism, the activity of understanding is constituted by the position of the understanding subject in that activity. On the psychoanalytic and Marxist accounts, then, understanding is not a transparent or innocent activity in that it is made possible by the subject's own class or subjective nature. Now, feminism also argues that understanding is not a transparent or innocent activity. Feminism points out that there are gender differences and argues that the gendered position of the understanding subject has a part to play in, and makes a difference to, the activity of understanding.

There are four main consequences of the idea that the position or nature of the understanding subject has a part to play in the activity of understanding. The first is that the definition or explanation of what understanding is subject to gender differences. Different genders will have a different idea of what constitutes an understanding of visual culture. It is worth making the point that few feminisms conceive of

themselves as scientific. Where many of the other approaches documented in the present volume are inspired by the successes of the natural sciences and want to emulate that success in a human science approach, some feminists regard the desire to imitate the natural sciences as itself being worthy of critical, gender-based analysis. The second consequence is that the object of understanding, what is to be understood, is also subject to gender differences. Different genders will provide a different set of objects, practices, institutions and personnel to be understood by visual culture. The third consequence is that feminist and gender-based accounts of understanding visual culture must be thought of as a critique of the prevailing disciplines. They do not exist alongside traditional accounts of visual culture but as a series of challenges to those accounts. Where Lynda Nead has argued that feminism 'is not and should never be an approach to art history' (Nead 1986: 121), the present chapter must argue that a feminist and gender-based account of visual culture is not only an approach amongst others but also a challenge to those other accounts. The fourth consequence is that, as a man, the present author is in a position different from that of a woman when it comes to presenting and discussing feminist and gender-based accounts of understanding visual culture. All these consequences will have to be explored in the following chapter.

Another interesting aspect of feminism is that it is ambiguous on the matter of whether it belongs more properly to structure-based or individual- or subject-based traditions of understanding visual culture. The present volume has tried to categorise approaches according to whether they are more structure- or individual-based. This attempt at categorisation becomes a problem with feminism. On the one hand, feminisms argue that gender structures are productive of the meanings of visual culture and therefore the basis of understanding. On the other hand, they argue that those (political) structures are personal in some sense and that therefore the subject's experience of gender is the basis of understanding. The 'Preface' to Penny Sparke's (1995) book *As Long as it's Pink: The Sexual Politics of Taste* illustrates this tension rather well. Sparke connects her personal experiences over the last thirty years to class and gender structures. In the 1960s, for example, she says that popular culture (like fashion, and visual culture in general) provided a variety of styles with which she could represent her developing personal identity. At the same time, however, she was already aware of the 'emerging political agenda of the women's movement' (Sparke 1995: vii). This is explicitly to present her personal

experiences as being political. As Judy Attfield among others has said, 'the personal is political' (Attfield 1989b: 206). Attfield also argues that there is something specific to a woman's experience that cannot be experienced by a man, and that as a result, design history needs to be re-evaluated by men, as well as by women (ibid.: 202).

This chapter will look at Judy Attfield's (1989a) and (1989b) essays, 'Inside Pram-Town: A Case Study of Harlow House Interiors, 1951–61' and 'FORM/female FOLLOWS FUNCTION/male: Feminist Critiques of Design', and at Penny Sparke's (1995) book, in order to illustrate how feminism proposes the experience of gender-based political structures as the basis for understanding visual culture. In her (1989b) essay, Attfield discusses some of the more philosophical issues raised by feminist and gender-based accounts of visual culture. In the chapter 'Those Extravagant Draperies', Sparke explains domestic interior design in both the UK and the USA in terms of gender roles and gender politics. And in her (1989a) essay, Attfield supplements her gender-based account with a notion of social class, drawing on Bourdieu and Veblen and charting the ways in which women could negotiate and challenge the officially sanctioned rules of 'good design' after the Second World War.

Finally, the chapter must consider gender-based approaches in terms of their strengths and weaknesses. It may be one of the ironies of such feminist approaches that both these women have chosen to research the domestic interior – an area that, as Attfield herself points out (1989b: 201), has been traditionally and ideologically associated with certain conceptions of femininity for many years. It has also been a criticism of feminist approaches that they are reductive. It may be argued that it is not possible, or desirable, to 'reduce' the understanding of visual culture to sex or gender-based politics. Visual culture, it can be argued, is about much more than sexual or gender politics. Many feminists may be seen as acknowledging this point when they use the class-based analyses of Marxism, Veblen and Bourdieu, for example, in addition to a strictly gender-based account of the domestic interior.

Feminism and understanding

That different genders will conceive of understanding differently was introduced above, as the first of the four consequences of the idea that there are gender differences and that the gendered position of the

understanding subject makes a difference to the activity of under-standing. Having said this, feminist accounts of those differences in understanding and writing about visual culture are rare. In a discus-sion of the role of objects in design and design history, Attfield notes that there is 'a tendency to suppose that an object-based study can somehow lead to a more "objective" investigation' (1989b: 211). She also paraphrases E. H. Carr, who was discussed in Chapter 2 as part of the debate around the scientific nature of historical understanding and the history of art and design. Carr was presented in Chapter 2 as being concerned with the trappings of science and scientific knowl-edge. It was suggested there that, although he was interested in facts as they are understood in science, as impinging on the observer from outside and independently of 'his consciousness' (Carr 1961: 9), Carr's position was that history was not a science in a strict positivist or empiricist sense. Attfield's paraphrase concerns the relation between the historian and 'her facts', the relation between 'the subjectivity of the historian' and historical facts. She says that

> the historian without her facts is rootless and futile; the facts without their historian are dead and meaningless. (Attfield 1989b: 211)

That is, she supports Carr's thesis that facts and interpretations affect each other 'reciprocally', but changes the gender of the historian as he is imagined by Carr (Carr 1961: 30).

So, Attfield identifies the issue concerning the gendered nature of understanding and locates it in the tradition that was covered above in Chapter 2. What she wants to make of the debate is that this 'sci-entific' tendency, the tendency to suppose that an object-based design history can lead to an 'objective' and therefore 'scientific' investiga-tion, is mistaken. The facts of design history do not exist 'out there', objectively and independently of the design historian's consciousness. The facts of design history must be related to the historian's con-sciousness and experience by means of much the same dialogue and reciprocity that Carr envisaged. Attfield quotes Pierre Bourdieu who says that the attempted 'objective' investigation is

> always bound to remain partial and therefore false, so long as it fails to include the point of view from which it speaks and so fails to construct the game as a whole. (Attfield 1989b: 211)

Including the point of view from which the investigation speaks is to take into account the idea that the gendered position of the under-standing subject makes a difference to the activity of understanding.

It is to present the investigation as having a relation to the experience of the investigating subject. This is precisely what was proposed above as one of the characteristics of a gender-based, or feminist approach to the understanding of visual culture. It was suggested in the 'Introduction' to this chapter that feminist or gender-based explanations of understanding were different from many other explanations because they took into account the gendered position of the understanding subject. They recognised that the gendered subject has a part to play in, and makes a difference to, the activity of understanding.

Evelyn Fox Keller tackles the notion of the gendered nature of understanding in a slightly different way. As reported in Elizabeth Chaplin's (1994) *Sociology and Visual Representation*, Keller argues that understanding is gendered in so far as 'science is a male body of knowledge' (Chaplin 1994: 11). She also suggests that there are 'hard' and 'soft' sciences, physics being 'masculine', or hard, and other, more subjective, forms of enquiry being 'feminine', or soft (see Williams 2000: 82–3). As noted above in Chapter 2, Descartes's *Discourse on Method*, first published in 1637, was one of the earliest methodological treatises to propose the objective, scientific investigation of the natural world. Descartes's account, which introduces a mind/body distinction into the account of knowledge, is seen by Keller as the origin of science's 'ideology of objectivity' (ibid.). This ideology separates 'knower (mind) from the known (nature), subject from object; and having divided the world into two halves, it then genders them, with the knower/mind/subject cast as male and the known/nature/object cast as female' (ibid.). Keller proposes 'overturn[ing] this dichotomy by producing . . . science which casts women in the role of active producers' (ibid.). As Attfield has just shown, it is by no means clear that visual culture or design history are, or even want to be, sciences in the sense intended by Keller. Nor is it at all clear that a simple 'overturning' of the hierarchy and placing women into the position from which they have hitherto been expelled is a sufficiently feminist gesture, leaving intact as it does the original hierarchy. However, it is interesting that the argument regarding the possibility of objectivity is structurally similar to that noted in Attfield's essay. The effect of both of these arguments is to eschew the possibility and desirability of such (objective) knowledge because of its gendered nature. Objectivity seems to be positively valued only within the terms of a masculine-gendered 'science'. A feminist design history and visual culture might be expected to examine this notion of objectivity much

more critically and would not necessarily accept it as a part or com-
ponent of understanding.

For feminists, for those adopting a gender-based approach to the
understanding of visual culture, understanding is a different activity
from that proposed by traditional history and design history. Where
traditional history and design history are rooted in the idea of an
objective science, dealing with facts that exist independently of the
people doing the understanding, feminist approaches will stress the
part of the understanding subject in the activity of understanding.
Having looked at the conception of understanding that might be
adopted by a feminist or gender-based approach to visual culture,
the next section will show how that conception manifests itself in
examples of feminist accounts of design and design history. What is
to be understood as visual culture, as well as the way in which it is to
be understood, are matters for feminist and gender-based approaches
to the understanding of visual culture.

Feminism: personnel, objects, institutions and practices

Many feminist, or women, writers on design and design history have
made the point that mainstream design history has a gender bias,
a malign influence and a single source. That source is variously
described as the Modern Movement, modernism or modernity.
Attfield argues that design history 'still suffers from its provenance in
the Modern Movement' (Attfield 1989b: 200). The Modern Move-
ment's celebration of industrial production methods and its faith in
the city, for example, were stressed by writers like Peter Reyner
Banham, Seigfried Giedion and Nikolaus Pevsner, who formed the
beginnings of design history. Cheryl Buckley also cites these writers
(1986: 3) and argues that modernism

> informed these dominant notions of good design . . . and legitimized the
> analysis of design as distinct objects. (Ibid.: 13)

She says that they write about history in such a way that their

> selection, classification and prioritization of types of design, categories of
> designers, distinct styles and movements, and different modes of produc-
> tion are inherently biased against women and . . . exclude them from
> history. (Ibid.: 3)

And Sparke explains how, when she began to study design history, 'vast
areas of knowledge' relating to material culture were missing: what was

documented was all linked . . . to the heroic buildings, objects, ideas and people (mostly men) who made up the story of modernism.

<div align="right">(Sparke 1995: viii)</div>

Mainstream design history provides a version of what is to be understood by 'design history'. It provides a list of types of design, production methods, people, styles and movements that are to be studied. The Modern Movement shows its male bias in its privileging of the 'masculine' aspects of design and design history – a modernist, or 'machine' aesthetic, mass-produced objects and industrial production, for example. This is associated with that movement's distinction between domestic and public work, where the former is seen as feminine and valued less highly than the latter, which is seen as masculine. Buckley has noted that in mainstream, modernist, design history, 'industrial design has been given higher status than knitted textiles' (1986: 4). Because of its gendered identity, industrial design is deemed to be of higher value than a 'feminine' design activity like knitting. Industrial design is therefore thought to be more worthy of being studied and understood than knitted textiles.

The feminist writers noted above all agree that design history has its source in the Modern Movement and modernism. They all agree that this source is male-dominated and that it has had an unhappy influence on design history. This influence consists in the pre-selection of types of design practice, modes of production, objects, people, styles and institutions as the only ones worthy of study and understanding. And they all agree that feminist perspectives 'offer design history a range of historical/critical methods which challenge the mainstream' (Attfield 1989b: 200). This challenge is comprehensive, tackling all the pre-selected topics noted above: how design is to be defined 'as a practice', 'what type of designed objects it should examine . . . what values are given priority in assessing it and even who it calls designers' (ibid.).

For feminists, then, in a gender-based approach, visual culture is to be understood as a set of objects, practices, institutions and personnel that is different from and critical of those prescribed by traditional, mainstream and 'masculine' design history. Where, as Sparke says, traditional, mainstream and 'masculine' approaches to design and design history will concentrate on 'heroic buildings', mass-production, institutions such as science and industry and a series of famous male names, feminist approaches may be expected to provide a critical alternative. It is probably worth noting at this point that this critical alternative may take the form of a different set of objects, practices,

institutions and personnel or it may take the form of understanding traditional concerns in a different way.

1 Personnel

The following paragraphs will consider both critical alternatives, looking first at attempts to provide a different set of objects, practices, institutions and personnel to be understood and then at attempts to understand traditional concerns in a different way. What has become known as the 'women designers' approach is an attempt to provide a different set of personnel for design history. Where traditional, mainstream and male-biased design history concentrates on male designers, from Thomas Telford to Antonio Sant'Elia (Pevsner 1960: 254–5) or from Josef Albers to Frank Lloyd Wright (Banham 1960: 331–4), the 'women designers' approach adds the names of women to that history (Attfield 1989b: 201, and see Pollock 1988: 1). This is to understand visual culture as the work, or product, of a different set of people.

Where the dominant tradition acknowledges only men as the producers of visual culture, a feminist approach might be to provide a group of women producers and designers, for example. This would be to provide different personnel for design history, a different set of people in terms of which visual culture is to be understood. To this extent, it is changing the understanding of visual culture: it is potentially a feminist approach that changes the way in which visual culture may be understood. It is not a very convincing approach, however, and Buckley and Attfield follow Griselda Pollock's (1988) argument against such an approach. They all argue that the approach leaves the original hierarchy intact and simply inserts a few famous women's names into that structure.

2 Objects

The attempt to provide a different set of objects to be understood takes the form of what Buckley has called 'redefining' the object of design history (1986: 7). Buckley points out that, where mainstream design historians have designated industry and the mass-production of objects as the proper focus of their understanding, feminist design historians have argued that this emphasises only one mode of production. Industry and the mass-production of consumer items is only one way of producing one kind of designed object. To emphasise

a single form of production in this way is to ignore many other kinds of production and many other kinds of object. It is to ignore objects like fashion, and clothing and textiles, for example, and, as Buckley points out, it is to exclude craft production (ibid.). Moreover, where craft production and history have been dealt with, they have been dealt with inadequately, in the manner of the 'women designers' approach which is noted above. On this account, objects like embroidery as well as sewn, crocheted and knitted items are included in design and design history, alongside the traditional machine-made and mass-produced items. This represents a significant change in the kinds of objects to be understood as design. This change has two main consequences. First, it includes in design and design history a lot of what had hitherto been excluded: it includes much of what women had designed and produced in the past but which had been ignored as not being proper design. And secondly, as Buckley points out, it gives women an 'opportunity to express their creative and artistic skills outside of the male-dominated design profession' (ibid.).

Other examples of feminist writers providing different objects to be understood as design include Lisa Tickner's (1976a–d) articles on clothing and footwear in *Spare Rib*, and her (1977) essay on trousers, Rozsika Parker's (1984) book *The Subversive Stitch*, and many of the essays in Attfield and Kirkham (eds) (1989) *A View from the Interior*, including Lee Wright's (1989) essay on the stiletto heel and the essays contributed by Lynne Walker and Pat Kirkham on arts and crafts and handicrafts respectively. The journal *Fashion Theory*, which was first published in 1997, is itself an effect of the introduction of new objects into design history and theory. It has included essays on the 'Little Black Dress' (Martin 1998), and the corset (Steele 1999), for example. All these essays, on objects like fashion, clothing, craft and handicraft, represent a move away from the kinds of objects and the sorts of production methods that design historians like Pevsner and Banham were interested in. These essays look at hand-made objects, or at objects which, while they may be industrially produced, are ephemeral, which either go out of fashion, or simply wear out, or break. And they look at hitherto ignored objects. In that they do these things, they propose a different set of objects to be understood as visual culture and they represent a challenge to the dominant modernist and male-biased design history. A feminist approach to understanding visual culture, then, may consist in producing or finding a whole new or alternative set of objects to understand.

3 Institutions

A feminist approach to understanding visual culture may also consist in the attempt to understand it in terms of a set of institutions that is different from that proposed by the dominant and male-biased tradition. An attempt to provide a different set of institutions for design history may be seen in Buckley's argument that much visual culture that has been produced by women for use in a domestic environment has been ignored (Buckley 1986: 5). She provides a good example of how the institutions to which visual culture is related affect the way in which it is understood. The institution in terms of which visual culture is understood can affect its interpretation. To show how institutions different from those proposed by the dominant tradition may be used to understand visual culture is a part of a feminist approach. Buckley shows how two institutions, the family and industry, affect the understanding of visual culture. Her first example is the making of clothes. This activity is called either dressmaking, or fashion, depending upon the institution in which the activity is performed. According to Buckley, 'dressmaking . . . has been seen as a "natural" area for women to work in', while 'fashion design . . . has been appropriated by male designers' (ibid.).

One explanation of this, one way of understanding the visual culture that is fashion and clothes, is to look at the institutions that the activity is associated with. Dressmaking is associated with the family, with domesticity and with small-scale home-production. Fashion design is associated with industry, with machinery and with large-scale non-domestic production. Because one set of institutions (industry and 'factory-based' work) have traditionally been under the control and direction of men, the activity that is fashion design has been privileged in society over dressmaking. Because the family and hand-made products (which, produced within the home, have not been deemed worthy of the name 'work') have traditionally been the province of women, the activity that is dressmaking has been seen as of low status in society. It is in relation to different institutions that the activity, making clothes, is understood. Understood from the perspective of one set of institutions, the home, the family and domesticity, making clothes is low-status and maybe not even 'proper' design or work. Understood in terms of another set of institutions, the factory, industry and work, making clothes is high-status and definitely design. The practice of providing an alternative set of institutions from which to understand visual culture may be seen as a feminist challenge to the

dominant design history and the institutions it understands visual culture to belong to. It is one way in which a feminist approach to visual culture may understand visual culture differently from the dominant tradition.

4 Practices

It should, perhaps, be noted that this is not so different from approaching visual culture as a different set of practices. One need only change the emphasis of the preceding two paragraphs so that they concentrate on the practices of dressmaking and fashion design, rather than the institutions with which these are associated, for this approach to be achieved or exemplified. An approach that concentrates on practices such as dressmaking, embroidery, knitting, textile design and interior design (or decoration), for example, may be seen as providing a different set of practices in terms of which to understand visual culture. By concentrating on these practices, which the dominant tradition of design history has neglected, this approach is providing an alternative to that dominant and male-biased tradition. To this extent, it may be described as feminist.

However, it is probably more convincing to suggest that the practice that has received most feminist attention, and which has changed the face of design history, and the understanding of visual culture, the most, is that of consumption. Consumption is a practice that receives little attention in traditional design histories: they tend to concentrate on the designer and the industrial processes and materials employed in production. A feminist approach to understanding visual culture, then, might consist in understanding it from the perspective of the user or consumer of design. Where the traditional male-dominated versions of design history mentioned by Attfield and Buckley concentrate on, and understand design from, the perspective of production and the designer, it is a feminist gesture to insist on understanding design from a different perspective, that of the user or consumer of design. For example, Attfield claims that Sparke's (1986) book *An Introduction to Design and Culture in the Twentieth Century* is devoted to 'mass-produced goods and the education and practice of professional designers' (1989b: 206). She also argues that the book represents traditional, mainstream design history in that it allows women to appear only as the passive consumers of visual culture (ibid.). This is fair: although Sparke deals with the way in which the post-war Italian scooter, discussed above in Chapter 3, was consumed by dif-

ferent cultural groups after the Second World War (Sparke 1986: 154–5), for example, much of the book concerns the institutions and practices of European high modernist design. The book concentrates on such traditional, muscular modernist topics as mass-production, architects, engineers, the Machine Aesthetic, materials such as aluminium, steel and plastic and institutions like the Bauhaus, and the Hochschule für Gestaltung at Ulm. When consumption is discussed, it is in terms of passive consumption. It is discussed as the possibly varying, but always pre-existing, meanings of objects like the scooter or the motor-car and not as the creation of meanings by the consumers of those objects (ibid.).

Although she, too, still thinks of the female consumer as passive, Buckley makes a slightly different critical point in her (1986) essay. She begins from the designer's perception of women as consumers and claims that the former make two basic assumptions concerning the latter. The first assumption is that women's primary role consists in 'domestic service to husband, children and home' and the second is that domestic appliances make women's lives easier (1986: 8). Both of these asumptions lead to stereotypical views of women as consumers. The first assumption is based on the sexual division of labour, which she says underpins 'our society', and which defines the roles of men and women in that society. Thus, men have 'superior employment' and do not do housework, and women are housewives and carers (ibid.). Consequently, designers 'assume that women are the sole users of home appliances', and advertisements for those appliances stereotype women as housewives who use domestic appliances and 'family-oriented products' (ibid.). As an example of the latter, Buckley cites car advertisements, which show women, not speeding in their Porsches, but parking hatchbacks near to supermarkets. The second assumption, that domestic appliances make women's lives easier, is also reinforced by advertising, but also by design historians like Reyner Banham. Banham (conceiving of two sexes – 'men and housewives' (ibid.)) defined women in terms of their use of 'woman-controlled machinery', like vacuum cleaners, and failed to realise that designs 'take on different meanings for the consumer' from those they have for designers, manufacturers and advertisers (ibid.). This second assumption is reinforced by advertising which shows women consumers of design objects 'ecstatic' as they clean the floor, operate the microwave or empty the washing machine (ibid.: 9).

So, Buckley's essay is critical of the stereotyping, by graphic designers and product designers, of women consumers of design objects.

Advertising stereotypes women as 'mothers, cleaners, cooks and nurses' (ibid.). It also portrays idealised and 'fantasy' versions of femininity – 'the immaculate designer kitchen with superwoman in control', balancing the roles of career woman and perfect wife (ibid.). These stereotypes and idealisations are presented as problems to be confronted. She is also critical of the fact that designers and design historians have neglected the position of the consumer in producing, advertising, and writing the history of design. Advertising, she says, reinforces the meaning of design 'as defined by the designer or manufacturer' (ibid.): for whom does the microwave mean 'convenience'? Buckley suggests that it means this for the advertiser and manufacturer, and for husbands and children, but not for the women who have to operate it. It does not mean 'convenience' for the consumer. The consumer's position in this process has been ignored and Buckley is critical of that fact. But the consumer is still as much the passive recipient of the meanings of the objects as she is of the objects themselves. The passivity of the consumer in this essay is revealed in the claim that 'designs take on different meanings for the consumer' (ibid.: 8). The consumer does not give the objects meanings, women do not construct their microwaves as 'convenient' or 'inconvenient'. It is the case either that the objects already have meanings or that the objects take on meanings. The speeding Porsche and the 'convenient hatchback' (ibid.) already have their meanings. Buckley says that design goods 'take on' meanings other than those 'designated' by the designer, the manufacturer and the advertiser. Only the housewife does not get to designate meaning: inexplicably, she alone receives meanings passively in this essay.

Consumption is a practice that is different from those covered in traditional design history. To this extent, it enables a feminist approach to understand visual culture differently from traditional approaches. It also enables feminist approaches to be critical of traditional approaches, exploring de Certeau's (1984) idea of the 'subversive consumer'. However, the passivity of the consumer is a problem. Angela Partington's (1992) essay 'Popular Fashion and Working-Class Affluence' provides an example of how the notion of the active consumer may be explained. Again, it enables a feminist, gender-based approach to understand visual culture, in this case fashion design, in a way that is different from traditional design histories. One of the things Partington is interested in in this essay is 'gendered consumption' (1992: 156), and the way in which women may be seen as active, and even subversive, consumers of fashion items. What she calls 'fashion history' tends to

'read off' clothes as 'expressions of class identity . . . as if the consumer was a passive victim of fashion' (ibid.: 146). Under the influence of Thorstein Veblen (1992) and Georg Simmel (1971) who were writing at around the turn of the nineteenth century, fashion history has presented fashion design as a form of visual culture which is expressive or reflective of social and cultural relations. Partington wants to argue that fashion design is better understood as 'the site of the active production of class-specific values and meanings by consumers' (ibid.: 149). Meanings are not 'expressed' or 'reflected', they are actively produced by the consumer, on Partington's account.

In particular, she wants to investigate the ways in which working-class women in the 1950s used fashion and other goods actively to 'articulate' or express their identities in 'new ways' (Ibid.: 146). To simplify Partington's account somewhat, they did this by taking the New Look, associated with the fashion designer Christian Dior, and adapting it to their own means. Dior's New Look first appeared in 1947. As a piece of *haute couture*, it would have been beyond the means of working-class women. Even given Dior's practice of allowing exact drawings to appear only one month after the fashion show (ibid.: 151), working-class women could not afford the dresses. Partington suggests that, even if they could have afforded the dresses, these women would not have adopted them in the form in which they first appeared (ibid.: 157). She argues that '1950s fashion were "improperly" consumed by working-class women' (ibid.). Existing styles, such as the New Look and the Utility styles, which were still available in post-war Britain, 'were sampled and mixed together' by these women to create an identity that was the product of neither professional designers nor 'official' design bodies. The 'soft, rounded shoulders, nipped-in waist and full, long skirts' of Dior's New Look, the 'square shoulders and short, straight skirts' of government-prescribed Utility styles, and the post-war 'shirtwaister' dress (which is itself presented as a development of Utility styles), were all sampled and mixed together (ibid.: 154).

This sampling and mixing of styles also had ideological connotations that Partington wants to stress. The women who created their own versions of New Look styles were also challenging the existing definitions of femininity. If the New Look identified a luxurious, frivolous form of femininity and if the Utility styles represented a more sensible and 'housewifely' look, then, by mixing the styles, these women were also challenging the ideologies that went with them. These dominant models of femininity were refused and challenged by

women taking elements of each and mixing them in the garments that they made. As Partington says,

> women used fashion to resist the dominant ideologies of femininity ...
> through the 'improper' consumption, or appropriation, of the New Look.
> 　　　　　　　　　　　　　　　　　　　　　　　(Ibid.: 158)

Where the alternatives were either wearing the Utility styles of 'dutiful housewife' or wearing the more glamorous New Look styles of the sex-object, the mixing of these styles was a 'challenge to the dichotomy separating "housewife" (functional woman) and sex object (decorative woman)' (ibid.: 159). The fashions worn by working-class women at this time are not given meaning either by official, government-related bodies or by 'professional' *haute couture* design houses. The women wearing these fashions are not passively receiving and consuming the meanings of the clothes they wear. Nor are they using fashion to express an already-existing class or gender identity. Instead, they are constructing their own versions of femininity and class identity from the styles that are available. They are giving the things they wear their own meanings. This is the basis of active consumption as it is used by Partington to explain and understand fashion.

Another version of active consumption is found in Sparke's (1995) *As Long as it's Pink*, which looks at 'feminine taste' and domestic interior design. Her conception of the consumer, and of the female consumer, has changed somewhat from that found in her (1986) book. Sparke points out that, until recently, most scholarly writing on consumption has ignored the matter of 'feminine taste' and conceived of consumption in entirely negative terms, as an effect of manipulation or a trap for the unwary (ibid.: 7). She says that, even when the matter of consumption has been dealt with positively, such writing has usually ignored the role of gender (Douglas and Isherwood 1979). Other studies have perpetuated the idea that women's consumption 'was entirely passive' (ibid.: 8). Sparke wants to develop an account of feminine taste and consumption that conceives of feminine taste as operating 'outside the value judgements imposed on it by masculine culture' and which understands consumption in 'specifically feminine terms' (ibid.).

In the chapter 'Those Extravagant Draperies', Sparke considers the conflict between the Victorian housewife and the 'design reformers' over the matter of interior decoration and design. The 'design reformers' included Prince Albert, who was President of the Society of Arts, Richard Redgrave, lecturer at the Government School of Design, the

architect A. W. N. Pugin, and the critic of art and society John Ruskin (ibid.: 53–4). These establishment and high status figures wanted to establish a 'knowledge of the arts and the principles of design among the people' and throughout the land (ibid.: 52). To simplify, what they objected to was 'feminine taste', or the feminine in design and decoration, which they thought 'lowered aesthetic standards' (ibid.: 57). The 'feminine' consisted in what these men saw as clutter, 'knick-knacks', fussy ornamentation, highly patterned chintzes, the 'gaudy' or conspicuous, and cut glass, for example. Sparke provides an illustration of a chintz with a 'highly ornate and naturalistic flower pattern' (see Figure 5.1), which was used in the 1851 Great Exhibition to demonstrate what Henry Cole, the Director of the South Kensington Museum, saw as the 'false principles of design' (ibid.: 56). Pugin railed against the intrusion into the Church of the feminine superficiality of 'the toilette table'. The 'result' of this intrusion, he said, 'is pitiable . . . pretty ribbons, china pots, darling little gimcracks, artificial flowers, all sorts of trumpery are suffered' (ibid.: 57). Ruskin thought that cut glass, another 'marker of feminine taste' (ibid.: 59), represented a threat to civilisation itself: 'all cut glass is barbarous', he said, adding that 'all very neat, finished and perfect form in glass is barbarous' (ibid.: 60).

In spite of this onslaught from the male Victorian establishment, Sparke says that women 'continued to make choices based on the dictates of fashion and comfort' (ibid.: 68). (Fashion was itself deplored by Eastlake, the Keeper of the National Gallery in 1878, as inevitably turning out to be 'hideous' (ibid.: 61).) She says that there was a 'tension' between the 'two systems of taste', the masculine and the feminine, but that this tension 'remained hidden' (ibid.: 68). However, what can be seen is that the interior design is understood in terms of differently gendered taste. Textiles, cut glass and ornamentation, for example, are presented, and understood, from the viewpoint of masculine and establishment 'good taste'. In these terms they are, of course, little short of an abomination and that is exactly how Pugin and Ruskin describe them. Sparke suggests, however, that from the perspective of feminine taste they represent choices made on the basis of fashion and comfort. The way the late-Victorian interior looked, then, is understood in terms of gendered differences in taste and consumption.

Later, in the chapter 'The Happy Housewife', Sparke looks at post-Second World War Britain and America, arguing that 'the post-war housewife' took from modernism what she wanted and transformed

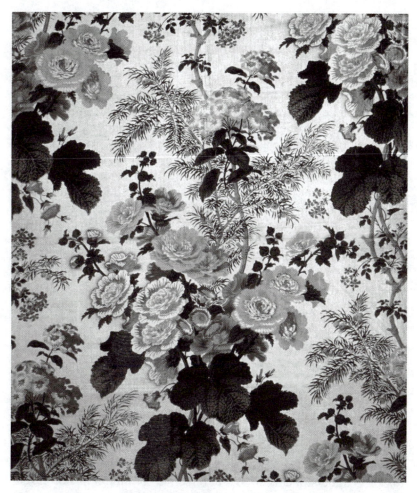

Figure 5.1 Hollyhock chintz, 1850

or subverted what she did not want (1995: 182). After the Second World War, there were acute housing shortages in both Britain and America (ibid.: 174). In America, the solution was found in new towns and standardised dwellings. William J. Levitt's company designed the Levitt house and built 17,450 of them in Levittown, Long Island (ibid.). In Britain, the government built the New Towns, such as Crawley and Harlow (ibid.: 176). Sparke introduces the unease of women on both sides of the Atlantic with their new houses. The houses

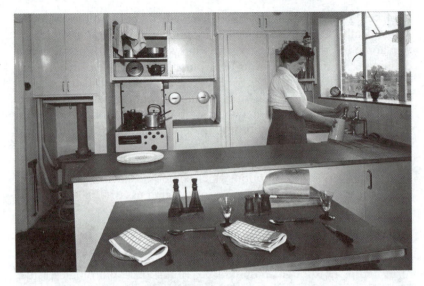

Figure 5.2 Harlow domestic interior, 1950

had their kitchens at the front, for example, supposedly in the name of making women feel part of the community as they did the washing up (see Figure 5.2). The women installed their own net curtains in search of some privacy. The architects, 'steeped in modernist ideology', had no time for privacy, pride in ownership and the other things that the women wanted (ibid.: 177). The interior design of people's houses is understood as representing 'feminine taste', which is itself explained in terms of the active consumption of the women who decorated and lived in those houses. The way the insides of people's homes looked, that is, is understood as an aspect of active consumption, not in relation to design professionals or the theorists of modernism.

The last example of consumption being used to actively construct the female consumer is that found in Attfield's (1989b) essay, which, like Sparke (1995), investigates the domestic interior. Indeed, Attfield's essay is the source of Sparke's treatment of these issues. Again, the idea is that the domestic interior is to be understood in terms of active consumption. The look of these interiors is understood in relation to the consumer's construction of the meaning of that interior, not in the terms of professional designers or town planners, for example. In their 'Introduction', Attfield and Kirkham do not explicitly acknowledge, as Sparke does, that domesticity is 'the oppressor'

(Sparke 1995: 6) or that it has been held to be a traditionally or ideologically 'feminine' subject. They point out that their subject is 'the home but the three case studies show how a shift of position can illuminate a different facet of women's relationship to design' (Attfield and Kirkham 1989: 3). The 'but' is significant. It is the 'shift of position' that is to 'transform familiar terrain into an unexplored world' (ibid.). The subject may be the domestic interior, a traditional location for the feminine, but it is to be understood differently from traditional accounts.

The shift of position is to understand the domestic interior in terms of women's active consumption, which sometimes means the rejection of dominant styles and design principles. In her essay (1989a), Attfield shows how women in the New Town of Harlow during the 1950s contested the dictates of 'official' design. Mr A. M., who had worked for Harlow Corporation Architects Department, recollects how 'every architect thought that after his house had been built . . . it should be furnished as he thought it should be' (ibid.: 222). Tautologies aside, Mr A. M. is referring to 'official' design. He is reporting how the architect has an idea of how the houses he has designed should be furnished. The Corporation also had an idea as to how they should be furnished and painted the walls, ceilings and doors the colours they thought they should be painted. Mr A. M. recalls how, as soon as people had moved in, they would redecorate. They would re-paper the walls 'with some of the most awful wallpapers . . . you'd throw your hands up in horror' (ibid.). Attfield also documents in this essay how the women occupants of the houses created their own private and display spaces, which had been neglected by the 'elitists' representing modern urban design (ibid.: 217–20). The introduction of net curtains to these houses is explained in terms of the way in which women 'experience' privacy differently from men (ibid.: 225).

Attfield also uses the work of Thorstein Veblen and Pierre Bourdieu to understand these interiors. Bourdieu's 'class analysis of taste', for example, is used to explain the social context and function of the criteria used by the 'design establishment'. And Veblen's theory of the leisure class is used to explain the place of display in the lives and homes of the women of Harlow (ibid.: 225). The criteria used by the design establishment, the 'elitist' architects and town planners of 1950s Harlow, for example, embody 'dominant cultural values that are not normally questioned' (ibid.). By showing how different classes can possess different tastes, Bourdieu's analysis of taste can be used to show how 'all tastes fit within a hierarchical framework with "high"

taste as dominant and therefore the measure by which the others are judged' (ibid.). The taste of the women occupants of the houses of Harlow can be seen as existing within such a hierarchy and as opposed to, or critical of, the taste of the dominant group, the elitist architects and planners. The 'conflict' over privacy and display are both approached in these terms by Attfield. In the matter of display, Attfield suggests that 'particular pieces of furniture' chosen by the women of Harlow may be used as examples of what Veblen calls 'conspicuous consumption'. According to Veblen's theory, different social groups identify themselves, and their difference from other social groups, by means of what goods they purchase and display. Glass-fronted display cabinets were still used in the 1950s, apparently, as were open shelves and pelmets. The sideboard was another item used for the purposes of display. In these explanations, a gender-based account is being supplemented with a class-based account. Although Veblen is not silent on the matter of gender and display (suggesting that women themselves should be the chief ornament of the household (1992: 126)), as they appear in Attfield's essay, both Bourdieu and Veblen are more concerned with class than gender.

Strengths and weaknesses

Writing in 1995, Victor Margolin says that 'feminism is the most powerful critique of design history thus far' (1995: 12). This judgement is surely not inaccurate. Previous sections have shown how feminist approaches to visual culture have thoroughly examined and profoundly changed the practices of design history. Feminist approaches have challenged what Sparke and Buckley, for example, have called traditional, modernist and patriarchal accounts of who is to be included in design history, proposing women designers as well as men. They have challenged these accounts in terms of the sorts of objects and the sorts of design that are worthy of study. By inserting and studying traditionally 'feminine' areas of design like textiles and fashion, for example, alongside the traditionally 'masculine' areas like industrial and product design, feminist approaches have critiqued those traditional design histories. Given that feminist approaches have so enlarged the province of visual culture, introducing objects and institutions that were once not deemed to be fit objects of serious study, it seems somehow inadequate to suggest that a strength of feminist approaches is that they are able to understand the full range

of visual culture. It could be argued that it is feminist approaches that introduced the full, or a fuller, range 'in the first place'.

Feminist approaches have also rewritten design history in terms of the sorts of institutions that are to be studied, adding the family and the domestic to the factory and the prestigious modernist art school, for example, and opening up new aspects of the design process. And feminist approaches have proposed that alternative practices, such as dressmaking, home decoration and, more significantly, perhaps, consumption are taken into account by design history. The former have been recast in terms of the 'male' versions of these practices, known as fashion design and interior design. There is not an aspect of design history that has not been radically challenged and changed by these feminist approaches. This fact represents one of the main strengths of such approaches. The critical energy and far-reaching nature of these gender-based approaches is a major strength of those approaches, perhaps enabling the present chapter to escape the effects of Nead's argument, noted above. Nead argues that feminism is not an approach among others, but a form of critique (Nead 1986: 121): the present chapter has shown that, as a collection of approaches, feminism constitutes a formidable critique of design history.

It is with regard to the goals and strategies of that critique, however, that some of the weaknesses of feminist approaches appear. What should be the goal, or goals, of a feminist and gender-based understanding of visual culture? What methods or strategies are best suited to achieve those goals? Should such approaches even have a goal, in the sense of an achievable end-point? In the 'Introduction' to their (1989) book, Attfield and Kirkham distinguish themselves from the 'woman designers' approach to understanding visual culture (1989: 1). Buckley also has little time for such an approach (1986: 4–7). The problem with it is that it merely inserts women into a structure and a hierarchy from which they have hitherto been excluded. It does not challenge the gendered nature of the structure or the hierarchy, or the practice of placing people into hierarchies, in any way. The 'woman designers' approach to design history, then, cannot be properly feminist: it does not challenge the structure and hierarchy that are themselves the product of the (male dominated) system that is to be critiqued. The question arises as to whether this question also applies to the critiques of the objects, practices and institutions which this chapter has presented as feminist. The insertion of female personnel into patriarchal and male-biased structures and hierarchies is not necessarily a feminist strategy: are the strategies adopted with regard to

objects, practices and institutions noted above also not necessarily feminist?

It could be argued, for example, that the 're-discovery' or re-evaluation of such traditionally 'feminine' practices as dressmaking and interior decoration and treating them on the same terms as the 'masculine' versions of those practices, fashion design and interior design, is merely to insert feminine practices into masculine structures. Such re-discovery may be seen as proposing that traditionally feminine practices are 'actually' the same as what have been seen as traditionally masculine practices. The re-evaluation of traditionally feminine objects, such as textiles and crafts, for example, in traditional masculine terms may also be seen as merely inserting the hitherto inferior term into the superior place in the dominant structure. And, in the case of institutions, claiming that domesticity and the home are as worthy of study, and for the same reasons, as traditionally masculine institutions like industry and mass-production, is to insert traditionally feminine institutions into a structure and hierarchy that is originally male-defined. In all these examples, what had been dismissed and excluded from design history on the basis of not possessing certain characteristics is now to be admitted into that design history on the basis of its actually or really possessing those characteristics. The consequence for the understanding of visual culture is that to follow this strategy is not to offer a feminist understanding of visual culture at all. It may still be a gender-based understanding, but the understanding is gender-based because the gender producing it is masculine, not because it is a different, or feminine, gender.

This strategy is a form of reversal (Barnard 1993: 24), in that it reverses the evaluation accorded one of the two terms in the hierarchy and inserts that term into the original, masculine, structure. Another strategy that may be pursued is that of refusal, where the original masculine structure is refused and another, specifically feminine one is set up. An element of this form of refusal may be seen in Sparke's claim to understand consumption in 'specifically feminine terms' (Sparke 1995: 8). The claim seems to be that there are forms of pleasure and 'aesthetic delight' that are essentially, or 'specifically', feminine. This is to refuse to operate the original structure and hierarchy and to set up an alternative structure, a 'specifically feminine' structure. The problem arises when the question as to where those 'specifically feminine' terms, pleasures and delights are to come from is considered. Are they the terms, pleasures and delights that were accorded women in the original, patriarchal or 'masculine culture'

(ibid.)? If they are, then it is not clear how specifically or essentially feminine they are, having been originally defined in a masculine culture. If they are not, then it is not clear where such terms, pleasures and delights are to be found. Again, the consequence for the understanding of visual culture is that it is not clear in what sense the understanding being offered is a feminist understanding. It may be a gender-based understanding, but its version of femininity is defined by the original, male-dominated, structure. The understanding that is offered by such an approach cannot, therefore, be a different, feminist, understanding.

Paradoxically, given the obscure gender identity of the understanding that may be offered by these approaches, Attfield's implied claim that no one strategy or goal should be privileged over any other may be the most feminist. She argues that

> feminism is a political position which seeks changes in the interest of women. There is no ultimate agreement as to what those changes should be, nor what strategies used to pursue them. (1989b: 200)

One of the consequences of this claim is that there is no 'ultimate' goal which a proper feminism would reach and that there is no proper, or specifically feminine strategy that should be used by feminism. Such a formulation avoids all the charges of essentialism that could be levelled at the previous strategies. It also enables a feminist account of visual culture to take up goals, strategies, investigations, pleasures and so on as it deems appropriate at the time, without being necessarily committed to any of them as 'the' feminist strategy to be adopted at all times. On such an account, then, the 'woman designers' approach so reviled by Attfield and Buckley has a limited validity. In an early essay, Attfield says that

> if the object of the exercise is to . . . show that some women have managed to succeed in becoming fairly successful professional designers . . . then there is good reason to start with a women-in-design approach. (1985: 26)

But it is only a start: 'feminist . . . design history should not be satisfied nor stop there' (ibid.).

Another potential weakness of a feminist approach can be seen in the argument that visual culture cannot be reduced to gender. This is the claim that a gender-based approach is reductive, that there is more to understanding visual culture than understanding the various consequences of gender. It might seem a little churlish to make such a claim, given the fecundity, energy and challenging insight shown by

many feminist approaches, but it is a claim that many feminists have acknowledged. Even the feminist accounts covered in the present chapter have felt the need to 'supplement' their gender-based accounts by referring to class structures. As noted above, Attfield used the class-based accounts of Veblen and Bourdieu, and Sparke says that the first route she took to explore the inequalities of design history was 'that of the domination of one class over another' (Sparke 1995: ix). These gender-based and feminist accounts of how visual culture may be understood think it necessary to supplement their gender-based accounts with an account of social class and class domination. The nature of class and of class domination will be dealt with in more detail in Chapter 6, which concerns Marxism and the social history of visual culture.

Conclusion

This chapter has tried to introduce the main strands of a feminist approach to understanding visual culture. The first task was to ascertain whether there was a specifically feminine form of understanding, one that was not part of the dominant, masculine tradition of scientific understanding. In the absence of much feminist literature on this topic, it was suggested that such a feminist understanding would be critical of the dominant, masculine and scientific tradition, which conceived of 'objectivity' as a virtue. It would, rather, consider the objects of visual culture in relation to the experiences of the people who were studying and understanding them. The second task was to explore the different things that might be proposed by a feminist understanding of visual culture. Using the example of design history, the personnel, objects, institutions and practices of traditional, male-biased and modernist design history were all seen to be thoroughly critiqued by a feminist approach; and an alternative set of people, objects, institutions and practices was seen to be established. Consumption, in particular, was shown to be a very successful critique of the dominant modernist and masculinist design history, challenging the latter's conception of what design history is about and who it is for.

In Vasari's *Lives*, the chapter on Madonna Properzia de' Rossi, the sculptress of Bologna, begins with a long list of all the achievements of women, in war, poetry, philosophy, grammar, astrology, agriculture, sciences and languages. He says that women have not been afraid to turn their 'delicate white hands' to the mechanical arts like ironwork

and sculpture (1963: 325–6). Were he alive today, therefore, the prospect of women bothering their pretty little heads with design history and the understanding of visual culture would doubtless upset him not at all.

Further reading

The chapter has concentrated on feminist and gender-based accounts of design, or material culture. It has neglected the treatment of feminist and gender-based accounts of fine art. The literature on this subject is enormous. However, places to start would include Linda Nochlin (1989) *Women, Art and Power and Other Essays* (London: Thames and Hudson); Griselda Pollock (1988) *Vision and Difference* (London: Routledge); Thalia Gouma-Peterson and Patricia Mathews (1987) 'The Feminist Critique of Art History', in *Art Bulletin*, 39.3, pp. 326–57; Whitney Chadwick (1990) *Women, Art and Society* (New York); Jaqueline Rose (1986) *Sexuality in the Field of Vision* (London). Laurie Schneider Adams has a chapter on feminist approaches to art in her (1996) *The Methodologies of Art* (New York: HarperCollins).

The study of consumption in design and material culture has taken off, certainly taking over from traditional design history and possibly even displacing feminist design history as a hot topic. A gender-based account of design may be found in Pat Kirkham's (1996) *The Gendered Object* (Manchester University Press). And books like Victoria de Grazia and Ellen Furlough (eds) (1996) *The Sex of Things: Gender and Consumption in Historical Perspective* (California: University of California Press), Stevi Jackson and Shaun Moores (eds) (1995) *The Politics of Domestic Consumption: Critical Readings* (Hemel Hempstead: Prentice Hall/Harvester), and Nicholas Breward's *The Hidden Consumer*, are all examples of where this topic has gone since the Attfield, Buckley and Sparke works covered here were written.

An updated overview of many of the topics covered in this chapter may be found in S. Clegg and W. Mayfield (1999) 'Gendered by Design: How Women's Place in Design is Still Defined by Gender', *Design Issues*, vol. 15, no. 3, Autumn, pp. 3–16. And an update on Cherry's account of the portrayal of women in the media may be found in the work of the Women in Journalism (WIJ) group, who investigated the portrayal of women in British newspaper photo-

graphy in 1999. They found that photographs of men outnumber those of women, that women were more likely to feature in 'irrelevant' images than men and that, while the men shown were politicians, professionals and sportsmen, women pictured tended to be 'actresses, models and other celebrities' ('Real Women: The Hidden Sex' from the WIJ Secretariat, 43 St Martin's Road, London, SW9 0SP, wij@kmcmillan.demon.co.uk).

Chapter 6

Marxism and the Social History of Art and Design

Introduction

The previous chapter opened with the observation that feminism was like Marxism and psychoanalysis in that it made the nature or position of the understanding subject into a problem. These approaches were said to make the position of the understanding subject part of the activity or process of understanding. Chapter 5 showed how feminist accounts of understanding made the gendered nature of the subject part of the process of understanding. For feminist accounts of visual culture, what was understood and how it was understood were both products of the gendered nature of the person doing the understanding. The understanding of mass-produced, industrial design, or home-made New Look frocks, for example, was seen to be dependent upon one's gender identity, differing according to whether one was male or female. Chapter 4 showed how, for psychoanalysis, the active role of the unconscious was part of the process of understanding. In psychoanalytic accounts of visual culture, what was understood and how it was understood were both products of the subject's unconscious desires and wishes. The understanding of Michelangelo's *David*, or of Dannimac advertisements, for example, was seen to be dependent not only upon one's gender, but also upon one's unconscious feelings and desires regarding one's father or towards women. The present chapter will look at what has become known as the social history of art. This is an approach to understanding visual culture, art in this case, that is based on the ideas of Marx and his followers. Some main

aspects of the tradition of the social history of art will be introduced here as having a basis in a Marxist approach to understanding. Marxist approaches to the understanding of visual culture also make the position or nature of the understanding subject a part of the process of understanding. They argue that understanding is dependent upon the economic, or class, position of the individual.

In his *Grundrisse*, for example, Marx (1818–83) wonders how it is that the art and epic poetry of ancient Greece can still be a source of aesthetic enjoyment for modern people (1977: 360). He says that this is not a question of understanding that ancient Greek art is 'bound up' with a certain form of society. That art is bound up with the society of which it is a part and a product is not in question; that much appears to be taken for granted. Marx's difficulty lies in understanding how that art can be a source of artistic pleasure and even an unattainable standard and model, for modern spectators and artists (ibid.). His point is that modern spectators and artists live in a society that is different from that of the ancient Greeks. It is a different sort of society from ancient Greece and they occupy different places in that society. On Marx's account the sort of society one is a member of, and one's position in that society, will influence one's understanding of art and design. Ancient Greece was not a modern nation: the Greeks employed mythology and operated a slave economy, for example. The modern nation has science and technology, and employs a capitalist economy. Consequently, Marx wonders whether

> the view of nature and of social relations which shaped Greek imagination and Greek art [is] possible in the age of automatic machinery and railways and locomotives and electric telegraphs. (Ibid.)

What he is wondering is whether it is possible to understand the imagination of the Greeks, as it is found in their art, given that their society was so different. The views of nature and of social relations held in such a society, for example, are different from those of modern society. Marx questions whether it is possible for a modern person to hold such views, and thus to understand ancient Greek art in the same way as the ancient Greeks. Because modern people are the products of a modern and scientific society, which has a capitalist economy, they have certain views of nature and of their fellows. They are likely to understand artistic works differently from people from a society that employs mythology to explain the world and which operates a slave-based economy. This is essentially the same question that was discussed in Chapter 2, where Schleiermacher and Dilthey were seen to

ask after the conditions for the possibility of understanding the works of the past. So, although he is rarely acknowledged as a classical hermeneutic theorist (see Bauman 1978: 48), Marx proposes the matter of understanding the art and visual culture of other times and places in classical hermeneutic terms. And, although she is pursuing an entirely different argument, Susan Sontag says that Marx's doctrine actually amounts to an elaborate system of hermeneutics, an 'aggressive and impious' theory of interpretation (in Fernie (ed.) 1995: 218).

Similarly, in *The German Ideology*, Marx castigates Max Stirner for imagining that the artist Raphael became an artist and produced his works independently of society, 'independently of the division of labour that existed in Rome at the time' (1970a: 108). By the division of labour, Marx is referring to the way in which capitalist economies force one or other occupation upon individuals (ibid.: 54). Some people work with their hands, others with their minds: manual labour is distinguished from intellectual labour. People are forced to take up one exclusive and specialised occupation, hunter, fisherman or critic, for example, and to remain with it, in fear of losing their livelihoods (ibid.). In capitalist societies, the way in which the economy is organised forces people into occupational roles from which there is no escape. What Marx wants to argue, against Stirner, is that Raphael is a product of such a society. He says that Raphael

> was determined by the technical advances in art made before him, by the organisation of society and the division of labour in his locality and . . . by the division of labour in all the countries with which his locality had intercourse. (Ibid.: 108)

Were it not for the division of labour in Italy and all the other capitalist countries with which Italy had business at the time, Raphael would not have been an artist. Whether Raphael, or any other individual, succeeds in becoming an artist or a designer 'depends on the division of labour and the conditions of human culture resulting from it' (ibid.). If society were to be organised differently, as in a socialist society, for example, this division of labour would not take place. What should be stressed here is that Marx is tying the possibility of understanding artistic production to specific historical conditions existing in specific capitalist societies. Understanding is dependent upon economic, or class, position.

The present chapter will show how Marxist approaches to visual culture make the economic, or class, position of the subject into part

of the understanding process. It will show how, in Marxist approaches, what is understood and the way in which it is understood are products of the economic, or class, position of the understanding subject. Here, the economic position and identity of the understanding subject has a role in and makes a difference to the activity of understanding. In order to investigate these claims in terms of visual culture, the chapter will look at the work of Arnold Hauser, Nicos Hadjinicolaou and Tim Clark on the social history of art. These writers will be used to investigate the idea that economic or class identity, one's position in society, is the basis of our understanding of visual culture. And the problems involved with Marxist accounts of visual culture will also be explained here. The dangers of arguing a crude, or vulgar, Marxist account, in which art and design are understood as simple reflections or products of economic realities, will be outlined in the accounts of Hauser and Hadjinicolaou. Gen Doy's and Griselda Pollock's critiques of Tim Clark's position in the social history of art will also be outlined. Doy's argument that Clark is not Marxist, or materialist, enough and Pollock's argument that Clark is reproducing certain masculinist assumptions of traditional art history will be explored here. The question as to whether there are aspects, or examples, of visual culture that are more or less successfully explained by a social history, or Marxist, approach will be investigated. Examples of visual culture that do not appear to be easily explained or understood in terms of social class and ideology will also be covered. The chapter will explore the argument that, *prima facie*, furniture and textile design are more appropriate or amenable to a Marxist account, while abstract art, for example, is less appropriate or amenable.

Marxism, understanding and structure

However, this chapter will first briefly reprise the debates surrounding the scientific character of our understanding of visual culture that were outlined in Chapter 2. It will explain and assess various claims regarding the status of Marx's references to 'scientific' understanding and criticism. This is a very ticklish subject for Marxists and it has generated an enormous and complex literature. The present section must assess the consequences of this debate for a Marxist understanding of visual culture without getting hopelessly lost in those complexities. This chapter will also discuss the location of a Marxist approach in the structural and hermeneutic traditions that were outlined in

Chapter 2. While Sontag locates Marxism in a hermeneutic tradition, as being concerned with interpretation, Marxism may also be located in the structural tradition in that it is the class structure of a society that is proposed by Marxism as the basis for understanding. In so far as this is the case, Marxism is also committed to the argument that the class structure of a society is the basis for understanding the visual culture of that society.

In the Preface to *Capital*, published in 1867, Marx conceives of his task in scientific terms. He compares his procedure, in the work, of using England as the chief illustration of his theoretical ideas to that of the physicist, who 'observes physical phenomena where they occur in their most typical form' (1954: 19). He also writes of the 'ultimate aim' of the work, 'to lay bare the economic law of motion of modern society', and of discovering the 'natural laws' of the movement of society (ibid.: 20). In both cases, by describing his own activity in the terms of natural science, it is clear that Marx is sympathetic to the idea that what he is doing is in some way scientific.

However, in the Preface to *A Contribution to the Critique of Political Economy*, published in 1859, Marx makes a distinction which is of more use to this section. He first identifies the 'economic foundation'. This is also known as the base, or the 'economic conditions of production' (1970b: 21). By this phrase, Marx means the technology, plant and raw materials used in the production of goods, along with the social relations into which people enter in order to produce those goods in any particular economy. The conditions of production, he says, 'can be determined with the precision of natural science' (ibid.: 21). He also identifies 'a legal and political superstructure . . . to which correspond definite forms of social consciousness' (ibid.: 20). This superstructure consists in various institutions, 'legal, political, religious, artistic or philosophic', and it is based upon the conditions of production. These are what Marx calls 'ideological forms'. They are the institutions in which people become aware, or 'conscious', of the conflict of interests that exists between classes, and 'fight it out' (ibid.: 21). Now, whatever one thinks of the relation between base and superstructure as Marx describes it here, two important points need to be stressed. First, it is significant that it is in ideology that the conflict of class interest is brought to consciousness and fought out. Secondly, nowhere does Marx say that this consciousness of class conflict and the ensuing ideological struggle is available to natural science. Understanding the conflict of class interest (in artistic institutions, for example) is not a matter for natural science on Marx's account here.

It is thus left open for a more social-scientific or historical set of approaches to understand the ideological forms in which people become conscious of class conflict and 'fight it out'. On this account, visual culture may be understood in social-scientific terms as the arena in which class conflict takes place.

In terms of the hermeneutic and structural traditions of understanding identified and discussed in Chapter 2, Marxist accounts appear to fit better into the latter than the former. The hermeneutic traditions were explained in relation to the horizons, or consciousnesses, of individuals. Individual consciousness was the basis for the 'fusion' of horizons described by Gadamer, for example, in the hermeneutic account of understanding. Structural traditions were explained with reference to the systems, or structures, in which ideas, and even individuals themselves, were meaningful. Marxism is a structural account in that it understands history and society as economic, or class, structures. Again, ideas and even individuals themselves are meaningful, and therefore understandable, in terms of economic structures on a Marxist account. As Marx says,

> [i]t is not the consciousness of men that determines their existence, but their social existence that determines their consciousness. (Ibid.: 21)

Social existence, or social being, refers to people's identity as members of social classes. Marx is trying to explain the way in which economic, or class identity determines consciousness: he argues that what people think, believe and understand is a product of their place in a social and economic structure, their class identity. To this extent, Marxism will be presented in this section as a structural approach, rather than a hermeneutic approach.

Arnold Hauser

Hauser's four-volume *The Social History of Art*, first published in 1951, covers art from the stone age to the film age. In this massive work, Hauser is concerned to understand art in terms of the social and economic organisations it is a part of. The history of art is conceived as a succession of styles and each style is linked to the economy and society it is a part of. The move from Neolithic, or stone age, art to the art of early Egyptian and Mesopotamian civilisations, for example, is presented as a 'profound revolution of economy and society' (1951, vol. 1: 22). The art of early Egyptian dynasties is described in the

context of a move 'from mere consumption to production', independent trade is starting up, new markets are developing while the population is forming different groups and coming together in new towns and cities (ibid.). The producer of art and design 'emerges from the closed milieu of the home and becomes a specialist whose trade is his livelihood' (ibid.: 23). Such a producer is no longer to be understood as a simple member of the household, he is now a 'craftsman', 'carving sculptures, painting pictures . . . just as others make axes and shoes' (ibid.). The status and definition of the artist changes in the transition from Neolithic to early Egyptian and Mesopotamian civilisations. He becomes a craftsman, almost a professional. The artist/craftsman and his production are understood here as being part of a particular social and economic organisation.

The account of the Romanesque style in the Middle Ages is also constructed in terms of a relation to economic, political and social factors. Romanesque art is said to be 'an art of the aristocracy' (ibid.: 159). In this feudal society, the property and power of both secular and religious nobility were rooted in the same social order. Romanesque art, then, is understood in its relation to the social order, feudalism, and in terms of the main social classes making up that social order, the aristocracy and the peasants. Hauser goes on to explain the cultural production of the Middle Ages as it relates to the social order. For example, the manor house is now the centre of the economy and production is geared to consumption: the feudal economy producing only as much as it needs (ibid.: 163). Examples of Romanesque art and design are understood in their relation to these social classes and the feudal economy. In Romanesque representations of the Passion, for example, Christ is shown standing on the cross, rather than hanging from it and he is usually clothed. This is explained by a reference to aristocratic taste, what Hauser calls 'social considerations', as much as by religious ideas (ibid.).

Impressionism is also understood in its relation to social and economic conditions. The stylistic change from naturalism to Impressionism, for example, is said to 'correspond to the continuity of . . . economic development and the stability of social conditions (1951, vol. 4: 156–7). The most important economic and social development that is used to understand Impressionism is the growth of modern cities (ibid.: 158). Impressionism is 'an urban art' for Hauser, partly because it 'sees through the eyes of the townsman' the new social classes that were inhabiting these new modern cities (ibid.). However, Hauser also says that Impressionism had 'nothing of the plebian about

it' and that it was an 'aristocratic' style (ibid.: 166). This latter association of the style with an aristocratic social class contradicts the earlier association of it with the new urban classes. However, Hauser explains the aristocratic temper of Impressionism in terms of its 'elegant and fastidious' disposition, its leaning towards 'experiences of solitude and seclusion and the sensations of over-refined senses and nerves' (ibid.). Thus, one is to understand the works of Impressionist artists in terms of their class identities – these artists coming mainly from the lower to middle ranges of the bourgeoisie, although some, like Toulouse Lautrec and Degas, are of aristocratic origin (ibid.).

Nicos Hadjinicolaou

Hadjinicolaou's *Art History and Class Struggle*, published in English in 1978, is rarely mentioned, at least in positive terms. However, he is covered here, if only briefly, because he takes an interesting position on the matter of style. To begin with, Hadjinicolaou does not base his understanding of style and art on the individual. To this extent, his approach is critical of approaches such as those covered in Chapters 3 and 4 above, where the individual, in the form of an individual's understanding or expression, is the basis for understanding visual culture. His position is also different from those formalists covered in detail in Chapter 8. And it is different from that of Hauser, considered above. He does not present the history of art as a sequence of styles that is to be understood in relation to large-scale economic and social developments, in the manner of Hauser. Nor does he simply present differences in style with no attempt at all to understand those differences in terms of economic and social factors, as people like Fry, Bell and Wölfflin are seen to do, in Chapter 8. Hadjinicolaou tries to understand style and differences between styles in terms of social classes. For him style belongs to classes or to sections of classes. The following paragraphs might usefully be read in conjunction with the sections on Bell, Wölfflin and Greenberg in Chapter 8.

The definition of style that Hadjinicolaou uses is slightly different from that found in Hauser and from that found in the works of Bell and Wölfflin. Style is an entirely formal matter for theorists such as Bell, Fry and Wölfflin. It is entirely to do with an artist's, designer's, period's or school's characteristic use of shape, line, colour and texture, for example. For Hadjinicolaou, however, style 'stems directly from the society which produces it' (Frascina and Harrison 1982: 244).

Following the Marxist art historian Frederick Antal, however, Hadjinicolaou defines style in terms of both form and content. He quotes approvingly from Antal, who says that the 'subject-matter of a work of art is of no less importance than its formal elements', and who defines style as 'a specific combination of the elements of subject and form' (ibid.). So, where the formalists in Chapter 8 will define style in terms of only the formal elements of visual culture, on Hadjinicolaou's Marxist account, style is both form and content. Antal continues by saying that

> the theme, the subject-matter of a picture, shows more clearly than anything else how completely the picture as a whole is but part of the outlook, the ideas, of the public, expressed through the medium of the artist.
>
> (Ibid.)

The subject-matter, then, as well as the form, of a picture expresses the ideology, the ideas, beliefs and values of a social class. For Hadjinicolaou, this is the first time that an art historian has adequately defined style and 'showed that style always belongs to a class or a section of a class' (ibid.).

He develops his account of style and ideology by arguing that style is 'visual ideology' and substituting the term visual ideology for style. On his account, then, visual ideology means

> a specific combination of the formal and thematic elements of a picture through which people express the way they relate their lives to the conditions of their existence, a combination which constitutes a particular form of the overall ideology of a social class. (Ibid.: 145)

Art and design are to be understood as visual ideology. The way people relate their lives to the conditions of their existence is through ideology, where ideology is defined as the ideas, beliefs and values that they hold. This means that paintings, for example, are to be understood in terms of the ways in which the form and the subject-matter express the ideas, beliefs and values (the ideology) of a social class. On Hadjinicolaou's account, art and design expresses the ideology of social classes. Visual culture is to be understood as expressing the ideologies of social classes. One consequence of this is that, where art historians have been accustomed to speak of 'individual style', 'regional style', 'national style' and 'the style of an epoch', the notion of visual ideology corresponds to the 'style of a social group' (ibid.: 246). As a part of the overall ideology of a social class, visual ideology goes beyond any particular painting, as well as beyond regional

or national territories, while at the same time being 'limited in time and space by each social formation' (ibid.). Where Hauser appears to simply associate style with large-scale economic and social formations, Hadjinicolaou ties style, understood as visual ideology, to social class. For him, art (and design, presumably) is visual ideology, the expression of a social class's ideas, beliefs and values.

Tim Clark

The work of Tim Clark represents a logical development on the work of Hauser and Hadjinicolaou in the conception of the relation between art, ideology and social class. In his *Image of the People*, published in 1973, Clark begins to describe and practise what he calls the 'social history of art'. In the first chapter of this work, Clark spells out what methods and subjects the social history of art should avoid. The first thing it should avoid, he says, is 'the notion of works of art "reflecting" ideologies, social relations or history' (1973: 10). Secondly, the social history of art should not present history as the 'background' to the work of art. Thirdly, Clark says the artist should not be conceived as responding to the

> values and ideas of the artistic community . . . which in turn are altered by changes in the general values and ideas of society, [and] which in turn are determined by historical conditions. (Ibid.)

Finally, the social history of art should not 'depend on intuitive analogies between form and ideological content' (ibid.). The first three points, that art should not be conceived and understood as either reflecting or expressing ideologies, and that art should not be conceived and understood as being determined by historical conditions, are clearly aimed at analysts like Antal, Hauser and Hadjinicolaou. The fourth point is slightly more complicated. Clark says, for example, that such analogies between form and content 'cannot be avoided altogether', and that it is better to work openly and critically with such analogies than to 'flirt with' and presumably be seduced by them (ibid.: 11).

This list of anathemas merely raises the question as to what should be studied by a social history of art. Is formal analysis, as proposed by Bell, Fry and Wölfflin in Chapter 8, simply and comprehensively to be discarded in favour of a 'radically restricted and empirical notion' (ibid.) of the social history of art? Such a restricted art history would

be limited to 'the immediate conditions of artistic production and reception: patronage, sales, criticism [and] public opinion' (ibid.). While these matters are important, while they are starting points for an art history, it is difficult to deal with any of them without quickly facing at least one of the four problems noted above. It is difficult to conceive, for example, of a study of patronage and sales that does not presuppose a 'general theory . . . of a capitalist economy' (ibid.). Attempting to understand paintings in terms of public opinion similarly leads the social history of art back to general questions concerning the relation of the artist, via that public, to historical conditions.

So Clark proposes that what he wants to explain in the social history of art

> are the connecting links between artistic form, the available systems of visual representation, the current theories of art, other ideologies, social classes and more general historical structures and processes. (Ibid.: 12)

He proposes that art be understood in terms of its relation to these things. While he is less than expansive on the identity of these 'more general historical structures and processes', he does say that he wants to get away from the notions that history is a simple 'background' and that artworks simply 'reflect' that background. He wants to criticise the idea, found in the work of Antal, noted above, for example, that history exists as a mere background to art. He says that he wants to discover the 'concrete transactions' which the conception of reflection hides (ibid.). And he wants to escape the notion that all art does is reflect or express ideologies. Clark proposes the idea that a work of art 'works' ideology (ibid.: 13). He says that a work of art may have ideology as its subject-matter, or 'material', but it 'works' that material. On this account, the work of art transforms ideology and in some cases it can even subvert it (ibid.).

Consequently, Clark's account of the three paintings which Courbet produced between October 1849 and summer 1850 – *The Stonebreakers*, *The Burial at Ornans* and *Peasants at Flagey* – concentrates on history and politics. Courbet's three paintings are presented as an intervention in a series of economic, political and social phenomena in France at this time. Clark describes how the French countryside was in turmoil during the period in which Courbet was painting these pictures. The main problems were economic (ibid.: 97). Farming was in crisis and there was mounting peasant debt (ibid.: 96). The bourgeoisie and the money lenders were contributing to the misery of the rural

poor and the money lenders in particular were seen by the rural poor as the cause of their mounting debts. Clark suggests that the problem was simple: that there were too many people and not enough land (ibid.: 95). And he describes the local politics of the time, including quotes from local newspapers and politicians and from popular almanacs (ibid.: 88). Courbet's work is presented as an intervention in these economic and political matters. It is presented as having an effect in these ideological debates. And it is presented as influencing the ways that people thought about the countryside, the sorts of people that lived and worked there and the justice of their various cases. Clark is trying to show that Courbet's work does not only reflect, or express, an ideology. Although Courbet is quoted as saying that he is 'with the people', that his sympathies lie with them (ibid.: 113), Clark suggests that the paintings 'articulate the history of Courbet and his family' and that this history is 'ambiguous' (ibid.: 114–15). The paintings are explained as an attempt to 'articulate' an ideological position, to work an ideology.

In his later work, *The Painting of Modern Life*, Clark's position on how art is to be understood has changed slightly. It may be thought of as an attempt to make more sense of the 'general historical structures and processes' that were left somewhat obscure in the previous book. In *The Painting of Modern Life*, Clark is in no doubt that economics is central. It may be that the structures and processes mentioned in the 1973 work are the capitalist economic structures and processes of the 1984 book. He says that his account of Impressionism will be in terms of 'class', 'ideology', 'spectacle' and 'modernism' (1984: 5): these are the concepts and ideas in terms of which Impressionism is to be understood. Presumably, these are the concepts in terms of which art, and visual culture in general, are to be understood in a historical materialist account of art (ibid.: 6). Moreover, economics, economic structures and processes, are now absolutely central to the understanding of art. As Clark says, in capitalist society, 'economic representations are the matrix around which all others are organised' (ibid.: 7). To this extent, Clark's later book may be said to be more Marxist, or, as he has it, more historical materialist, than the earlier one. Economics is not central to *Image of the People*, but it is to *The Painting of Modern Life*.

However, Clark is still very keen to distance himself from the 'vulgar' Marxism of people like Antal, Hauser and Hadjinicolaou. Vulgar Marxism conceives of the economic base of society as being made of 'sterner and solider stuff than signs' (ibid.: 6). Such Marxism

sees the base as being more fundamental than, and having a determinate effect upon, the sphere of ideology, the 'signs' mentioned by Clark here. Alternatively, Clark proposes explaining the social order as a form of classification, a means of establishing social 'solidarity, distance, belonging and exclusion' (ibid.). Solidarity, distance, belonging and exclusion are established by means of representations, or 'systems of signs', and Clark wants to argue that these systems of signs exist as a 'hierarchy of representations' (ibid.). Far from being more basic, or determining, than these systems of signs and representations, the economic realm itself is said to be a 'realm of representations' (ibid.).

Clark also follows Marx in his insistence that it is social class which is the 'determinant fact of social life' (ibid.: 7). Class being defined in terms of economics (a relation to the means of production), economic representations prove again to be the 'matrix around which all others are organised' (ibid.). As Clark says, it is not that one can simply read off a person's 'religious beliefs, voting habits, choice of clothes, sense of self, aesthetic preferences and sexual morality' from their class identity and class position. Things like choice of clothes and aesthetic preferences are separate and discrete 'worlds of representation', but all are 'constricted and invaded' by class (ibid.). These separate worlds are the 'systems of signs' of the previous paragraph, which exist in a hierarchy, and by means of which the social order is constructed. It is by means of choice of clothes, voting habits, religious beliefs, and so on, that one negotiates the 'solidarity, distance, belonging and exclusion' that makes up society for Clark. On this view, then, visual culture (art, fashion and aesthetic preferences in general) is to be understood as a set of representations. Visual culture here is understood as a sign system which ultimately produces and reproduces a class hierarchy, a social order. It has, that is, an ideological role.

Ideology is defined by Clark as indicating the existence of 'distinct and singular bodies of knowledge' (ibid.: 8). Ideology is not a collection of mistakes. Nor is it a set of images and ideas that are common and peculiar to a specific class. Thus paintings cannot be understood as pictures of mistaken world-views, nor as representations of belief systems belonging to specific class groups, on Clark's account. Ideology is knowledge and representation for Clark (ibid.). In a move that is not dissimilar to that made by Barthes in his (1973) work *Mythologies*, which is dealt with in the following chapter, Clark describes ideologies as having a 'naturalizing' function (ibid.). Ideology makes knowledge appear to be natural, rather than as having

been produced. Ideology makes meanings appear to be natural, rather than the products of

> special and partial social practice . . . tied to the attitudes and experiences of a particular social class, and therefore at odds . . . with the attitudes and experiences of those who do not belong to it. (Ibid.)

On this view, ideology denies that knowledge and meanings are the products of more or less antagonistic negotiations between social classes. Knowledge and meaning are experienced as if they were 'out there' in the world, rather than the products of differing and conflicting class positions.

Consequently, Clark understands paintings in terms of class. In his account of Manet's *Olympia*, for example, he says that 'class was the essence of Olympia's modernity and lay behind the scandal she provoked' (ibid.: 88). The painting looks the way it does because it 'indicates' (ibid.: 146), or argues, that prostitution involves matters of class, which is something that the bourgeoisie of the time did not want to be reminded of. The painting is to be understood in terms of social class and ideology, in Clark's account. The scandalised critics who, in 1865, denounced Manet's work drew attention to, and concentrated on, the way in which Olympia was painted: they were concerned with her lack of human form (ibid.: 92), they thought she was a 'sort of female gorilla' (ibid.: 94), they thought she was 'dirty' and looked like a 'cadaver', her charcoal outlines and greenish, bloodshot eyes 'provoked' the public (ibid.: 96). All these things are, for Clark, coded references to social class. They are the things that the critics said, and how they understood the painting, because they were 'perplexed' by the way the painting argued that sex and class were thoroughly 'in her body' (ibid.: 146). The nakedness, as opposed to the nudity, of Olympia is a 'sign of class', it shows that 'we are nowhere but in a body, constructed by it' (ibid.). And it shows that there is an economic relation, a class relation, in the social interaction between prostitutes and the bourgeoisie. As Clark says, 'the images of sickness, death, depravity and dirt' all carried the connotation of a lower social class, but the understanding of the painting went no further because the critics 'could not identify what in the picture told them where Olympia belonged' (ibid.). Manet's work indicates the place of prostitution in an ideology, in a network of ideas and beliefs concerning sexual and social (class) relations: to this extent it scandalises. The ideology of the bourgeois critics leads them to scandal and denunciation.

Gen Doy

Gen Doy's (1998) book *Materialising Art History* contains critiques of the authors covered so far as well as some positive suggestions for the project of a materialist, or Marxist, art history. Doy's argument in this book is much more complex and covers more issues than this chapter can usefully accommodate: the following paragraphs will therefore concentrate on the arguments and issues raised by the authors covered thus far.

The main thrust of Hauser's art history, as it was presented above, was his conception of art history as a succession of artistic styles. Each artistic style was presented in relation to the economy and society it was a part of. Doy argues that this aspect, the main aspect, is 'probably Hauser's weakest point' (1998: 69). It is weak because it is not dialectical. That is, Hauser's conception of style is not dialectical in that it does not allow for the possibility of conflict, or difference, within styles (ibid.: 66). It is also undialectical in that it does not allow for the possibility of conflict, or difference, within the societies that he presents as the background to the artistic styles (ibid.). Doy argues that, because Hauser cannot see that 'tensions and contradictions exist within so-called styles', he is forced to make an 'awkward and contradictory' case. In his account of the (neo-)Classical David, for example, Hauser claims that David's classicism is 'in harmony' with the Consulate and the Empire, that that classicism was 'found already created' by the 'bourgeois revolutionaries' in 1789 and that the 'real style' of the revolution was Romanticism (ibid.:). Had Hauser been able to suggest that tensions and differences exist within styles, such an awkward and contradictory understanding could have been avoided. Hauser was seen, above, to describe Impressionism as an aristocratic style, 'having nothing plebian about it'. He also said that it was created by the 'lower and middle bourgeoisie'. This, argues Doy, is to ignore the possibility that sections of society, class groups, may contain difference and contradiction (ibid.: 67). On Doy's account, it is a failing of Hauser's account that artistic styles are understood as a temporal succession of different meanings, rather than as containing different meanings at the same time.

As it was described above, the principal feature of Hadjinicolaou's art history was his notion of 'visual ideology'. What traditional art histories had understood as style was re-described by Hadjinicolaou in terms of visual ideologies belonging either to classes, or to fractions

of classes. It is this aspect that Doy identifies as problematic. She sug-
gests that Hadjinicolaou's understanding of art as visual ideologies
does not allow him to 'escape accusations of economic determinism'
(ibid.: 69). Economic determinism is the view that art, for example, is
the direct expression of a class's ideology. It reduces art, that is, to an
expression, or reflection, of a pre-existing and determining reality. In
what is called 'vulgar' Marxism's case, the pre-existing and determin-
ing reality is the economic base, the relation to the means of pro-
duction. So, on Doy's account, it is a weakness of Hadjinicolaou to
understand paintings as 'visualisations of the ideologies of class frac-
tions' (ibid.). However, this aspect of Hadjinicolaou's work is prob-
lematic because it contains aspects which should be retained, as well
as those that should be rejected. Hadjinicolaou's work represents an
advance on understanding art as a succession of styles, in the manner
of Hauser. It also represents an advance on understanding art as the
work of 'great individual geniuses', as expressionist accounts of visual
culture are wont to do. And it represents an advance on idealist
approaches to understanding visual culture which understand art as
the expression of the 'spirit of the age' (ibid.: 70).

Clark's attempt to develop a social history of art is treated at some
length and much more circumspectly by Doy. The feature of her
critique that is pertinent here, however, concerns the way in which
Clark presents art's relation to economics. It concerns whether Clark
understands art in materialist or idealist terms. Clark is accused of not
giving 'primacy' to the realm of the economic in *Image of the People*.
The economy is not mentioned in the list of objects and methods which
he thinks a social history of art should study. This absence of a concern
with the economic has been noted above and such an absence can
only indicate idealist tendencies. Clark also writes of the 'connecting
links' between 'artistic form ... systems of visual representation ...
ideologies [and] social classes', for example (Clark 1973: 12). Doy
understands these links in terms of 'mediations' and suggests that,

> [t]hese relations and mediations ... sometimes have the air of abstract his-
> torical processes which manifest themselves in material form so that we
> can perceive them ... rather than being seen as the product of human
> activity in social history. (Doy 1998: 77)

On Doy's account, then, Clark comes close to being an idealist in
his earlier work. In his later work, *The Painting of Modern Life*, Clark
also leans towards idealism, according to Doy. The problem in this
work is that Clark misconceives the relation between the 'material

world' and representations of that world (ibid.: 85). Doy says that the 'meaning of . . . representations can only be understood by relating them to material life', but that Clark argues that 'everything depends on how we picture the links between . . . representations and . . . "social practice"' (ibid.). For emphasising the 'conceptualisation' of representations, as opposed to their relation to material life, Clark is deemed to be dangerously idealist.

In her book *Materialising Art History*, Doy also ties her critique of Marxist traditions to another strand of thought that is pertinent to the understanding of visual culture, postcolonial theory. She wants to defend these traditions from the accusation that they have little to offer to the understanding of visual culture in terms of 'race' and culture (ibid.: 9). Postcolonial theory is a series of attempts to comprehend visual culture in terms of the relation between 'the West' and other, different, non-western cultures. It looks at visual production in the light of the inherited histories of imperialism, colonialism and slavery that characterise the West's relations with non-western cultures in the eighteenth, nineteenth and much of the twentieth centuries. Often beginning from the work of Said (1979, 1993) and Bhabha (1994), such analyses thematise the historical invisibility of ethnic and 'racial' issues and are interested in the ways in which the West constructs, makes sense of, or appropriates, non-western art and design. There are many ways in which this relationship may be approached. As Walker and Chaplin point out, artists like Delacroix and Ingres in the nineteenth century represented the East, the Orient, as essentially 'exotic', a collection of 'harems, odalisques, despots, the desert, mosques and so on' (Walker and Chaplin 1997: 39). Such a representation is criticised for being 'mythical and an aspect of European colonialism' (ibid.).

Doy's case begins by attacking postcolonial theorists for neglecting class. She points out that Said and Bhabha

> are keen to jettison notions of class since the postcolonial intellectual, exiled in the imperialist academies, is likely to be from the bourgeoisie or petty bourgeoisie of so-called 'Third World' countries. (Doy 1998: 211)

She also believes that much postcolonial theory does not understand the relation between gender, 'race', class and economics. For Doy, economics is primary:

> I would argue that we cannot fully understand particular representations of such notions as gender, 'race' and class if we do not ultimately attempt to locate them in specific economic conjunctures, and in the social relations which flow from these. (Ibid.: 215)

As this quote shows, for Doy, economics and social relations are primary, they are where 'race', for example, is to be 'located'. Consequently, in her account of Renée Green's mixed-media installation *Revue,* Doy draws attention to Green's project of trying to understand 'how black people ... were commodified' (ibid.: 242). This is an economic term and refers to the way capitalism makes people into buyable and sellable objects. Green's work, for Doy, does not only encourage the 'questioning of essentialism, but also [leads to] an awareness of history and social oppression' (ibid.: 243). Again, the analysis of the example of visual culture that is presented here is in terms of the social and social class. Finally, she points out that Green is 'a real-life woman in a particular economic, historical and cultural conjuncture both within the contemporary USA and within the world position of the USA' (ibid.: 244). Her analyses here are contrasted with those of Bhabha, for example, for whom, she says, economic and class-based analyses would be a 'minor consideration' (ibid.).

Griselda Pollock

The work of Griselda Pollock also contains implicit or explicit critiques of these Marxist and 'social history of art' traditions. One strand of these critiques concerns the way certain concepts in Marxist theory are to be understood, and another concerns a gap, or lacuna, in Marxist theory. Both have consequences for the understanding of visual culture. With regard to the first critique noted above, Pollock implicitly opposes Clark's account of representation in a way that prefigures Doy's. (She also explicitly comments on the work of Antal and Hadjinicolaou (ibid.: 27–30).) In her (1988) *Vision and Difference*, Pollock is interested in the way that cultural practices are defined and discussed as 'practices of representation' (Pollock 1988: 6). As such, representation is not understood as a mirror of the world, merely reflecting social reality. Instead, it is understood as a refashioning, a re-presentation, of one thing in terms of another thing (ibid.: 6, 28). Ideology has been understood in Marxist theory and in the social history of art in terms of representation. Pollock raises the problem, however, that 'ideology does not merely refer to a collection of ideas and beliefs' (ibid.). Ideology is not only representation, as some versions of Marxism and the social history of art (as practised by Clark, for example) would have it. Against this, Pollock argues that ideology refers to

material practices embodied in concrete social institutions by which the social systems, their conflicts and contradictions are negotiated in terms of the struggles between . . . the dominant and the dominated. (Ibid.: 7)

Such a critique, that art is to be understood as a material practice and as a part of the concrete struggles between unequal partners, prefigures Doy's criticism, noted above.

The second strand of Pollock's critique concerns a gap in the Marxist and social history of art approaches to understanding art. As Doy points out, Pollock has criticised Clark for 'paying little attention to gender' and to the ways in which women's oppression affects spectators, producers and consumers of art (Doy 1998: 101). As Doy also points out, however, Clark does indeed deal with women and gender oppression, but not in 'the feminist manner that Pollock would prefer' (ibid.). For Pollock, Marxism and the 'related discipline' which is the social history of art, suffer from what amounts to a blind spot when it comes to sexual and gender differences and their role in the production and consumption of visual culture (Pollock 1988: 5). So, while Marxism offers certain theoretical and historiographical advantages, its 'paternal authority' must be challenged. This is because, when they do not 'fall beneath its theoretical view', when they are not invisible to Marxist theory, 'sexual divisions are virtually natural and inevitable' according to this authority (ibid.). According to Pollock, sexual and gender differences are not usually seen by Marxism. When they are seen, they are seen as natural and inevitable. In neither case, then, do they have a role that should be investigated and explained in the production and consumption of art.

What Pollock proposes is a 'feminist historical materialism' (ibid.). Such a feminist historical materialism would not simply substitute gender for class as the main explanatory category. Rather, it would decipher 'the intricate interdependence of class and gender, as well as race, in all forms of historical practice' (ibid.). As an approach to the understanding of art, Pollock recommends paying attention to

the interplay of multiple histories – of the codes of art, of ideologies of the art world, of institutions of art, of forms of production, of social classes, of the family, of forms of sexual domination whose mutual determinations and independences have to be mapped together in precise and heterogeneous configurations. (Ibid.: 30)

Only by dealing with all of these separate and distinct histories can the complexity of the processes and relationships involved in the production and consumption of art be understood. Pollock believes that

such an approach will enable art history to escape the inadequate reflectionist and reductionist understanding of art as a simple vehicle of ideology (ibid.).

Elements of such a feminist historical materialist approach can be found in Pollock's account of Gauguin's and Manet's pictures of women. Comparing various paintings of women in bed, Pollock suggests that women like Venus and Danae are often accompanied by another woman (1992: 20). Moreover, the skin of the other woman, playing the role of 'death' to the younger and more attractive woman's 'sex', is often 'darker' than that of Venus or Danae (ibid.). Pollock uses this insight to understand Gauguin's and Manet's paintings of women in bed, *Manao Tupapau* and *Olympia*. The latter is understood in terms of an 'assertive modernity', which negates orientalism and refers to the 'working-class woman, displaced from her African home through colonial slavery and now in wage slavery' (ibid.). In this half-sentence, Pollock presents the painting as to be understood in terms of class, gender and postcolonialism. She says that, although Clark

> nods in the direction of feminism by acknowledging that these paintings imply a masculine viewer/consumer, the manner in which this is done ensures the normalcy of that position leaving it below the threshold of historical investigation and theoretical analysis. (1988: 53)

So, Pollock's understanding of *Olympia* has much in common with Clark's, but it adds the critical investigation and analysis of the position of the masculine viewer/consumer. Pollock's account of *Olympia*, for example, points out that 'the painting signifies commodity, capital's penetration of bodies and desires', but it also insists that it represents the 'spaces of bourgeois masculinity where working women's bodies are bought and sold' (1992: 35). Olympia is a 'gender other' to the bourgeois man who has the power to purchase pleasure, as well as a class 'other' (ibid.).

Strengths and weaknesses

Having considered the protagonists of the Marxist and social history of art approaches, the following paragraphs will investigate the strengths and weaknesses of those approaches to understanding visual culture. The strengths of Marxism and the social history of art are not dissimilar to those of the feminist approaches noted in the previous

chapter. Both, for example, involve the position of the viewer or spec-
tator in the business of understanding. The feminisms covered in
the previous chapter were seen to make the gendered position of
the viewer, spectator or user of design objects part of the process of
understanding. Marxism and the social history of art, as covered in the
present chapter, make the class position of the viewer or spectator
of art a part of the process of understanding visual culture. Clark
reported the views of the bourgeois critics of *Olympia* as a part of the
process of understanding that painting. Pollock adds gender and eth-
nicity to class as being constitutive of understanding. Similarly, Hauser
makes the social and economic conditions of the spectator part of
his explanation of different styles. And Hadjinicolaou proposes that
visual style is the ideology of different social groups. In all these exam-
ples, the position of the person doing the understanding has been
implicated into the process of understanding.

Marxist and social history of art approaches have also radically
changed the personnel and the institutions in terms of which art has
been understood, and they have changed the personnel that are part
of the understanding process. For example, where formalist art and
design histories do not approach art or design in terms of individuals
at all, Marxist and social history of art approaches posit an individual
who is a product of a class structure. Where expressionist approaches
to understanding art and design refer to a 'neutral' and 'innocent' indi-
vidual who is doing the expressing, Marxist and social-history-based
approaches will insist that that individual is, again, a product of a
class structure. In both these cases, the personnel, the individual, and
the type of individual, have been radically challenged by Marxist
and social history of art approaches. With regard to institutions, the
accounts covered in the present chapter have introduced criticism,
for example, to the process of understanding. In Clark's treatment of
Olympia, various institutions are used to construct an account of the
meaning of the work. Critics, social commentators and historians,
as well as journalists are all examples of the way in which different
institutions are implicated in the process of understanding in Clark's
account. Art criticism, journalism and social commentary are not
the sorts of institutions that are found in formalist, or expressionist
accounts of art and design, for example, and it must be a strength of
Marxist and social history approaches that new institutions and per-
sonnel are admitted to the account.

It is a major strength of these approaches, then, that they do not
allow the understanding of visual culture to be described as though it

were happening in a social or historical void. What is referred to above as the personnel, the producers and consumers, of art and design, is not above or beyond history and society. For Marxist and social history approaches, the class position of the producers and the observers has a constitutive part to play in the understanding of art and design products. The class position of the individual observing or understanding subject (which is defined in terms of economics for such approaches) has a constitutive role to play in that subject's understanding of visual culture. Those observing and understanding visual culture are not innocent or neutral. Similarly, the institutions in which the production and consumption of art and design take place are neither innocent nor ineffective. Art and design themselves may be considered as institutions that have a constitutive role to play in the way visual culture is understood. Where more traditional and uncritical approaches (in formalist and iconographical traditions, for example) may not consider art and design to be institutions that are worthy of investigation, Marxist and social history of art approaches will thematise these institutions and show their role in the under-standing of art and design. Pollock, for example, refers critically to the 'professional transvestism' that is normally 'required' of women schol-ars in art history (1992: 8). She discusses art history in terms of its being an institution that has gender and a 'colour'. Art history is an institution: in addition to a class identity, it has a gender and an ethnic identity. It is not neutral and innocent. These critical and self-critical aspects of the Marxist and social history approaches are, to repeat, among the major strengths of such approaches.

The weaknesses of these approaches will be investigated by looking at the question of whether they can understand forms of visual culture that are not fine art, paintings and sculptures. The present chapter, and these approaches, have been predominantly concerned with fine art, with paintings. Now, it may be possible to accuse Hauser or Hadjini-colaou of being unable to explain the social history of photography or crafts, by using their methods. It may also be the case that Clark has chosen a particularly appropriate, or 'easy' example of visual culture when he chooses to study the oil paintings of Courbet or Manet. And it may be that Marxist and social history approaches have trouble in understanding and explaining abstract art, furniture or tex-tiles. The following paragraphs will look first at the claim that the approaches covered in this chapter so far cannot easily understand and account for abstract art.

Doy has noted the 'tendency' of Marxist and social history of art approaches to avoid 'non-figurative/non-objective art', quoting Hadjinicolaou, who refuses to discuss abstract painting at all (1998: 173). Hauser's reluctance to deal with abstract art is attributed to an 'aversion' to discussing post-Revolutionary Soviet art, rather than to ignorance or politics (ibid.: 66). Max Raphael, however, provides an exception, discussing Picasso, at least. In her more sociological approach, Janet Wolff has suggested that abstract art, along with chamber music, does not seem 'amenable' to sociological analysis (ibid.: 173). And, echoing the suspicion voiced above, Doy suggests that Clark is 'happier' dealing with representational art, which is relatively easy to relate to social reality, than he is dealing with abstract art (ibid.: 87). With the exception of Raphael, then, the Marxist and social history of art approach is less than convincing on the matter of how abstract art may be understood. Doy implies that this is because representational art is 'fairly easy to relate to social reality' (ibid.). The reflection of a middle-class man standing in front of a bored barmaid, or the challenging stare of a working-class prostitute, for example, do indeed seem easier to discuss in terms of historically specific economic and gender roles than a triangular red shape on a black background, after all. However, Doy meets this challenge and devotes a chapter to Clark's account of Abstract Expressionism and to Malevich's *Black Suprematist Square* of 1913–15. The following will concentrate on her account of Malevich.

The work is, as the title suggests, a black square, 79.5 × 79.5 cm, painted in oil on canvas. Doy presents the work in terms of economics, class, history and gender, as well as in terms of more obviously formalist and expressionist concerns. Class and history, for example, are invoked when Malevich is said to have identified himself with peasant subjects and with the countryside during a period of political and social unrest between 1912 and 1916 (ibid.: 194). Malevich later identified himself with a form of 'blustering and ultra-left individualist anarchism' (ibid.: 192). The politics of the period is sketched in by Doy, the relations and activities of the Bolsheviks, anarchists and Communist Party politicians after the First World War being charted. Malevich is said to have scorned paintings of the female nude, and the *Black Suprematist Square* was made into a pillow and exhibited in a glass case in an attempt to criticise the 'masculine bias of modernist fine art' (ibid.: 195). More formal and expressionist concerns are apparent in the references to Malevich's claim that the natural world

should be seen as 'masses from which to make non-objective forms by intuitive feeling' (ibid.: 191).

As Doy says, none of these accounts is complete and much work needs to be done regarding all of them. However, it remains the case that the account provided above could be provided for any and all paintings produced at this time and place. It does not further the understanding of the painting to suggest that 'the painting itself is the result of a transformation of materials by labour' (ibid.: 196): there is a sense in which this could also be said of all but Conceptual Art works produced at any and all times. The elaboration provided, that this transformation results in 'an art work that is at the same time a material object and an embodiment of non-objectivity' (ibid.), could also be applied to all abstract works. The problem of how a Marxist or social history of art approach may be applied to the understanding of abstract art remains.

The question of whather a Marxist or social-history-type approach can help to understand furniture or textiles, for example, is less complicated. The work of Adrian Forty, while not explicitly a part of the Marxisms and social histories of art covered here, provides some idea as to how an approach based on social history might begin to understand design. In his (1986) *Objects of Desire*, Forty covers many aspects of design in social and economic terms. Furniture and textiles are both understood in terms of their relation to economic groups and processes. The production and consumption of printed and plain cotton textiles in eighteenth-century England, for example, is understood in terms of industrial processes, economic class and social status. Forty describes how, in the eighteenth century, printed cottons were popular with middle- and upper-class women (1986: 73). They were relatively expensive, owing to the production methods used, and seen as fashionable and affordable by these high-status women. With the expansion, and mechanisation, of the Lancashire cotton industry, printed cottons became cheaper and more easily affordable to working-class women. As a consequence, the middle- and upper-class women started wearing plainer, more expensive cotton dresses (ibid.: 75), in order to distinguish themselves from their inferiors. Forty also reports how the patterns printed onto the cottons were accorded higher or lower status, as they were associated with different social classes. Smaller patterns were thought to be middle-class, as opposed to the 'blotchy abominations' worn by the lower orders (ibid.: 76). These textiles, then, are being used by social groups to define and communicate their identities, and to distinguish themselves from

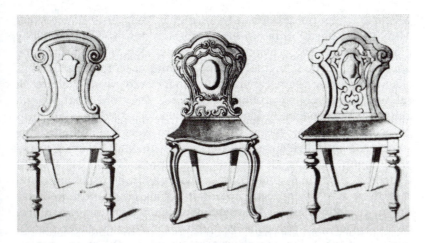

Figure 6.1 Hall chairs, *c.* 1850

other social groups. Furniture is also understood in terms of a relation to economic class, class identity, and to consumption. The nineteenth-century middle classes found that they needed somewhere for tradesmen to sit while they were dealt with. The hall chair, therefore, was developed; these had elaborately carved backs and turned legs but with a plain, flat seat (see Figure 6.1). The chair needed to be elaborate and decorative, in order to be fit to display in the hallway. But it did not need to be comfortably upholstered, because it was for the use of tradesmen. The way the chairs look, then, is understood in terms of class and consumption. A social class is using them to create and communicate a class identity, in opposition to other social classes in the social structure.

Conclusion

This chapter has introduced some of the principal representatives of Marxist and 'social history of art' approaches to understanding visual culture. It has tried to present these representatives as proposing a consistent and shared project; each representing something of an advance on the previous participant. Clearly, such a presentation of unity and agreement will not find favour with all those who support or practise a Marxist or social-history-based approach. However, it enables the chapter to introduce the principal features and methods,

which can then be developed by further reading. It is claimed that Marxist and social history of art approaches are most appropriately placed towards the structural end of the spectrum in which the approaches covered in the present volume are organised. This is claimed because these approaches understand visual culture in relation, ultimately, to economic structures. They understand visual culture as the product of class structures and class is defined in terms of economics in Marxism. Consequently, every reference to the subject, or an individual, should be read with Marx's advice to the effect that social being determines consciousness (1970b: 21). It is not that there is an individual consciousness (and understanding), and then there is a society made up of individuals, for Marxist accounts; rather the individual (and the individual's understanding) is a product of society. The individual is a product of social existence. Consequently, as with the approaches discussed in the next chapter, structure produces both the individual and the individual's understanding of visual culture.

Finally, as with the feminisms discussed in the previous chapter, the problem of reductionism must be noted. The gender-based approaches to understanding visual culture, the feminisms, of the previous chapter were seen to consider themselves in need of supplementing by an account of class. Judy Attfield's account of the domestic interior, for example, began with an account of gender but added an account based on class to it. Conversely, it is often argued that Marxism uses class to explain all social phenomena and that other accounts are needed to supplement that class-based account. Doy's version of a Marxist approach to understanding visual culture uses gender to complete the understanding of her examples. Pollock also introduces gender to her version of the social history of art. In both cases, then, there seems to be the recognition that all phenomena, even all visual phenomena, cannot be explained solely in relation to class.

Further reading

While this chapter has concentrated on the Marxist 'social history of art' approach, Marxist sources have been neglected. Georg Lukàcs and Louis Althusser are both major figures in the development of the thought of Hadjinicolaou, Clark and the others. Lukàcs's (1971) *History and Class Consciousness* (London: Merlin Press) is central here. Althusser's essays, 'Ideology and Ideological State Apparatuses',

'A Letter on Art in Reply to André Daspre (April 1966)', and 'Cremonini, Painter of the Abstract', in *Lenin and Philosophy and Other Essays* (New York and London: Monthly Review Press) are also of great importance in the development of the social history of art. Frederick Antal's (1948) *Florentine Painting and its Social Background* (London: Routledge and Kegan Paul) studies style in terms of the socio-economic organisation of society. But, as the title suggests, society is here conceived merely as a 'background' to art, an approach that is not seen as especially sophisticated by later Marxists. Walter Benjamin's essay 'The Work of Art in the Age of Mechanical Reproduction', in his (1970) *Illuminations* (London: Fontana), explores the idea that what the work of art loses in an age of mechanical reproduction is its 'aura', or feeling of authenticity. He also discusses the innovations and role of photography and the relation of modernity to fascist politics.

O. K. Werckmeister starts from Marx's comments in the Preface to *A Contribution to the Critique of Political Economy*, and the *Grundrisse* in his essay 'Marx on Ideology and Art', in *New Literary History*, vol. IV (Spring 1973). He goes on to look at the difficulties of formulating a Marxist history of art from Marx's writings and investigates the differences between Marx and contemporary Marxists on the role of art in culture and revolutionary change. Werckmeister's (1991) essay 'A Working Perspective for Marxist Art History Today', in *Oxford Art Journal*, vol. 14, no. 2, complains that Marxism has been adopted by the academy as one method among others. The previous chapter noted that Linda Nead made a very similar point concerning feminist approaches (Nead 1986: 121).

Margaret A. Rose's (1984) book *Marx's Lost Aesthetic* (Cambridge: Cambridge University Press) constructs an aesthetic theory from Marx's earlier writings, in the *Economic and Philosophical Manuscripts*, of 1844, for example, and uses them to consider nineteenth-century European painting, post-Revolutionary Russian art, and Leninism and Stalinism. Although he is dealt with in the present volume in the chapter on formalist and stylistic approaches, Clement Greenberg's essay 'Avant-Garde and Kitsch', in (1986) *Clement Greenberg: The Collected Essays and Criticism*, vol. 1, edited by John O'Brian, explains some of the differences between avant-garde art and popular, mass-produced trash in not always very well disguised Marxist terms.

John Roberts's (ed.) (1994) *Art Has No History!* (London: Pluto Press) has an excellent Introduction which presents the history and

main debates of art history and historical materialism. It also contains a plethora of useful bibliographic references. John Tagg (ed.) (1981) *Proudhon, Marx, Picasso: Essays in Marxist Aesthetics* (London: Lawrence and Wishart) contains Max Raphael's essay 'The Marxist Theory of Art'.

On the matter of postcolonial theory, Annie E. Coombes's essay 'Inventing the "Postcolonial": Hybridity and Constituency in Contemporary Curating', in D. Preziosi (ed.) (1998) *The Art of Art History: A Critical Anthology* (Oxford: Oxford University Press), introduces many more central concepts, considers western practices of displaying the art of the 'other', and discusses the *Magiciens de la terre* exhibition in Paris in 1989. Olu Oguibe's (1993) essay 'In the "Heart of Darkness"' (in *Third Text*, no. 23, pp. 3–8) considers the problems involved in ascribing the idea of 'modernity', a staple of western art-historical criticism, to the art of Africa.

Chapter 7

Semiology, Iconology and Iconography

Introduction

This chapter will consider the understanding of visual culture in terms of semiology and iconology. These approaches to visual culture use, or presuppose, a structural account of what understanding is. Developing the structural account of understanding that was introduced in Chapter 2, this chapter will consider various levels on which visual culture may be understood structurally, from the definition and explanation of the sign to the account of how meaning is produced. The work of Ferdinand de Saussure (1857–1913) and Charles Sanders Peirce (1839–1914) on the nature and definition of the sign and on the explanation of different types of sign will be used to introduce a structural account of visual culture.

Different types of structure have been used to explain the production of meaning in visual culture. Other chapters in this book present class and gender, for example, as structures in terms of which visual culture may be understood and made meaningful. This chapter will look at the work of Erwin Panofsky and Roland Barthes to illustrate how different structures have been employed to understand visual culture. Panofsky uses narrative structures in order to understand paintings, while Barthes uses structures of knowledge, epistemological structures, to explain how advertisements, for example, may be understood. This chapter will also consider the meaning of these items of visual culture in structural terms. It will show how different levels, or types, of meaning are employed by these theorists in explaining

how visual culture may be understood. And, most importantly, it will explain how those different types, or levels, are generated. The production of meaning will be explained in relation to structures, in terms of syntagmatic and paradigmatic relations between things.

These structural accounts are interesting in that so many of them understand themselves to be scientific in some way. Following on from the discussion in Chapter 2 of what understanding is, and how the sort of understanding possible in the natural sciences differs from that which is possible in the human sciences, it is fascinating to see the theorists of structuralism and semiology present their activities as scientific. In their different ways, both Saussure and Peirce conceive the semiotic enterprise as a scientific one: they both believe that the sort of understanding they can achieve is scientific. In the *Course in General Linguistics*, published after his death, Saussure says that

> a science that studies the life of signs within society is conceivable. . . . I shall call it semiology. Semiology would show what constitutes signs, what laws govern them. . . . Linguistics is only a part of the general science of semiology. (Saussure 1974: 16)

In his essay 'Logic as Semiotic: The Theory of Signs', Peirce presents logic, or semiotics, as a science. He says it is a 'formal . . . doctrine of signs'. In terms reminiscent of those used by the empiricists explored in Chapter 2, Peirce says that semiotics will be based on observation; observation will lead to abstraction and the production of 'fallible' statements concerning what 'must be' the nature and character of all signs used by a 'scientific' intelligence, that is, 'by an intelligence capable of learning by experience' (Peirce 1955: 98).

Panofsky adopts a slightly different approach. He presents his work in the history of art as a 'humanistic discipline'. He says that

> Man's signs and structures are records because, or in so far as, they express ideas separated from, yet realised by, the processes of signalling and building. (Panofsky 1955: 28)

This appears to indicate the fact that human signs and structures are meaningful in ways that natural phenomena are not, which was discussed in Chapter 2. However, he also believes that there are 'striking analogies' between the problems, the methods and the sort of understanding achieved by the humanist and the scientist. First, Panofsky says that

> while science endeavours to transform the chaotic variety of natural phenomena into . . . a cosmos of nature, the humanities endeavour to trans-

form the chaotic variety of human records into . . . a cosmos of culture.

(Ibid.)

Secondly, in terms of method, both scientist and humanist begin their investigations and proceed by way of 'observation' (ibid.: 29). And thirdly, as 'individual monuments and documents can only be . . . interpreted . . . in the light of a general historical concept' and vice versa, so 'the understanding of natural phenomena . . . depends on a general physical theory and vice versa' (ibid.: 32). Barthes also at one point conceived his semiological investigations as being scientific in some sense. As noted above, he thought of works such as *The Fashion System* and *Elements of Semiology* as being scientific. One look into these works, with their quasi-scientific terminology, their talk of 'Method', 'Species', 'Genera' and 'Classification' (Barthes 1983: v–viii, and 1967: Contents), for example, is evidence of the scientific 'dream' that Barthes seems to have been in at this time (Larrain 1979: 236).

The following sections, then, will present the main ideas and methods of structural and semiological accounts of visual culture. They will examine the nature of the sign, the nature of the meaning, and understanding, that these approaches pursue. And they will explain the production of meaning, again in terms of structures, in terms of the different sorts of relations between signs. The strengths and weaknesses of this approach must also be investigated. Some critics have suggested that, far from carrying out Saussure's promise to be the science of the life of signs within society, semiology has ignored society, or is incapable of reaching it at all. Such critics present structural and semiological approaches as a sterile formalism, unable to explain content. These points will be taken up in relation to Barthes's account of connotation and myth, which may be seen as his attempt to account for the phenomena that Marxist critics discuss in terms of class society and ideology. Other critics have dismissed structural approaches as 'immoral' (Wolff 1975: 50), because it ignores the human side, the role of the human subject, the individual producer and consumer of signs. The present chapter will discuss these issues in terms of a possible dialectic between the structural and the hermeneutic, with each being presupposed by the other. The work of Hebdige, who was seen in Chapter 3 to combine elements of a structural approach with those of a hermeneutic approach, and of Ricoeur will be presented here with a view to a more sustained discussion in Chapter 9.

The sign

Saussure and Peirce do not disagree fundamentally on the definition and nature of the sign. Saussure is concerned with the ways in which languages work and is first of all interested in the nature of the linguistic sign. This section will look at Saussure's account of the linguistic sign and show how it has been adapted for use in relation to visual culture. Saussure says that the linguistic sign is a 'unity', or a 'unit' (Saussure 1974: 65ff). It is a unit consisting of a signifier and a signified. The sign unites, 'not a thing and a name, but a concept and a sound-image' (ibid.: 66). He calls the sound-image the 'signifier' and he calls the concept the 'signified'. So, in language-use, the sounds one hears are signifiers and they signify, or stand for, concepts, or meanings. These ideas may be used to apply to visual culture, visual signs. The signifier may be thought of as any physical object which has been given a meaning. The signifier may be thought of as the material or physical vehicle of meaning. Thought of in this way, it is the sign's image as we are able to perceive it visually: it could be gestured, drawn, painted, photographed, computer-generated and so on. The signified may be thought of as the meaning that is associated with, or given to, the signifier. It may be thought of as the mental concepts or thoughts that come into one's head on seeing (or hearing, etc.), the signifier.

The most important aspect of Saussure's theory is that the relation between signifier and signified is 'arbitrary'. As he says, all of the rest of his structural linguistics follows from this one point (ibid.: 67ff). It might be suggested that much of what follows, semiologically, also follows from the idea of the arbitrary nature of the sign. What he is trying to explain is where value, or meaning, comes from. Meaning is not God-given, nor is it the gift of the individual. Meaning does not fall from the sky and it is pointless looking to history for the source of meaning. The link between signifier and signified is arbitrary: it does not matter which signifier signifies which signified so long as the community of sign-users agree. To this extent the relation is arbitrary. For Saussure meaning is, and can only be, a product of difference. Linguistic value for Saussure, and meaning for the semiologist, can only be the product of the diffrences between all signifiers and all signs, given the arbitrary nature of the sign. It should be noted that Saussure's sign is, to this extent, the same as Peirce's 'symbol', discussed below.

Peirce's account of the sign is not very different, although it is very differently expressed. For Peirce, a 'sign' or 'representamen' is 'some-

thing which stands to somebody for something in some respect or capacity' (Peirce 1955: 99). Peirce's basic idea, of one thing standing for, or representing, another thing, is the same as Saussure's idea. However, as a philosopher, Peirce is concerned with signs other than the linguistic: he wants to explain all signs and takes his account somewhat further than Saussure. When a person perceives a sign, it creates in that person's mind another sign, which he calls the 'interpretant'. The sign, he says, stands for something: this something he calls the 'object'. And the sign stands to somebody for something in some respect. There is something about the sign which makes it operate as a sign: this respect, he calls the 'ground' (ibid.). At this point, Peirce's account becomes incredibly complicated. Fortunately, the remainder is also largely irrelevant to the needs of this chapter (see also Hawkes 1977: 123ff). It is the relation between the sign and the object, the respect in which a sign represents its object, that is of most interest to students of visual culture. This is because this aspect of the sign enables Peirce to produce a more sophisticated typology of the sign than is possible with Saussure's account. Saussure is limited to one model of the sign: the sign is a unity of signifier and signified. Peirce argues that there are three different types of sign, corresponding to the three different ways in which the sign may relate to its object. The three different types of sign are 'icon', 'index' and 'symbol' (Peirce 1955: 102–3).

In an iconic sign, the relation between sign and object is one of 'likeness'. An iconic sign looks like, or resembles, the object it is the sign of. Thus, for example, a passport photograph of an individual is an iconic sign of that individual. A portrait of the President, or the Queen, is an iconic sign of the President or the Queen because, ideally, at least, it resembles them. In their different ways, photographs, diagrams, maps and some genres of paintings (like landscapes and portraits) are iconic signs. This is because the relation between the sign and the thing in the world is one of likeness or resemblance.

In an indexical sign, the relation between the sign and the object is an existential, or causal relation. The indexical sign is 'really affected' by the object, as Peirce has it (ibid.). So, for example, smoke is a visual index of fire. Indexical signs are often used in advertising: a haze on the horizon has been used as an index of heat in car advertisements, while sweat on a model's back or brow has been used as an index of exertion in anti-perspirant and soft drink advertisements. They are indexical signs because they are caused by the heat, or the exertion. The Eiffel Tower is an indexical sign of Paris and Gaudí architecture

is an index of Barcelona: both are indices in that they are existentially linked with those cities. In art, brushstrokes may be thought of as indexical signs of the artist's presence: they are caused by the artist. There is a sense in which all photographs are indexical as all photographs are caused, at one level, by the action of light on sensitive paper.

The symbol, for Peirce, is different again. (Peirce's symbol is also not necessarily the same as other people's symbols: he has a very precise definition of it.) Confusingly, Peirce's symbol is very similar to Saussure's sign, in fact. In a symbol, the sign and the object are connected or related by convention, or 'law' (ibid.). Here, a community of sign-users agrees that a particular sign will relate to a particular object: there is neither resemblance, as with the icon, nor causal/existential relations, as with the index, here. As with Saussure's sign, the relation between sign and object is 'arbitrary'. The red triangles on the bottles in Manet's painting *A Bar at the Folies-Bergères*, painted in 1881, for example, are symbols of the Bass brewing company. The trident on the front of some Italian sports cars is a symbol of the Maserati company. And the roses in advertisements for flower-delivery companies are symbols of love. In none of these cases has the sign been caused by the object, nor do they resemble the object. A community of sign-users has 'agreed' that the sign will stand for the object.

These categories are not mutually exclusive. Even as apparently simple a piece of visual culture as the sign for a 'crossroads' in the British Highway Code is at the same time an iconic, an indexical and a symbolic sign (see Figure 7.1). The red triangle around the outside of the sign is a symbol. According to the rules in the Highway Code, it means that the sign is a 'warning' sign, rather than an informative

Crossroads

Figure 7.1 Highway Code: 'Crossroads' sign, 1993

sign. The triangle does not look like a 'warning'. Nor has it been caused by a warning. The convention is that the red triangle means 'warning'. The representation of the crossroads in the centre of the sign is a mixture of icon and symbol. It is iconic in that its shape is determined by the shape of the object it represents: it is at least recognisable as a crossroads. And it is symbolic in that it does not look exactly like a crossroads: it could, conceivably, represent a Christian church, for example, or many other buildings. The point is that convention dictates that when this sign is seen, it is understood by the community of sign-users to represent a crossroads. Finally, the sign is indexical in that it has, in a sense, been caused to exist by the existence of the actual crossroads in the world. There is a causal, or an existential, link between the sign and the object.

Denotation and connotation

Denotation and connotation are the names of two different types, or levels, of meaning. Denotation is the kind of meaning understood when shapes, lines, colours and textures are understood as representing things in the world. It is the kind of meaning that is understood when the answers to the questions, 'What is that?', or 'What is that a picture of?' are understood. Denotation is often explained as the 'literal' meaning of an image. Connotation is slightly more complex. Connotation is often explained as the thoughts, feelings and associations that accompany one's perception of an example of visual culture. It is the feelings that a photograph makes one feel, the associations that a piece of design has, or the thoughts that come into one's head whenever one sees a particular typeface, for example. The *locus classicus* for the semiological presentation of these two levels of meaning is Roland Barthes's essay 'Rhetoric of the Image' in his (1977) *Image, Music, Text*. Barthes has more than one name for these different types or levels of meaning. Denotation is variously called a 'non-coded iconic message' (Barthes 1977: 36–7), a 'literal image' (ibid.) and the 'perceptual message' (ibid.). Connotation is variously called the 'coded iconic message (ibid.), the 'cultural message' and the 'symbolic' message (ibid.). (It should be noted that 'iconic' and 'symbolic' are not used in their Peircean senses here. 'Iconic' simply means 'to do with images', 'symbolic' means 'cultural'.)

In this essay, Barthes carefully and quite rigorously analyses an advertisement for Panzani pasta. He looks in detail at both denotation and connotation. He identifies signs, and analyses these signs in

terms of their signifiers and signifieds. And he explains the rhetorical, or naturalising function of denotation, the ways in which the apparent 'naturalness' of the denotative message leads a spectator to believe the entirely unnatural, culturally specific and historically located connotational messages. The account of denotation is fairly straightforward. Denotation is what one understands when one understands what the image is an image of. As Barthes says,

> I . . . 'understand' that it assembles in a common space a number of identifiable (nameable) objects, not mere shapes and colours. (Ibid.: 35)

Recognising shapes, lines, colours and textures as representing things in the world is understanding the denotational meaning of an image. The signifieds of denotation are 'the real objects in the scene'. The signifiers are 'these same objects photographed'. Together, they form denotative signs (ibid.). One does not need to know very much in order to understand these signs. One needs to know what an image is, and what a tomato, or a string bag, is, for example, in order to recognise and understand an image of a tomato. Barthes says that this knowledge is 'bound up with our perception', but that it is not nothing. He also says that it is a 'matter of almost anthropological knowledge'. But, he says, '[t]hat knowledge is not nil' (ibid.: 36).

(This ambivalence indicates a genuine problem concerning the very possibility of denotation. Barthes wants to argue that denotation, at least in photographs like the one considered here, is a 'message without a code'. He says this knowledge is 'bound up with our perception'. But he also seems to recognise that there can be no uncoded messages. As he points out, this knowledge is 'not nil': one has to learn to see an image, or to recognise pictures of tomatoes. It also seems unlikely that one can look at images without having feelings, or without making associations: it is not as though the connotation-producing elements of one's response to visual culture can be 'switched off'. This would be akin to negating one's life-world, or escaping from the horizons of the familiar in Gadamer's account of understanding, discussed in Chapter 2. Steve Baker develops these points in his (1985) essay 'The Hell of Connotation', arguing that denotation, as used by semiology, does not and cannot happen, but defending Barthes's use of the term as a purely analytic tool. If one must learn to see an image, then there can be no uncoded messages and, strictly, denotation cannot exist, except as a tool for analysing the workings of pictures.)

Connotation was explained above as the thoughts, feelings and associations accompanying one's perception of examples of visual

culture. Barthes identifies four connotative signs in the Panzani advertisement: he then analyses their signifiers and signifieds and explains what one needs to know in order to understand this level or type of meaning. The first connotative sign is the idea that 'what we have in the scene represented is a return from market' (ibid.: 34). The signifier of this sign is the half-open bag, with the contents spilling out onto the 'table'. The signified of the sign is twofold: the freshness of the products and the domestic nature of the scene. What is needed in order to understand this sign is some experience of 'shopping around for oneself', as opposed to other culturally possible ways of providing for oneself, going to the freezer, gathering nuts and berries, having one's food bought, cooked and prepared by servants, and so on. The second connotative sign concerns the Italianness of the products. The signifiers are the colours of the tomatoes, pepper and mushrooms, reds, greens and whites, and the 'tricoloured hues of the poster. The signified is 'Italy, or rather *Italianicity*' (ibid.). What one needs in order to understand this sign is 'familiarity with certain tourist stereotypes'. One needs to know the colours of the Italian tricolour and the stereotype of pasta-eating Italians.

The third connotative sign concerns the idea of a 'total culinary service'. The signifier, which Barthes does not provide, is the collection of items, the tins, pasta, sauce and vegetables. The signified is the idea that Panzani provides everything one needs for the dish to be prepared. Barthes does not tell us what is needed in order to understand this sign. It seems likely, however, that some knowledge of 'one-stop' shopping, or of those brands which enable the shopper to put together an entire meal from their products, would be useful here. Finally, the last, and most obscure, connotative sign which Barthes identifies concerns the graphics, the layout or 'composition of the image' (ibid.: 35). The signifier here is the arrangement of the items in the scene, and the signified is the idea of *nature morte*, or still life. What one needs to know in order to understand this sign is, as Barthes says, 'heavily cultural'. One needs to have some idea of traditions of western art, where the still life is a recognised genre.

Denotation and connotation are not only applicable to graphic, painted or photographed images. Other examples of visual culture may be analysed and explained using these ideas. As Barthes has also pointed out, all kinds of three-dimensional design, such as furniture, product, fashion, textile, automobile and interior design, may be understood in terms of denotation and connotation (see Barthes 1967: 25–31, and 1973: 88–90, 97–9). Clothes, cars and vacuum cleaners, for

example, are advertised, bought and sold almost wholly on the strength of the connotations they hold for sections of the market. One of the ways of interpreting Lunt and Livingstone's insights (1992), as reported by Tim Dant is by pointing out that items like CD players and hi-fi systems have youthful connotations while items like washing machines, computers and microwave ovens have connotations of the family (Dant 1999: 30). There is often not much difference in terms of denotation between items, yet the connotations of those items may be utterly different. In terms of denotation, the BMW 3- and 5-series are virtually indistinguishable. Both have much the same body shapes and sizes; the curves are all of similar radius; the wheels, door handles and wiper blades are visually much alike. And yet the connotations of the two series are somewhat different. The 5-series has connotations of a more discerning, mature, or at least older, driver. The 3-series has yet to escape the connotations it picked up, and which Audi have successfully satirised in their advertising, in the 1980s, of the ignorant, aggressive 'Yuppie'.

These, then, are denotation and connotation as explained by Barthes in his essay 'Rhetoric of the Image' and as applied to other, three-dimensional, forms of visual culture. According to Barthes, they are different levels or types of meaning and require slightly different things in order to be understood. It is plausible to suggest, with Baker (1985), however, that there is no connotation-free perception of visual culture and that even denotation requires some culturally specific knowledge in order to be understood. Consequently, on such an account, they are not different levels or types of meaning – first and second level, as Barthes calls them – and they do not require different types of knowledge in order to be understood. They may, however, as Baker says, be separated for analytical purposes.

Structure: narrative, syntagm and paradigm

The notion of structure is clearly central to the semiological account of understanding. Barthes's account of connotation presupposed the use of various structures in order to explain how the understanding of the advertisement was possible. There were art-historical structures, made up of different genres of paintings, and historical sequences of paintings. There were structures of tourist stereotypes, with different nationalities and their characteristics. There were different ways of ensuring that one was fed. Each of these things exists, and is mean-

ingful, only within a structure. As a direct result of the arbitrary nature of the sign, which says that the meaning of a sign is a product, not of its own properties, nor of authorial or artistic intention, but of its difference from all other signs, each sign is meaningful and understandable only within those structures of differences. It is the relation to all other signs, the way a sign differs from all other signs, that generates the meaning of that sign. The following paragraphs will explain what is meant by structure.

A structure is essentially a system of differences, or relations. A sign relates to, or differs from, other signs in two ways. Semiology calls these two relations, or differences, syntagmatic and paradigmatic differences or relations. Syntagmatic difference is the difference between things, signs, that come before or after one another. Paradigmatic difference is the difference between things, signs, that can replace one another. These relations, or differences, sound difficult, but practice will make them both familiar and useful. A good way of introducing these sorts of difference is by using a menu. Syntagmatic difference explains the relations between the Starter, Main and Sweet courses. These things, 'signs', come before and after each other and you will appear rude or ignorant (change the meaning of the signs) if you ask the waiter for them in the 'wrong' order. Paradigmatic difference explains the relations between the choices offered within any one of these courses. These things, 'signs', are not consumed one after the other, they may replace one another and you will attract unwanted attention (produce a different meaning) if you try to eat three main courses one after the other. With syntagmatic difference the relation between signs is expressed in terms of 'this, and then this, and then this'. With paradigmatic difference, the relation between signs is expressed in terms of 'this, or this, or this'.

Visual culture may also be understood in terms of these differences and relations. A comic strip, for example, is a good example of both sorts of difference. In any comic strip, from 'Peanuts' to 'AD 2000', individual frames come before and after each other and there are individual frames which contain one or more actions. Any comic strip will, therefore, contain syntagmatic and paradigmatic relations. The understanding of these comic strips is wholly dependent on syntagmatic and paradigmatic differences. Changes in either the syntagmatic or paradigmatic relations will affect the understanding of the entire strip. Film and television are also heavily dependent on syntagmatic relations. Most films and television programmes are structured in such a way that there is a beginning, a middle and an end. Film directors

sometimes play around with the syntagmatic structure by introducing flashbacks, or by showing the main climactic event first, and then explaining how it came about, or by deliberately mixing up periods of time. The most serious attempt to change the meaning of a film by changing the syntagmatic order in which events in the film are seen, or of demonstrating how syntagmatic difference constructs the meaning and affects one's understanding of a film, was the 1997 Taiwanese film *Blue Moon*. This film consisted in five reels, to be shown in any order. Clearly, if the order in which the reels are seen constructs the meaning of the film, then there will be a total of 120 films to be seen here, each to be understood in a different way.

Although any comic strip could be used here, the workings of syntagmatic and paradigmatic difference may be seen very clearly in an extract from a picture story that appeared in *My Guy* magazine (Figure 7.2). In this frame, we see a young man and a young woman looking at each other. She is saying that she is upset because she is in love with him and he has to return to Germany. He appears to be

Figure 7.2 Single frame from *My Guy*

unperturbed by her predicament. Apart from this, there is not a lot to understand here. What is needed in order to understand more of the meaning of this frame in the comic is what comes before and after the frame. What has led to these people being here in this way? What are the consequences of this snatch of dialogue? How do they resolve the situation? To know what comes before and after the frame is to know the syntagm, or sequence, that it exists within. It would also help if we knew why he has to go to Germany. Why is this appropriate behaviour? Why does he say, 'That's the luck of the draw'? Has there, perhaps, been some lottery? If she is so in love, why not move to Germany? Can she not resign cheerfully to her inevitable return? Maybe she could read a book instead? Relocation, resignation and reading are the paradigm from which a choice has to be made: each of the actions could potentially replace each of the others. To know why she has chosen to perform this particular action and not the others, and to see what has happened before and after the frame, is to understand much more about this frame.

Looking at the reproduction of the whole page (Figure 7.3), we can see what comes before and after this piece of dialogue. What comes before Figure 7.2 is that the couple have met on holiday. It is their last evening together. She is attracted to him and wants to take the relationship further. What comes after Figure 7.2 is that the young woman realises that her new friend is not German, but English. His use of colloquial English has given him away as a native speaker. Now we have more of the syntagm, we understand a lot more about the individual frame. We also see why cheerful resignation, reading a book or relocation are inappropriate things to do. Knowing more about the paradigm, and why the actions are chosen, also helps us to understand the meaning of this particular frame. On the next page, which reveals more of the syntagm, she is thrilled to learn that he is English as she thinks it means they will be able to keep in touch. The crucial piece of syntagmatic knowledge, which is not revealed until the penultimate frame, is that, although he is English, he really does live in Germany and that therefore they will probably never see each other again. The meaning of the individual frame changes as it is viewed in the context of the changing syntagm. The syntagmatic and paradigmatic relations here clearly enable the understanding of the images in the strip. It is this structure of differences, differences between signs that come before and after each other and differences between signs that may, or may not, replace one another, that enable the understanding of visual culture.

Figure 7.3 Whole page from *My Guy*

Syntagmatic and paradigmatic relations may be seen to enable the understanding of other examples of visual culture. The history of art, and the history of design, may be thought of as providing syntagms. They provide sequences of images, or objects, which come before or after each other. Much energy is expended making sure that the sequence is correct. This concern with syntagm may be seen on the level of individual artists and designers and on the level of movements and schools of art and design. Art and design historians are often very concerned to show that the early work of an artist or designer is different from the late work of that artist or designer. They talk of 'early' and 'late' works and so on. Other art historians are concerned to chart the ways in which Mannerism follows the Renaissance and is itself followed by the Baroque, or by the way in which Art Nouveau follows Post-Impressionism and is in turn followed by Cubism. Artists, designers, movements, schools and styles are all arranged into syntagms by art and design historians. The meaning of these artists, designers, movements, schools and styles is generated or produced by their places in these syntagms. Consequently, these elements are understood by virtue of their places in the syntagms.

Alternatively, these styles may be thought of as replacing one another. They may be thought of in terms of the paradigmatic choices available to artists and designers. The various styles available (realist, impressionist, futurist, vorticist and so on) may be thought of as a paradigm, from which a selection must be made. The meaning, and the understanding, of the work produced will change as one or other style is chosen in which to execute that work. In art, brush-strokes may be visible or invisible, photography may be in-focus or out-of-focus, it may be in colour or black and white, paintings may or may not employ or emphasise perspective, they may be abstract or representational. In design, curves may be of large radius or small radius, textures may be shiny or matt, colours may be pastel or saturated, the designs may adopt a 'techno' or a 'retro' look. In typography, the design of typefaces, elements of letters, may be considered, and the production of meaning understood, in terms of syntagms and paradigms. Upstrokes, for example, may be thick or thin, ascenders and descenders may be long or short, serifs may be present, as in Roman types, or absent, as with Futura types. If present, they may be large, as with Slabserif designs, or small, as in Bodoni, or ornamental, as with Tuscan styles. The range of ascenders or upstrokes may be explained as a set, or paradigm, from which a choice must be made. The finished, or complete, typeface may be thought of as a syntagm: the entire letter being

thought of as a whole, analogous to a sentence, for example. All these elements exist as paradigms and choice in each of them will influence the understanding of the work, or syntagm, produced.

Panofsky's account of painting in terms of iconology and iconography also employs structures to understand visual culture. His account bears some resemblances to that of Barthes, noted above. Panofsky proposes three levels of meaning, three ways in which paintings may be understood. He calls them 'pre-iconographical description, iconographical analysis and iconological interpretation' (1955: 58). Pre-iconographical description, the primary level of understanding, consists in recognising that lines, colours and volumes in images represent objects and events. On the basis of 'our practical experience', 'everyone can recognise the shape and behaviour of human beings, animals and plants' (ibid.). This level seems to correspond to Barthes's account of the knowledge that is 'bound up with our perception', noted above (Barthes 1977: 36), and it shares the same problems. For example, Panofsky says that 'everyone' can recognise the shapes and behaviour of humans. This ignores the fact that people have to learn how to recognise images, and images of people in paintings. If this has to be learned, then it must be cultural and subject to variation in time and space. Panofsky refers to Rogier van der Weyden's painting the *Three Magi*, in which 'a small child is seen in the sky'. In the painting *Christ Resurrecting the Youth of Nain*, an entire town appears to be floating in the sky (Panofsky 1955: 59–60). It is impossible to explain the differences between these floating things in pre-iconographical terms because in terms of the shapes and lines in the paintings, the same thing is happening. Recourse to a more sophisticated level of understanding is required in order to explain one (the floating baby) as a miracle, and one (the floating town) as a pictorial convention.

Iconographical analysis relates these motifs, these human beings, animals and plants, for example, to structures. Panofsky says that this level of understanding deals with 'stories and allegories . . . themes and concepts' (ibid.: 61). On this level of understanding, then, a painting is understood when the things, human beings and objects in it are linked to stories, characters in those stories, concepts and so on. Panofsky uses Leonardo da Vinci's painting *The Last Supper*, to illustrate this point. Understanding on the iconographical level is achieved when the humans in the painting are connected to the story of Jesus Christ's life as narrated in the New Testament and to the concepts that are part of Christianity. Thus, when one understands that the central character is Jesus, the person in profile three to his right is Judas and

that concepts like betrayal and fidelity are central to the Christian story, one begins to understand the painting. The painting is connected to the text, the Gospel of St John 13: 21, in Panofsky's account, and to the narrative structure of that text. In virtue of these connections, the painting may be understood. As with Barthes's account of denotation, unless one knows these stories, concepts and so on, one is unlikely to understand the painting: understanding the painting depends upon knowing the stories, concepts and so on.

Iconological interpretation relates the stories, concepts, themes and allegories found in the iconographical account to the underlying principles of nations, periods of time and people (ibid.: 64–5). It uses these concepts, stories and so on to give clues to the underlying nature of the times and places in which paintings are produced. On this level of understanding, paintings are regarded as

> documents bearing witness to the political, poetical, religious, philosophical and social tendencies of the personality, period or country under investigation. (Ibid.: 65)

This is the most demanding level of understanding and Panofsky implies that it requires the most work. There is no text to which one can go to find the underlying principles of nations, periods or characters. Rather, one must reconstruct them sensitively and intuitively (ibid.: 64). This level of understanding is made possible by a special 'diagnostic' mental faculty (ibid.), which one must exercise carefully. It is thus not available to everyone, but is 'conditioned by personal psychology and "*Weltanschauung*"' or 'world-view' (ibid.: 66). To describe this level of understanding in slightly Gadamerian terms, one's insight into the political, philosophical, religious and social tendencies (the world-view) of the place and time whose art works one is investigating, is conditioned by one's own world-view. As in Barthes's account of connotation, then, this level of understanding operates through placing elements of the art works into the social, philosophical, religious and political contexts, or structures, of the times and places one wishes to understand.

Strengths and weaknesses

It is, however, the impact and role of the social, historical and political contexts in which the objects of semiological study are found that causes problems for semiology. As noted in the introduction to this

chapter, there are those critics who consider that semiology is incapable of accounting for the role of the social, the historical and the political. Terry Eagleton is a good representative of these critics. He argues that structuralism and semiotics 'contained the seeds of a social and historical theory of meaning, but they were not . . . able to sprout' (Eagleton 1983: 109). Saussure asserts the right of semiology, the science that studies the life of signs within society, to exist, but semiology does not take up the challenge of providing a satisfactory account of either society or historical change. Semiology has two conceptions of time, neither of which are sufficient, for critics like Eagleton, to the task of explaining historical change. Structuralism and semiology study systems or structures of signs 'synchronically', as those structures exist at the particular moment they are being studied. This is methodologically necessary, given the idea that the relation between signifier and signified is 'arbitrary': the only source of meaning is the structure of differences between signs as they exist for a sign-using community at the moment that that community is using those signs. The structure of differences, as it existed last week or last century, is, strictly, irrelevant to the structure of differences as they exist at the moment they are being studied (see Barthes 1967: 98). Diachronic difference is the name for the difference between the structure as it exists in different moments of time and Eagleton says that semiology's treatment of historical change is merely to show one synchronic system following another (Eagleton 1983: 110). This is not, for such critics, a satisfactory account of history and historical change.

That this is a serious criticism of the use of semiological approaches in the understanding of visual culture is clear. It is also one that a quick reading of some semiologists does little to dispel. In the Conclusion to his *Elements of Semiology*, Barthes says that the objects analysed and examined by semiological research are dealt with only in terms of their own meaning (Barthes 1967: 95). He says that fashion, for example,

> evidently has economic and sociological implications; but the semiologist will treat neither the economics nor the sociology of fashion: he will only say at which level . . . fashion economics and sociology acquire semiological relevance. (Ibid.: 96)

This might be read as a call to downplay, or even ignore, the social and economic aspects of fashion. However, Barthes also says that other factors, like the sociological, are not to be introduced 'prematurely', they are not to be introduced before the structure in which

fashion is meaningful, for example, has been properly constituted and described (ibid.: 95). These factors must themselves be treated semiologically: 'their place and function in the system of meaning must be determined' (ibid.: 96). What Barthes is proposing is that these other factors, which must include history and politics alongside sociology and economics, must be studied as well as the meaning of elements of visual culture. The 'place and function' of historical, sociological, economic and political factors in the meaning of visual culture cannot be neglected. But these factors must be placed in relation to the construction of the meaning of the examples of visual culture. This is emphatically not to ignore, or downplay, these other factors.

The idea that semiological approaches have little conception of society and politics also has some force. For Eagleton, semiology conceives of society only as a 'monolithic structure', which has little room for the specificities of 'concrete social individuals': semiology is interested 'not in what people actually said, but in the structure which allowed them to say it' (ibid.: 114). Moreover, it presents the behaviour of individuals as freely chosen, rather than as being socially and historically located and rather than as interacting politically with others, who are in turn similarly socially and historically located. There is no room for an account of visual culture which is 'inevitably social' and 'dialogical', which ties individuals into a 'whole field of social values and purposes' (ibid.). Semiology lacks, then, an account of visual culture where the individuals using that visual culture are socially and historically located, where that visual culture is used to negotiate social and historically located tasks and struggles. It lacks, in short, a theory of what Marxists call ideology. Eagleton argues that it is not simply a matter of asking 'what a sign means'. It is, rather, a matter of

> investigating its varied history, as conflicting social groups, classes, individuals and discourses . . . [seek] to appropriate it and imbue it with their own meanings. (Ibid.: 117)

Following Volosinov/Bakhtin, Eagleton says that signs are not contentless, formal markers of difference, they are 'the very material medium of ideology' (ibid.).

Again, these are serious criticisms. However, it is again worth looking at the work of Barthes for a response. In his *Mythologies*, Barthes is explicitly concerned with history, and with the ways in which history gets turned into nature. He is concerned with the work

of ideology. The way he gets at ideology is through his conception of connotation, as described above. What Barthes calls 'myth' in the essay 'Myth Today' is a form of his idea of connotation: a form of connotation that attempts to deal with the social, political and historical factors which critics say are ignored by semiology. Barthes's famous example is of the June 1955 cover of *Paris-Match*. He describes the image on the cover in terms of denotation:

> a young Negro in a French uniform is saluting, with his eyes uplifted, probably fixed on a fold of the tricolour. (Barthes 1973: 116)

He then describes the image in terms of its connotations:

> that France is a great Empire, that all her sons, without any colour discrimination, faithfully serve under her flag, and that there is no better answer to the detractors of an alleged colonialism than the zeal shown by this Negro in serving his so-called oppressors. (Ibid.)

Although, as Baker points out,

> the French West African Troops, of which the boy was an *enfant de troupe*, played no part in the Algerian war, Barthes rightly acknowledges that events in Algeria would have influenced a French audience's reading of the photograph in June 1955. (Baker 1985: 170)

Among the events in Algeria at this time was an intensification of the activities of the Algerian FLN, fighting against France. In May 1955, for example, the FLN had destroyed an army convoy and murdered a French administrator. The French governor-general's response was to ask the government for ten more battalions of men (ibid.). The connotations of this image, as Barthes describes them, have a place in social, political and historical contexts. They are an intervention in those contexts. What Barthes wants to do in his treatment of the connotations of this image is to show that they have an ideological function. In the midst of the ethnic and colonial conflicts that were taking place at this time, the connotations of the image are that 'all France's sons, without any colour discrimination, faithfully serve under her flag' (Barthes 1973: 116). The image is supporting and communicating an ideological message that denies the conflict and asserts that all is well colonially and ethnically in France and her Empire. What is more, for Barthes, it does this in a way that purports to be innocent: it does it in a way that does not appear to be the work of historically and politically located individuals. Nevertheless the image clearly is, or Barthes can read it as, the work of historically and politically located and inter-

ested individuals. These people exist in concrete political and histori-
cal struggles. They have arguments concerning those concrete strug-
gles and circumstances to communicate. These are people who want
to communicate the message that France's sons faithfully serve the
Tricolour and that the unrest and war is misguided.

For Barthes, though, the image works ideologically. It tries to pass
itself off, not as the politically specific, or located, work of historically
and politically located individuals, but as something eternally true, as
innocent, or neutral. In this way it attempts to turn history into nature.
It attempts to say that this message is a natural, and therefore correct,
message. It attempts to hide its historical and political specificity
because that is to encourage the idea that its message is contingent
on local historical and political differences. Connotation, or 'myth' as
he has it here, is the way in which that naturalisation is carried out:
'the very principle of myth is that it transforms history into nature'
(Barthes 1973: 129). As Barthes says,

> [s]emiology has taught us that myth has the task of giving an historical
> intention a natural justification, and making contingency appear eternal.
> Now, this process is exactly that of bourgeois ideology. (Ibid.: 142)

The historical intention here is to communicate the idea that France
is a great Empire and that her sons serve the flag loyally, whether they
are black, white, Algerian or French. The ideological function of the
image is to communicate and support this message. The way it does
this is to make the (political, historical and social) message appear to
be natural and eternally true. In the light of this, it may seem churlish
of Eagleton to say that structuralism and semiotics concede a conno-
tative dimension but shrink from the 'full implications' of that dimen-
sion (Eagleton 1983: 122). In drawing critical attention to the ways in
which images attempt to turn the work of history into nature, in
drawing attention to the constructed and historical nature of what
purports to be innocent and natural, Barthes is trying hard to make
his account of myth and connotation do some serious ideological work
in this essay.

However, it is undeniably a strength of structural and semiological
approaches that they can be used to understand any and all examples
of visual culture. It was noted above, in the section on denotation and
connotation, that these ideas could be applied to all kinds of graphic
images: painted, drawn, photographed and computer-generated
images are all available to structural analysis and understanding.
Barthes also points out that all kinds of three-dimensional design,

including furniture, product, fashion, textile, automobile and interior design, may be understood in structural terms (see Barthes 1967: 25–31, and 1973: 88–90, 97–9). Architectural design, along with fashions, clothes, cars and most household goods, for example, are advertised and may themselves be understood in terms of the structures of denotation and connotation and of syntagm and paradigm. Whether this is due to the influence of what Vico, Lévi-Strauss, and Jameson refer to in their different ways as the permanent structures of the human mind, is not clear. Vico argues that people can understand 'civil society' because that society has been made by humans and 'its principles are therefore to be found within the modifications of our own human mind' (Vico 1968: 96). Much of the work of Lévi-Strauss implies that the structures found in the world (binary oppositions, metaphor/metonymy, for example) are somehow indicative or reflections of the very workings of the human brain. And Jameson has argued that structuralism is nothing less than a search for the 'permanent structures of the mind itself' (1971: 109). These thinkers share the idea that the world and its contents, including visual culture, may be understood because it is somehow homologous with, the product of, the structures of the human mind.

Conclusion

By way of a conclusion, this chapter will consider one final issue which might be considered a problem for a structure-based understanding of visual culture. Being a structure-based account of how understanding works, the above pays little attention to the role and place of the individual in understanding. In these structural and semiotic accounts of visual culture, there has been no mention, for example, of individual intention. The beliefs, hopes, fears and desires of human subjects as they go about understanding visual culture have not been any part of the explanation. There is a distinct sense in which, far from being the starting point for understanding, the subject, or individual consciousness, is in fact the product of structural understanding. In a way that is the exact mirror image of what has been seen in Gadamer's Heideggerian account of understanding (where human beings were said to be their understanding of the world), the structural account posits the individual as the product of the structures that are used in understanding. In semiology, the human subject seems to be little

more than the product of the structures that are used in understanding visual culture. So, the problem is that it seems counter-intuitive to explain understanding without an individual subject that is doing the understanding.

Whilst not going as far as Janet Wolff, who has suggested that structuralism is 'immoral' because it does not give 'primary importance to the dignity of the individual' (Wolff 1975: 50), Eagleton does say that a theory of meaning which 'seems to squeeze out the human subject' is 'very curious' (Eagleton 1983: 116). Equally, Eagleton is not suggesting that all the insights of semiology should be abandoned in favour of an approach such as that advocated by E. D. Hirsch, where intentions are thought of as central to understanding and conceived as 'essentially private "mental acts"' (ibid.: 114). What he is suggesting is that it 'seems impossible to eradicate some element of interpretation, and so of subjectivity' from the structural account of understanding (ibid.: 122). There has to be some moment of individual interpretation in order to first arrive at a set of signs in terms of which to begin and conduct one's understanding. Eagleton sees this as a consequence of the very notion of connotation that structural and semiotic accounts are keen to carry out. He says that 'the tone in which you say "Pass the cheese" can signify how you regard me, yourself, the cheese and the situation we are in'. There is an individual, subjective element to all cultural productions, visual and linguistic, and Eagleton thinks that semiotics has failed to consider the 'full implications' of this (ibid.).

What this conclusion would propose, then, is that there is a dialectical relation between structural and interpretative moments in understanding. That each presupposes the other and that neither can 'work' without the other. Hebdige used structural concepts in his essentially intention-led account of the meanings of Vespa and Lambretta scooters (Hebdige 1988: 85). Edmund Leach admits the 'intentional operations of the designer' into his structuralist account of Michelangelo's Sistine Chapel paintings (Leach 1977: 10). And Paul Ricoeur argues that 'there is no recovery of meaning without some structural comprehension' (Ricoeur 1974: 57). Leach, Hebdige and Ricoeur see a need to include the non-structural, the hermeneutic, the role of the human subject, in their accounts of structural understanding. They all posit the need for some kind of dialectic between the subject-based and the structure-based in their accounts of understanding. These points will be followed up in the Conclusion.

Further reading

Semiology is not very fashionable in visual culture circles at present. However, the best introduction to the ideas of Saussurean and Barthesian semiology is still Jonathan Culler's (1976) *Saussure* (Fontana/Collins). Parts I and II of Paul Cobley (ed.) (1996) *The Communication Theory Reader* (London: Routledge) contain readings from the main theorists covered here, and later Parts provide readings on cinema, advertising and *Dallas*. Umberto Eco's (1976) book *A Theory of Semiotics* (Bloomington: Indiana University Press) is not an easy book; it gives somewhat philosophical accounts of the sign, denotation and connotation. Alex Potts' essay 'Sign' in Robert S. Nelson and Richard Schiff's (1996) book *Critical Terms for Art History* (Chicago: Chicago University Press) summarises many positions in semiology in terms of art and sculpture. Norman Bryson's (1981) *Word and Image: French Painting of the Ancien Régime* (Cambridge: Cambridge University Press) uses some of Barthes's ideas concerning denotation and connotation to explain a range of art works. His work generally draws on structural and semiological traditions: see also his (1983) *Vision and Painting: The Logic of the Gaze* (London) and (1988) *Calligrams: New Essays in Art History from France* (Cambridge: Cambridge University Press).

The use of semiology in design is less common than it is in relation to art and painting. I am reluctant to recommend my own (1996) *Fashion as Communication* (London: Routledge), but Chapter 4 covers fashion as sign, denotation and connotation and in terms of syntagmatic and paradigmatic differences. Gunther Kress and Theo van Leeuwen's (1996) *Reading Images: The Grammar of Visual Design* (London: Routledge) offers a version of semiological analysis. It concentrates on graphic design, looking at advertising and, most interestingly, at what might be called everyday graphics – wedding invitations, newspaper layouts and the illustrations accompanying instructions and educational matter. This is not an introductory text and it pursues some complex terminologies.

Mikhail Bakhtin, who may or may not have written the book *Marxism and the Philosophy of Language* (Cambridge, Mass., and London, England: Harvard University Press, 1973) under the name of V. N. Volosinov, attempts to use structuralist and Marxist ideas in explaining meaning in language. He argues that words are not just semiological markers but that they have ideological functions. He does not deal with visual culture, however.

And the anthropologist Claude Lévi-Strauss has a fascinating essay on Poussin in his (1997) *Look, Listen, Read* (New York: Basic Books, Harper Collins). This essay blends a structural approach with a concern for the formal. There are also a few comments on art in his chapter 'The Science of The Concrete' in (1972) *The Savage Mind* (Weidenfeld and Nicolson).

Chapter 8

Form and Style

Introduction

In Chapter 2 it was suggested that the approaches covered in this book could be located at one or other point along a spectrum that had subject- or individual-based approaches at one pole and structure-based approaches at the other. It may not be immediately obvious where on this spectrum formal or stylistic approaches to understanding visual culture are to be located. By 'formal' is meant elements of visual culture that are said to be 'intrinsic' or 'internal' to the work; elements such as shape, line, colour, texture, and layout or composition. The word 'stylistic' refers to the treatment of these elements that is characteristic of an individual, artistic movement or school, period or nationality. Formal and stylistic characteristics of visual culture, involving colour and texture can plausibly be explained as the work of the individual artist or designer. It is the individual artist or designer who makes use of blue, or of shiny surfaces in a characteristic way. They can also be presented as the result of the understanding subject seeing them in the work. Different individuals will select, or favour, different formal characteristics of works to comment on.

However, this chapter will argue that the idea that visual culture is best understood in terms of form or style is located towards the structure-based end of the spectrum. It will argue that formal and stylistic characteristics may be conceived as structures, as collections of elements organised into meaningful structures and understood in terms of coded differences. Approaches that stress the roles of form and

style in understanding may be said to be concerned with the 'internal structures' of items of visual culture. They are interested in the ways in which colours relate to each other, or in the ways parts of a work relate to each other in the 'layout' or composition. This is to be concerned with the internal structures of visual culture, the ways in which elements of works relate to each other. Such a definition of structure is not incompatible with that implied by Roger Fry in his essay 'Art and Life'. In this essay, he says that Impressionism re-establishes 'purely aesthetic criteria' in terms of which to understand art, and rediscovers 'the principles of structural design and harmony' (1925: 12). What Fry is here calling 'design' is said to have a structure: the elements of a painting fit together into a structural whole or harmony. The sense of structure used in this essay also follows the definition developed in the previous chapter, on structuralism and semiotics.

The formalist critic Clive Bell argued that

> in order to appreciate a work of art we need bring with us nothing but a sense of form and colour and a knowledge of three-dimensional space.
>
> (Bell 1958: 28)

His understanding of a painting is presented wholly in terms of the formal characteristics of the painting; there is nothing outside the picture to distract us. Heinrich Wölfflin (1950), in art history, and Siegfried Giedion (1948), in design history, both eschewed the mention of named individuals in their explanations of visual culture, choosing instead to concentrate on the stylistic characteristics and qualities of images and objects. Wölfflin describes the stylistic differences between Classic (or Renaissance) and Baroque art in terms of five pairs of concepts. Each pair describes two opposed features, the linear and the painterly, for example, where one feature is characteristic of the Classical and one is characteristic of the Baroque. These five pairs of concepts form a structure and the formal and stylistic differences in the paintings are understood according to them. These formal and stylistic characteristics are the concepts in terms of which Classical and Baroque art is to be understood, on Wölfflin's account. In the essay 'Modernist Painting', Clement Greenberg (1993) attempts to understand centuries of art history in terms of the formal characteristics of paintings. The formal characteristic he identifies is that of 'flatness': 'starting in Venice in the sixteenth century', the history of painting may be understood in terms of a formal characteristic, increasing 'flatness', on Greenberg's account. More recently, Mary Acton (1997) has concentrated on the formal elements of

paintings in order to understand them. These writers will be presented as proposing that form and style are the basis for the understanding of visual culture.

The various weaknesses of an understanding based on the formal and stylistic features of visual culture must also be explained in this chapter. One weakness is that this approach to understanding visual culture neglects the different contexts in which visual culture exists and of which it is the product. It is possible to provide a complete formal analysis of an item of visual culture without once mentioning social class, for example, or gender. Both Wölfflin and Greenberg cover long periods in their study of the formal and stylistic characteristics of paintings without once mentioning the social class, or the gender, of either the producers or the consumers of those paintings. Bell is certainly mistaken if he argues that we need bring nothing from life in order to understand painting and it is difficult to see how such an approach could have anything interesting or even relevant to say about design. That these approaches neglect the various contexts of visual culture will be presented as a weakness: it will be argued that an understanding of class, gender and ethnic contexts, for example, is part of a satisfactory understanding of visual culture. It will be recalled from Chapter 2, above, that it was the formalist and stylistic (in the technical sense) critics like Morelli and Berenson who believed that their approach to understanding paintings was, or could be made, 'scientific'. This chapter will argue, first, that such object-based and, therefore, supposedly 'objective' accounts of visual culture are mistaken, and secondly, that they cannot have anything to say about the content of visual culture. The arguments concerning these supposedly 'objective' accounts of visual culture that were investigated in Chapter 5, on feminism, will be seen to apply to formalist and stylistic approaches.

The chapter will then consider the work of Dick Hebdige and Ted Polhemus. These writers are concerned with the formal and stylistic elements of visual culture, but their accounts of it are much more successful than Bell's and Wölfflin's, for example, in that they have something to say about its 'content'. Hebdige and Polhemus relate visual culture, fashion, to contexts such as class, gender and ethnicity. Their understanding of visual culture is not limited to its 'internal' structures and intrinsic formal properties. In his (1979) *Subculture: The Meaning of Style*, Hebdige associates styles with subcultures, and charts the ways in which youth cultures in post-war Britain create and communicate identities and values by means of fashion, clothing and music. Polhemus carries on this tradition in his (1994) *Streetstyle*, which

surveys modern youth cultures and explains the clothes and fashions they wear in terms of constantly evolving visual styles. It will be shown that analyses like those of Hebdige and Polhemus are effective critiques of the kind of approach exemplified by Bell, Wölfflin and the other formalists. Hebdige and Polhemus argue that style is part of a network of social and cultural signifying practices, not simply a collection of shapes, colours and textures to which we need bring nothing of our knowledge of the outside world.

Form and style: Clive Bell, Heinrich Wölfflin and Clement Greenberg

1 Clive Bell

This section will look first at Clive Bell's formalist account of art, written just before the First World War. As noted above, he says that to

> appreciate a work of art, we need bring with us nothing but a sense of form and colour and a knowledge of three-dimensional space. (1958: 28)

A little earlier than this, he says that in order to

> appreciate a work of art we need bring with us nothing from life, no knowledge of its ideas and affairs, no familiarity with its emotions. (Ibid.: 27)

It is worth pointing out immediately that much hangs here on what is meant by 'appreciate': Bell uses the same word twice in close succession and clearly means to use it rather than any other word. It seems that Bell does not mean that, in order to 'understand' a work of art, we need bring with us only a sense of form and colour and a knowledge of three-dimensional space. The context makes that clear. He says, for example, that contemplating art

> transports us from the world of man's activity to a world of aesthetic exaltation. For a moment, we are shut off from human interests . . . we are lifted above the stream of life. (Ibid.)

It is apparent that whatever is going on when one appreciates a work of art, it is not an everyday or ordinary activity. Nor is it quite the same thing as understanding a work of art. Although he says that it is not an emotion that is familiar to us from life (ibid.), Bell's 'appreciation' is described in terms of an emotion. We feel, he says, 'an aesthetic

emotion for a combination of forms' (ibid.). This emotion 'springs
... from the heart of an abstract science' and is akin to the rapture
felt by a pure mathematician as he contemplates his solutions (ibid.).
(Parenthetically, it might be noted that even Bell, who eschews any
reference to vulgar, worldly understanding, is taken by the idea that
what he is describing is in some way scientific. This theme connects
him directly with the discussions in Chapter 2 concerning the allure
of scientific knowledge and understanding.)

The representation of recognisable objects in paintings and the
context of paintings are both considered largely irrelevant by Bell.
Representation, he says, is not bad in itself (ibid.), nor is it neces-
sarily 'baneful' (ibid.: 28), but it can detract from the appreciation of
form and it can be a 'sign of weakness in an artist' (ibid.: 29). The
appreciation of paintings requires enough knowledge of representa-
tion to be able to recognise three-dimensional space but no more. As
he says, if the representation of three-dimensional space is indeed rep-
resentation, then 'there is one form of representation which is not
irrelevant' (ibid.: 28). The irrelevance of context is demonstrated by
those people 'who feel little or no emotion for pure form' (ibid.: 29).
When 'confronted by a picture', these people immediately look to the
context of the picture. They refer the forms of the painting back 'to
the world from which they came' (ibid.). Those who do not appreci-
ate a painting properly look to the context, the world from which they
came, the 'world of human interests' (ibid.), in order to obtain some
purchase on it. In these ways, then, Bell dismisses both the represen-
tation of recognisable objects, or content, and context from his
account of the appreciation of paintings.

These ideas are used to 'appreciate', if not to understand, the work of
Cézanne. Cézanne, he says, is the 'perfect artist' (ibid.: 141), he is the
'Christopher Columbus of a new continent of form' (ibid.: 139). He is
these things because he creates 'significant form' (ibid.: 18). Significant
form is the combination and arrangement of forms in such a way that
they 'move us', or affect us emotionally. Bell says that significant form
is the 'combination of lines and colours ... that moves me aesthetically'
(ibid.: 20). Having gone to live in Aix-en-Provence, Bell suggests that
Cézanne came to understand the landscape there 'as an end in itself and
an object of intense emotion' (ibid.: 140). From then on,

> Cézanne set himself to create forms that would express the emotion that
> he felt for what he had learnt to see. The rest of Cézanne's life is a con-
> tinuous effort to capture and express the significance of form. (Ibid.)

For Bell, then, Cézanne's career after around 1880 is an attempt to express this significant form, to use line and colour to capture aesthetic emotion. It is in these terms, the terms of line, colour and significant form, that Bell thinks paintings should be approached. While he would not and does not say that paintings are to be 'understood' in these terms, it is clear that 'appreciation' stands in for the activity that the present volume has been pursuing in the name of understanding.

2 Heinrich Wölfflin

The work of Heinrich Wölfflin, writing in the 1920s, also approaches paintings in terms of their formal elements. He looks at formal qualities of paintings in order to identify and explain the style of paintings from different periods. Meyer Schapiro has defined style as 'constant form – and sometimes the constant elements, qualities and expression – in the art of an individual or group' (Schapiro 1998: 143). Style is the constancy, or consistency, in the way an individual, or a group, treats the formal elements of art, or visual culture. It is a consistency in the treatment of line, colour, texture and other formal elements shown by an individual or a group. Wölfflin is interested in the stylistic consistency shown by Classical and Baroque artists in their paintings and he is interested in the development of one style into the other. He identifies five pairs of concepts, each of which refers to a formal element of painting and in terms of which these styles and the development between them may be understood (1950: 14–15).

The first two concepts are the 'linear' and the 'painterly' (ibid.). Dürer and Bronzino are linear painters while Rembrandt and Velázquez are more painterly. One of the differences between the styles is that linear style, or linear vision, 'sharply distinguishes' shapes while painterly style does not, letting shapes melt into one another (ibid.: 19). Linear style uses lines to establish boundaries between people and backgrounds, for example, while painterly style uses colours and textures to blur those boundaries. Wölfflin writes of the 'metallic distinctness of lines and surfaces' in a Bronzino portrait and of the indistinct patterns and ungraspable forms of a Velázquez portrait (ibid.: 45–6). The second pair of concepts are 'plane' and 'recession'; Classic, or Renaissance, art 'reduces the parts of a total form to a sequence of planes, the baroque emphasises depth' (ibid.: 15). Leonardo's *Last Supper* represents planar painting, as does Palma Vecchio's painting of *Adam and Eve*. Tintoretto's *Adam and Eve* and

the paintings of Vermeer are examples of recessional paintings. This is a more subtle and difficult pairing than the linear and the painterly. While all pictures involve recession (ibid.: 82), the difference between Classical and Baroque styles is to be found in the way that 'recession is made effective' (ibid.: 75). In Palma Vecchio's *Adam and Eve*, it is as if Adam and Eve are figures in a relief:

> What we meet here as plane-arrangement is by no means the continuation of a primitive type, but the essentially new classic beauty of figures energetically posed in the plane, so that the stratum of space looks uniformly living in all its parts. (Ibid.: 76)

By contrast, in Tintoretto's *Adam and Eve*,

> this relief-like quality is destroyed. The figures have withdrawn into the picture. (Ibid.)

In this latter, plane has given way to recession.

The third pair of stylistic concepts is made up of 'closed' form and 'open' form. While all pictures should give the impression that they are 'self-contained', Classic paintings exhibit closed form while Baroque paintings exhibit open form (ibid.: 15). Wölfflin explains these concepts by saying that in Classic paintings, the 'tectonic', the way in which horizontal and vertical directions demonstrate the construction of the work, is clear. In Baroque paintings, the work of these horizontals and verticals in constructing the image is less clear. Barend van Orley's portrait of Carandolet is compared with Rubens' portrait of Dr Thulden to illustrate this contrast. Van Orley's work is dominated by horizontal and vertical lines. Carandolet's eyes, mouth, chin, cap and shirtsleeve all form horizontal lines, echoed by the woodwork behind him. Uprights formed by a line at the end of Carandolet's sleeve and by a frame on the wall behind him provide a vertical contrast. Overall, as Wölfflin says, the 'whole is so fitted into the picture-space that it looks immutably fixed' (ibid.: 136). The Baroque, represented by Rubens' portrait, in contrast, lacks such bearing. The system of horizontals and verticals has not been abandoned altogether, but it has been 'made inapparent' (ibid.: 137). In Rubens' painting, 'the movement runs diagonally' (ibid.). The diagonals here run from top left to bottom right and are formed by Dr Thulden's arms, by the lapel of his cloak and by the book he is holding. Finally, so far from fitting the whole into the picture-space, the 'artist seeks to create the impression that the frame and the content have nothing to do with each other' (ibid.).

The fourth pair of concepts are 'multiplicity' and 'unity'. In Classical composition, which exhibits multiplicity, 'the single parts, however firmly they may be rooted in the whole, maintain a certain independence' (ibid.: 15), while Baroque composition invites perception of, or as, a whole (ibid.). Other ways in which Wölfflin characterises the differences in style are to say that the former sees in detail and the latter sees as a whole (ibid.: 155), and that the Classical provides an 'articulated system' where the Baroque provides an 'endless flow' (ibid.: 158). The head of Jean de Dinteville in Holbein's double portrait *The Ambassadors*, is contrasted with Velázquez's portrait of Cardinal Borgia, and Titian's *Bella* is contrasted with Velázquez's *Venus*, to illustrate the differences in style here. In Holbein's head, 'the forms stand side by side as independent and relatively co-ordinated values' while, in the Velázquez, 'certain groups of forms take the lead' (ibid.: 167). The eyes, nose, mouth and moustache, for example, in the Velázquez portrait are emphasised at the expense of the rest of the image, while the Holbein offers a more 'even' image in which features are equally stressed. Similarly, the Classical Titian contrasts with the Baroque Velázquez in the matter of nude women. Wölfflin's case is less convincing here, perhaps, but he says that the Titian (see Figure 8.1) shows

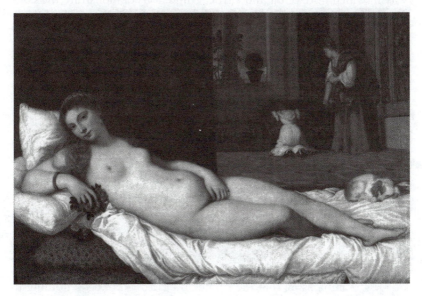

Figure 8.1 Titian (Tiziano Vecellio), *Venus of Urbino*, 1538

nothing but clearly defined limbs organised in a harmony in which the separate tone can still be distinctly heard as such, (Ibid.: 168)

while the effect of the Velázquez (see Figure 8.2), is based on the

whole as a whole, subjected to a leading motive and the uniform accentuation of the members as isolated parts [is] surrendered. (Ibid.: 169)

Finally, Wölfflin suggests that Classical and Baroque paintings may be distinguished in terms of their 'absolute' and 'relative' clarity. As he often does, Wölfflin uses Leonardo's *Last Supper* as an example of the Classical. In this painting, which he says represents the 'highest stage of Classic clarity', we can see everything that is happening and 'the content of what is happening is determined by the grouping' (ibid.: 208). In terms of style, Tiepolo's *Last Supper* represents the 'opposite' of Leonardo's (ibid.: 88) and provides a 'typical baroque version' of the events (ibid.: 208). In the Tiepolo, Christ

certainly bears all the necessary emphasis, but he obviously does not determine the movement of the picture, and among the disciples abundant use is made of the principle of darkening and covering the form. (Ibid.)

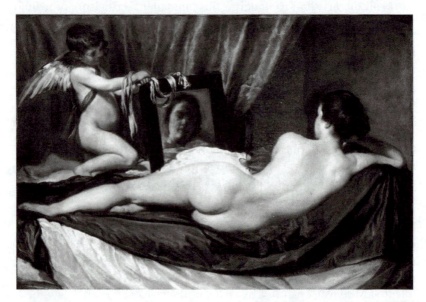

Figure 8.2 Diego Velázquez, *The Toilet of Venus* ('The Rokeby Venus')

For example, in the Tiepolo, there are deep shadows and the brightest light, and a group of disciples sits in front of Christ. In the Leonardo, there is much less deep obscurity and nothing gets in the way of telling the story. It is mainly in the use of light (ibid.: 200) and colour (ibid.: 202) that the absolute clarity of the Classical and the relative clarity of the Baroque are distinguished by Wölfflin. Again, these are entirely formal elements of painting. As in Wölfflin's account of the stylistic differences generally, it is the formal elements of painting that do all the work.

3 Clement Greenberg

In his essay 'Modernist Painting', written in 1960, Clement Greenberg presents another way of understanding visual culture in formal terms. For Greenberg, modernity begins with the philosophy of Immanuel Kant, in the eighteenth century (1993: 85). Kant is the first modernist philosopher because he uses reason to establish the limits of reason: he uses the concepts and procedures of the mind to establish what the mind may legitimately be said to know. Greenberg thinks that this way of using the distinctive methods of a discipline to establish the limits of that discipline is what characterises modernity. Following Kant's work, all the arts had to undergo this 'immanent' criticism according to Greenberg (ibid.: 86). They had to establish what their distinctive methods and procedures were, what was peculiar and special only to them, in order to be in the more secure possession of those methods and procedures. Each art had to 'eliminate' every effect that was shared with, or borrowed from, any other art so that each art could establish its 'purity'. This notion of purity could then be used to set standards of quality and guarantee each art's independence from the other arts (ibid.). What painting 'shared with no other art' was what Greenberg calls 'flatness' (ibid.: 87). It shared colour with the theatre and it shared sculptural form with sculpture, for example, but no other art's methods and procedures included flatness. Flatness is to do with the two-dimensionality of the picture's support. Paintings commonly take the form of pigment applied to a flat, two-dimensional support, the canvas. Painting shares this with no other art. Consequently, on Greenberg's account, modern painting is that which draws attention to, or announces, this two-dimensionality. Modern painting draws attention to the flat surfaces on which it is painted and Manet's are 'the first Modernist pictures by virtue of the frankness with which they declared the flat surfaces on which they were painted' (ibid.: 86).

Having said this, Greenberg then seeks to apply this idea of flatness to western painting since the sixteenth century. He may be seen as trying to understand western painting since the sixteenth century in terms of the formal qualities of painting. He says that, while naturalistic western painting owes a debt to sculpture (from which it gets a knowledge of shading and the knowledge of how to create the illusion of depth), 'some of the greatest feats of Western painting are due to the effort it has made over the last four centuries to rid itself of the sculptural' (ibid.: 88). Some of the 'greatest feats of Western painting' from the last four or five hundred years, then, are to be understood as the attempt to escape the sculptural, as the attempt to eradicate the illusion of depth and relief. These greatest feats are to be understood in terms of a progressive or increasing 'flatness'. Providing little or no detail, Greenberg says that 'starting in Venice in the 16th century and continuing in Spain, Belgium and Holland in the 17th' (ibid.), painting attempted to rid itself of the sculptural by using colour. Artists from the sixteenth and seventeenth centuries used colour to explore and develop flatness in their paintings. Continuing the account, Greenberg says that, although David reacted to this in the eighteenth century by trying to 'revive' the sculptural, Ingres, his pupil, produced

> portraits that were among the flattest, least sculptural paintings done in the West by a sophisticated artist since the fourteenth century. (Ibid.)

By the middle of the nineteenth century, 'all ambitious tendencies in painting had converged ... in an anti-sculptural direction' (ibid.). From the fourteenth century to the nineteenth century, Greenberg understands western painting as getting more and more flat.

Greenberg's account continues into the nineteenth and twentieth centuries. With Manet producing the first modernist pictures, the Impressionists used the purely optical to undermine shading and everything else that connoted the sculptural (ibid.: 89). The Impressionists 'discovered that the most direct interpretation of visual experience must be two-dimensional' (1986: 201). Cézanne furthered the cause of flatness by breaking up 'the objects he depicted into multiplicities of planes that were as closely parallel as possible to the canvas's surface' (ibid.: 202), and which were 'borrowed' by Picasso and Braque (1982: 110). The Cubism of Picasso and Braque 'eventuated in a kind of painting flatter than anything in Western art since before Giotto and Cimabue' (1993: 89). Léger develops flatness by abandoning recognisable objects altogether and paints 'abstract pictures with planes defining cylinders and cones ... and flat rectangles

that define not even volume' (1982: 111). Although modernist paint-ing strives towards the ever flatter canvas, 'absolute flatness' can never be achieved (1993: 90). Even Mondrian, who Greenberg says 'arrived at the flat picture' (1982: 112), suggests a third dimension as soon as he places colour onto the canvas (1993: 90). Even the thinnest layer of paint is enough to suggest depth and the goal of ultimate flatness is disallowed. However, the point is made that Greenberg effectively presents western painting since the fourteenth century in terms of a formal quality of that painting. He understands four or five centuries of visual culture in terms of flatness. The formal quality of painting, the flatness of the picture surface, is the key to understanding that painting.

There is one more point which deserves to be made here with regard to Greenberg's account and it relates back to what Bell says about representation and three-dimensional space. Bell's formalist account stressed that all that was necessary to appreciate a work of art was 'a sense of form and colour and a knowledge of three-dimensional space' (1958: 28). Only on the condition that the repre-sentation of three-dimensional space is properly called representation would Bell allow that this one form of representation was not irrele-vant. Greenberg has a slightly different opinion on the matter of space and representation. In 'Modernist Painting' he says that it is

> not in principle that modernist painting in its latest phase has abandoned the representation of recognisable objects. What it has abandoned in prin-ciple is the representation of the kind of space that recognisable, three-dimensional objects can inhabit. (1993: 87)

Bell disagrees. He argues that three-dimensional space is 'neither irrelevant nor essential to all art' but that 'every other sort of repre-sentation is irrelevant'. 'Every other sort of representation' must include the representation of what Greenberg calls 'recognisable objects'. Bell also suggests that

> pictures which would be insignificant if we saw them as flat patterns are pro-foundly moving because, in fact, we see them as related planes. (1958: 28)

It is the relation between flat planes, what this chapter has called the internal structure of the painting, and not the flatness itself, that pro-vides significant form for Bell. For Greenberg, it seems that the flat-ness is significant in itself. Whatever their disagreements, they both agree on the fact that it is in terms of the formal characteristics of paintings that those paintings are to be understood.

Finally, this chapter will consider Acton's account of paintings in terms of their formal characteristics. Acton says that her account is an account that is based on 'looking' (1997: xxix), but it is clear that most of her concerns are with what have been called here the formal aspects of painting. She is interested in the artist's use of composition, or layout, the use of space and perspective, and in the use of tone and colour. The account is also interested in form, although Acton uses the word form in a slightly different sense from how the other formalist critics noted here have used it. Form in Acton's account refers to the way in which an artist creates an illusion of volume, or three dimensions in a work (ibid.: 51). This sense of form is akin to what Wölfflin explores in his notions of plane and recession. Acton is not unconcerned with the way in which content or subject-matter inform the understanding of paintings; nor is the 'period, context and present state of the picture' irrelevant. But her main approach to understanding paintings is formal; cultural history and the development of style, for example, are not part of this approach (ibid.: xxix).

Strengths and weaknesses

It is surely one of the strengths of Wölfflin's account of the differences in style between Classic and Baroque art that that account is completely captivating. Chapters containing a plethora of examples, comparisons and convincing arguments come and go until the book is finished. Only on completion of the text does it register that, in some two-hundred and thirty pages, the social and historical contexts of the production and consumption of these paintings, sculptures and buildings have not been mentioned. Lectures on the formalist account of style are much the same: double projection (itself introduced to the study of the history of art by Wölfflin) ensures that the hour passes in a flurry of stylistic comparisons, the eye flitting from one screen to the other. Toward the end of the hour, student and lecturer are equally surprised to find that social class, iconological content and cultural variation have all been utterly neglected. Greenberg's formal account in terms of flatness is almost as absorbing. Examples of the artists he mentions appear and disappear in the mind's eye as the two or three pages on which he covers four or five hundred years of art history come and go. For whatever reason, these examples are also completely convincing.

Another strength of a formal and style-based approach to understanding visual culture is that it can deal with all kinds of visual culture. The present chapter has concentrated on art, and on painting

in particular. But Wölfflin's account covers architecture and sculpture as well as painting. The ideas concerning form and style that Wölfflin develops may be used to understand other types of art apart from painting. The approach may also be applied to automobile, furniture, product, graphic and fashion design. There is not, after all, an example of visual culture that does not have form and style. Much of what passes for popular criticism of fashion, graphic and automobile design, in newspapers and magazines, for example, is concerned with the style of those products. It is the shapes and styles of cars, frocks and advertisements that attract attention in these cases. This is to follow a formalist approach. It is to understand these products in terms of their shapes, lines and colours and in terms of their style. The following section, on Hebdige and Polhemus, will look at two examples of how style may be used to understand fashion design, for example. Any example of visual culture that has shape, line, colour, texture, and composition or layout, can be discussed in terms of form and style and to this extent a formalist approach must be deemed successful. An approach to visual culture that does not immediately or automatically exclude many examples of visual culture must have something going for it.

However, to say that a formalist or stylistic approach does not automatically rule too much out is perhaps to damn it with faint praise. There are many positive weaknesses involved in such an approach. The first is the one noted above, that it ignores or neglects the role of class, gender, ethnicity, history and other forms of cultural diversity in understanding visual culture. This is a weakness that a formalist or stylistic approach has been held to share with the other structuralist forms of approach studied in the previous chapter. Eagleton's critique of structural approaches has already been noted, in Chapter 7, but it will do no harm to reprise elements of it here. He says, for example, that structuralism is 'hair-raisingly unhistorical' (1983: 109). The approaches explored in this chapter have understood visual culture in terms of the relations existing between the formal elements of paintings. Some have argued that the relations between colours, shapes and lines, for example, in paintings are the basis for an understanding of those paintings. Another has argued that the relation between linear and painterly aspects of pictures is the basis for an understanding of the styles of those pictures. To this extent, these are structural approaches. As structural approaches, approaches that concentrate on the relations existing between the 'internal' elements of examples of visual culture, formalist and stylistic approaches to understanding visual culture admit of this criticism.

Thus, Wölfflin's account of the stylistic differences between Classic and Baroque visual culture is unhistorical. His account makes no reference to the role of history in the production or reception of visual culture. The understanding of the painterly in Baroque architecture that was achieved by the people of the seventeenth century is never touched upon by Wölfflin. The people of the time may have had little or no idea of the painterly, or the linear, for all Wölfflin knows. Even if they did operate with such ideas, what those ideas meant to those people, and how they might differ from a twenty-first-century understanding of them, is no part of Wölfflin's approach. To this extent his account is unhistorical. It is also, as Hauser points out, 'unsociological' (Hauser 1951, vol. 2: 165). Similar problems can be raised with regard to Greenberg's account of modernist painting. Greenberg's account makes no reference to how the people of sixteenth-century Venice understood 'flatness', or even whether they had any idea of 'flatness' at all at the time. 'Flatness' is an idea that a mid-twentieth-century art critic uses to understand the visual culture of the past. It appears throughout the four or five hundred years of Greenberg's account as though it is always and everywhere the same concept, applying in an identical way to the visual culture (and the understanding of that visual culture) of very different historical circumstances. To this extent, Greenberg's account is unhistorical.

It was also noted that it is entirely possible to cover Bell's, Wölfflin's or Greenberg's account and never once mention class, ethnicity or gender. The role of class, ethnicity and gender in understanding the form or the style of visual culture is never mentioned by these writers. As far as these writers are concerned, the visual culture that they discuss has been produced and consumed in a world devoid of different classes, genders and ethnic backgrounds. Ideas like 'significant form', 'plane and recession' and 'flatness', for example, are treated as though their reception or understanding by different groups of people is not a problem. They are assumed to be innocent and neutral concepts, as understood by innocent and neutral individuals. To adapt an argument used by Eagleton, the fact that the people applying and understanding such concepts are as likely to be working-class black women as they are to be middle-class white men 'is simply slid over' (1983: 115). The comfortable, domestic and bourgeois interiors of Pieter de Hooch, Vermeer and Janssens, for example, are never discussed in terms of their class location. Nor are they contrasted with the peasants working in Ruysdael's fields, or carousing in Bruegel's, Bosch's and Ostade's country weddings and public houses. The

Venuses, Andromedas, Bellas and Odalisques on sofas of Titian, Velázquez, Rubens and Boucher are presented and understood in terms such as the articulation of their limbs, their relation to the vertical and the part played by drapery in the unity of form. They are not understood in terms of the presentation of female flesh for the entertainment and enjoyment of wealthy male patrons and viewers.

Another problem with formalist and stylistic approaches is more philosophical. In his version of a formalist approach, Bell said that, in order to appreciate a work of art, we need no more than 'a sense of form and colour and a knowledge of three-dimensional space' (Bell 1958: 28). In this version, it is as if aesthetic experience has an order, or that it can be analysed into two components: first there is the experience of the formal properties of a painting and then there is the interpretation of those formal properties as representing things in the world. Bell writes of the 'representative element' of a painting as if it could be separated from and opposed to the formal element (ibid.). One of the consequences of Gadamer's position, which was investigated in Chapter 2, is that 'perception always includes meaning' (Gadamer 1975: 82). Nicholas Davey argues that this strand of Gadamer's thought constitutes a serious challenge to a formalist understanding of art (Davey 1999: 12). As Gadamer says, 'pure seeing', the sort of seeing that involves perceiving only form and colour and three-dimensional space and which Bell believes is possible, is a dogmatic abstraction (Gadamer 1975: 82). Perception cannot be abstracted from the understanding of meaning. It is not the case that a distinction can be made between 'the having of sensations and perceptions and . . . the attribution of meaning and value to those sensations' (Davey 1999: 12). If it is impossible to separate the elements of visual experience in this way, if it is impossible to isolate the purely formal aspects of perception, then the formalist approach to visual culture cannot in fact be possible.

A similar argument is made by Paul Crowther, who investigates 'Gadamer's reservations about the worth of this purely aesthetic attitude' (Crowther 1983: 350). The main point he makes is that an aesthetic approach like that of Bell, for example, 'abstracts from all conditions of a work's accessibility' (Gadamer 1975: 77). As Crowther says, such an approach

> ignores those questions of purpose, function and content which make an artwork a candidate for interpretation as opposed to . . . sensuous appreciation. (Crowther 1983: 350)

As noted above, Bell insists on the word 'appreciation' when refer- ring to how a work of art is to be related to. He seems studiously to avoid using anything like 'understanding' to describe that relationship. Clearly, if Crowther is correct, then it is no surprise that Bell avoids such a word. Bell avoids purpose, function and content and is there- fore limited to the purely sensuous appreciation of art.

Davey's presentation of Gadamer's argument against the purely aesthetic consciousness mirrors an argument that structuralism in general has to confront. It was noted in Chapter 7 that semiology, and semiological accounts of visual culture, posit a distinction between denotation and connotation. Denotation is often explained as the 'literal' meaning of what is perceived, what the photograph, for example, is a photograph of. And connotation is often explained as the associations that the photograph has, or takes on, for a viewer. Barthes points out that the distinction between these two 'messages' is not made 'spontaneously'. In an 'ordinary reading' of a photograph, or a painting, this distinction is not made. The viewer of the image receives 'at one and the same time' the denotational and the conno- tational messages (Barthes 1977: 36). Consequently, for Barthes and semiology this distinction is made for analytical, or as he has it 'oper- ational' (ibid.: 37) purposes only. This is akin to arguing, against Bell, for example, that the purely formal aspects of the image cannot be isolated or separated from the meaningful aspects: there can be no pure perception, apart from an understanding of the image. The fol- lowing section will consider the work of Hebdige and Polhemus, sug- gesting that, while they are concerned with the formal aspects of visual culture, they are also concerned with the 'content' of that visual culture. It will argue that, in addition to being interested in the shapes, lines and colours of visual culture (the formal and the stylistic), these two can also account for its purpose, function and content.

Dick Hebdige and Ted Polhemus

The work of Dick Hebdige and Ted Polhemus on fashion and cloth- ing is presented in this section in the attempt to show that they over- come the weaknesses of the formal approach noted above. These authors both concentrate on the notion of style. They both illustrate how visual culture may be understood in terms of style, while escap- ing the problems noted above. These authors show how a formal aspect, the style of visual culture, may be understood in terms of class,

gender and ethnicity. With these two writers, then, the formal and stylistic aspects of visual culture are not abstracted or isolated from purpose, function and content; to the contrary, those aspects produce and communicate class, gender and ethnic identity. The full title of Hebdige's highly influential book is *Subculture: The Meaning of Style*. From the start, he is concerned, not with a pure or isolated conception of style, but with the meaning of style, the meaning of shapes, lines, colours and textures as they are found in fashions and clothing. He is concerned to show how style in fashion and clothing may be understood in terms of meaning. He is concerned to show how style in fashion and clothing may be understood in terms of a relation to class, ethnicity and, to a lesser extent, gender. Polhemus's book *Street-style* is subtitled 'From Sidewalk to Catwalk' and he, too, is not concerned with a pure conception of style. Polhemus is also interested in understanding style, the shapes, lines, colours, textures and so on of fashion and clothing, in terms of class, ethnicity and, to a greater extent than Hebdige, gender. Both writers, then, want to show how visual culture may be understood in terms of style. And they both want to show how style may be understood in terms of the production and communication of class, gender and ethnic identity.

There are many examples of the way in which style is understood in terms of class in Hebdige's book. The visual styles of teddy boys, Mods, skinheads and Punks are all presented to be understood in terms of social class. The teddy boy, for example, is described as 'effectively excluded and temperamentally detached from the respectable working class' (Hebdige 1979: 50). His haunts are said to be 'deep in the traditionally working class areas of south and east London' (ibid.: 51). But his visual style, the clothes he wore, are based on 'aristocratic Edwardian style' (ibid.: 50). The 'theft and transformation' (ibid.: 104) of Edwardian-style drape coats by the teds is a revival of a particular, class-specific style in Hebdige's account. (It is worth noting, parenthetically, that the style adopted by teds is also understood partly in terms of a relation to other ethnic groups. The style of the teds is presented in the context of an ambivalent relation to other ethnic groups. The teds were happy to adopt parts of black style – rhythm and blues music, for example – but they were also 'frequently involved in unprovoked attacks on West Indians' (ibid.: 51).)

The Mods are said to be a 'working class youth culture' (ibid.: 52). They took the 'conventional insignia of the business world – the suit, collar and tie, short hair', along with the 'ultra-respectable' scooter, and transformed them for their own purposes (ibid.: 104–5). Mod style

is described as the appropriation of a respectable, middle-class style and its transformation into something just a little 'too smart' (ibid.: 51). Mod style is also understood here in terms of a relation to black culture. For example, unlike the teds, the Mods were happy to adopt black music and dances. They are said to have 'responded positively' to West Indian presence and 'sought to emulate their style' (ibid.: 52). Skinheads are also understood in terms of class. They are described by Phil Cohen as 'a caricature of the model worker' (ibid.: 55). Their visual style,

> [t]he boots, braces and cropped hair were only considered appropriate and hence meaningful because they communicated the desired qualities: 'hardness, masculinity and working-classness'. (Ibid.: 114)

As Hebdige says, 'any imagined bourgeois influences (suits, ties, lacquer, "prettiness")', were suppressed in the interests of the skins' exploration of 'the lumpen' (ibid.: 55). Skins are also presented in terms of a relation to ethnicity: they are 'aggressively . . . chauvinist' (ibid.: 55), but they are also happy to borrow certain aspects of black style. While beating up West Indian immigrants (ibid.: 58), skins were happy to wear Crombie overcoats, listen to reggae music and copy other aspects of West Indian style (ibid.: 56). Here, visual style is explained and understood as a form of communication and in terms of a relation to class, gender and ethnic identities.

There are also many examples of the way in which style is understood in relation to ethnicity in Hebdige's book. The visual styles of West Indians and Rastafarians are explained as the production and communication of an ethnic identity. Hebdige reports the style of the first generation of West Indian immigrants to Britain. The clothes these immigrants wore 'reflected' their aspirations (ibid.: 41).

> Each snowy cuff had reflected a desire to succeed, to 'make the grade' in the terms traditionally laid down by white society, just as, with tragic irony, all hopes of ever really fitting in were inadvertently belied by every garish jacket sleeve – too loud and jazzy for contemporary British tastes. (Ibid.)

The children of these immigrants, however, created a different visual style and new identities. Hebdige describes 'Rasta style' in terms of 'a more obviously African "natural" image' (ibid.: 43). Young black Rastas adopted the 'tam' in place of their father's pork-pie hat: Tonic, mohair and terylene were discarded for garments made out of cotton, wool and denim, and

> girls began to leave their hair unstraightened, short or plaited into intricately parted arabesques, capillary tributes to an imagined Africa. (Ibid.)

The different generations of West Indians created and communicated their different identities by means of the styles they adopted – by means of the clothes they wore. In this way Hebdige understands visual culture in terms of ethnic and, briefly, gender identity.

However, it is in relation to Punk that the analysis in terms of style is most developed. Style is explained as a form of communication, as homology and as a signifying practice. Fashion and clothing, the shapes, colours, lines and textures of what people wear, are explained in terms of communication. These shapes, lines, colours and textures are not 'appreciated' only in so far as they are formal qualities: those formal and stylistic qualities are understood in terms of what, and how, they communicate. Style is first explained as 'intentional communication' (ibid.: 100). Using a distinction between 'transparent' and 'less consciously constructed' press photography and 'intentional' and 'emphatic' advertising photography (which he attributes to Barthes 1977), Hebdige introduces the differences between subcultural and 'normal' styles of dress (ibid.: 100–1).

> Subcultural stylistic ensembles – those emphatic combinations of dress, dance . . . etc. – bear approximately the same relation to the more conventional formulae ('normal' suits and ties, casual wear, twin-sets etc.) that the advertising image bears to the less consciously constructed news photograph. (Ibid.: 101)

Like advertisements, subcultural styles are 'obviously' constructed or fabricated. They display their own codes. And, directing attention to themselves, they fully intend to communicate. Mainstream styles, in contrast, try to hide themselves, to appear as part of the background, as part of nature. And what these subcultural styles communicate, on Hebdige's account, is their own 'difference' from, and opposition to, the other styles (ibid.: 102). At the same time, of course, subcultural styles create a sense of identity for those using them. Style is used by subcultures to create and communicate an identity and a sense of difference from 'mainstream' cultures and styles.

For Hebdige, Punk differentiated itself from mainstream culture by means of style, by means of fashion and clothing. It created an identity for itself by these means (ibid.: 106–12). It created a sense of chaos and it communicated that chaos 'on every level because the style itself was so thoroughly ordered' (ibid.: 113). Not only the fashions and clothes, but the graphics and typography of Punk created and communicated 'anarchic style' (ibid.: 112). The idea that chaos and anarchy can be created and communicated by means of a stylistic whole is explained for Hebdige in the idea of homology. Homology is the idea

of a 'symbolic fit' (ibid.: 113) between the values and lifestyles of a subculture and the forms in which those values and lifestyles are created and communicated. There is a 'fit' between the boots, braces and cropped hair of the skinheads and their values of 'hardness, masculinity and working-classness' (ibid.: 114). And there is a 'fit',

> a homological relation between the trashy cut-up clothes and spiky hair, the pogo and amphetamines, the spitting, the vomiting, the format of the magazines, the insurrectionary poses and the 'soulless', frantically driven music. (Ibid.)

However, despite this fit, 'nothing, not even these forbidden signifiers (bondage, safety pins, chains, hair-dye, etc.) is sacred and fixed' (ibid.: 115). This 'absence of permanently sacred signifiers' is a problem for the 'semiotician' (ibid.).

It is a problem because, unlike the style of the teds, or the skinheads, this aspect of Punk style shows how style itself begins to unravel. As Hebdige puts it,

> The key to punk style remains elusive. Instead of arriving at the point where we can begin to make sense of the style, we have reached the very place where meaning itself evaporates. (Ibid.: 117)

It is at this point, and for the first time, for Hebdige, that the actual practice of signifying, the process of signification, becomes part of Punk style. Drawing on the work of the Tel Quel group in France, Hebdige introduces the idea of art as work, as 'practice' (ibid.: 118). Conventional theories of art see art as imitating or reflecting a pre-existing reality, in the same way as some accounts of fashion sees fashion as reflecting pre-existing class identities. The work of Julia Kristeva and the Tel Quel group proposes art as transforming reality, as being concerned with the 'ideological implications of form, with the idea of a positive construction and deconstruction of meaning' (ibid.: 119). This account of art and style enables Hebdige to provide an account of Punk as being in the process of creating its own versions of reality. As a process of signification, or a series of transformative processes, Punk has no single key.

The difference is illustrated in a comparison with the skinheads. The skinheads, says Hebdige, 'theorized and fetishized their class position, in order to effect a "magical" return to an imagined past' (ibid.: 120). Punk fashions and clothing, however, 'did not so much magically resolve experienced contradictions as represent the experience of contradiction itself in the form of visual puns (bondage, the ripped

tee-shirt, etc.)' (ibid.: 121). Skins and teds, for example, both ascribed fixed and 'sacred' meanings to their fashions and clothes: there were definite and revered signifieds to such signifiers as drainpipe trousers and Dr Martens boots. These signifieds have been explained above in terms of rigid class and gender identities. On Hebdige's account, Punks were more interested in the process of signification, they were more concerned with the signifier than the signified and there were no sacred and revered meanings (signifieds) to the artefacts they cut up and used. Hebdige argues that skins and teds exemplify a different attitude from Punk, towards what Kristeva calls '*signifiance*', the work of the signifier, the process of exploring how language works, both constructing and desconstructing meaning (ibid.: 124–5). Skins and teds use signification to construct a meaningful identity, to communicate, represent and express themselves. Punk uses '*signifiance*' to transform the signifier, to escape the stable meaning and to destabilise identities. As Hebdige says, the style of the skins and the teds

> says its piece in a relatively direct and obvious way and remains resolutely committed to a 'finished' meaning, to the signified . . . punk style is in a constant state of assemblage, of flux. It introduces a heterogeneous set of signifiers which are liable to be superseded at any moment. (Ibid.: 126)

The differences between punk on the one hand and skins and teds on the other

> are reflected not only in the objects of subcultural style but in the signifying practices which represent those objects and render them meaningful.
> (Ibid.: 127)

To adapt an old saying, it was not just what they did but the way in which they did it that distinguished punk from other subcultural styles.

Although he is still concerned to understand visual culture in terms of the formal properties, the style, of that visual culture, Polhemus is also concerned to understand that style in terms of its relation to class, gender and ethnic identities. While Polhemus's account of style is less heavily theoretical than Hebdige's, the underlying definition of style is much the same. Polhemus's accounts of the function of style and of the ways in which style works are also compatible with Hebdige's. As Polhemus says, 'style isn't just a superficial phenomenon' (1994: 15). Style is more than a collection, or assemblage, of shapes, lines, colours and textures, to be appreciated in their own terms and with no relation to the outside world, or 'life'. A version of what Hebdige calls homology is at work here: for Polhemus, 'like looking is like thinking'

(ibid.). There is a fit between the style adopted and other aspects of lifestyle. The shapes, lines, colours and textures chosen by a group 'encode . . . all those ideas and ideals which together constitute a (sub)culture' (ibid.). The styles adopted by a (sub)culture, then, are communicative. They create, identify and communicate an identity for and to the members of the group and to those who are not members of the group. As Polhemus says, 'stylistic commitment brings a sense of group solidarity and comradeship' (ibid.).

One major difference from Hebdige's account of style, however, is that, for Polhemus, style is inherently conservative (ibid.: 13). Styletribes, identifiable groups of people sharing a style, 'hope that they will be timeless, unchanging' on Polhemus's account (ibid.: 15). Members of the Bracknell Chopper Club, who tattoo their arms with 'an elegant pair of gold wings' to signify their permanent identification with the club, are produced as examples of this conservatism (see Figure 8.3). For Hebdige, it was the skins and the teds who were conservative in this way; Punks were not conservative in any way on his account. Polhemus has a slightly different understanding of this conservatism. Confusingly, the example of Punk is used here. Polhemus points out that, while mainstream culture will often dismiss styles such as Punk as a passing fad, members of those subcultures 'want to believe

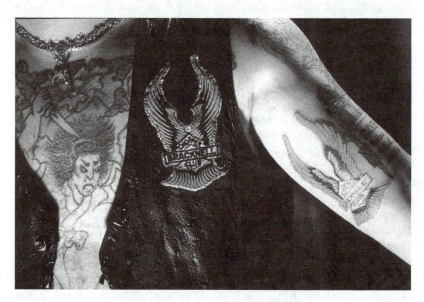

Figure 8.3 Tattoo, Bracknell Chopper Club

that their tribe will carry on "forever"' (ibid.). The futility of this con-
servative desire is shown, for Hebdige, by those Punks who rallied to
the cry 'Punk's not dead', while all around them more Punks were seen
on postcards being sold on the King's Road than on the King's Road
itself. The confusion arises because Polhemus then says that the 'spirit
of Punk' may still be very much alive. It may have moved on (in a
fashion akin to that described by Hebdige as an example of its revolu-
tionary nature), to influence other contemporary styletribes (ibid.).
What might appear to be conservatism on one account appears as
revolutionary and changing identities on another.

Most of Polhemus's *Streetstyle*, however, is given over to describing
the development of one style into other styles. It describes how ele-
ments (formal aspects of fashion and clothes such as shapes, lines,
colours and textures) are adopted by one styletribe, dropped by a fol-
lowing tribe and revived by yet another. Each separate appearance of
the stylistic element invests that element with a different meaning. The
leather jacket has become a cliché of youth culture: adopted and
transformed by Rockers, Mods, Punks, Mutant Rockabillies and
Pervs, for example. 'A Tribe Called Quest' even adopt it to communi-
cate what Polhemus calls 'Afrocentric style' (ibid.: 107). However, like
Hebdige, Polhemus is concerned to relate the formal qualities of visual
culture, such as the style of fashions and clothes, to gender, class and
ethnic identity. He, too, is not content to 'appreciate' form in terms of
the aesthetic emotion it generates. B-boys and flygirls, for example,
are explained by Polhemus in terms of black cultures that existed in
the South Bronx in New York during the 1980s. They are evidence of
how ethnic and gender identities may be created by means of style.
B-boys took their name from the style of dancing they favoured –
break-dancing. Flygirls dressed to look attractive, 'fly' being 'street
slang for well-dressed, attractive, sexy' (ibid.). The 'casuals' of 1980s
Britain are explained in terms of their class origins. They are said to
have developed out of the working-class skinheads, taking over the
idea of using fashion and clothing to show pride in 'proletarian origins'
(ibid.: 100). Polhemus connects them with an upwardly mobile
working class, who were encouraged by Margaret Thatcher to pull
themselves up by their own, Lacoste and Burberry, bootstraps and
buy their own council houses (ibid.: 101). Indie-Kids, in contrast, were
middle-class and deliberately mis-interpreted the 'style of the under-
privileged' (ibid.: 122). Large, battered boots, charity-shop clothing
and under-sized or over-sized garments (as though they could not
afford the luxury of clothes that fitted) were the key ingredients of

this style (ibid.: 123). Again, Polhemus is presenting the formal aspects of visual culture to be understood in terms of gender, class and ethnicity. It is not the case that the shapes, lines, colours and textures of the clothing and fashions he deals with are isolated from the world. They are understood in terms of how they are used by youth cultures to create and communicate identity.

Conclusion

Both Hebdige and Polhemus, then, show how to answer the charge that formal approaches neglect the various contexts of visual culture. The versions of formalism exemplified by Bell, Wölfflin and Greenberg all admitted the charge that they could not account for the part played by class, gender and ethnicity in the production and consumption of visual culture. The approaches of Hebdige and Polhemus have been presented as formalist approaches. These approaches have been explained as being concerned with the formal qualities of visual culture. They are concerned with the shapes, lines, colours and textures of visual culture and with the ways in which those formal qualities are made into signifying practices. In this way, a concern with the formal qualities of visual culture, the styles of fashions and clothes, for example, can be made to escape the charge that it neglects aspects such as gender, class and ethnicity.

The formal approaches of Hebdige and Polhemus, as well as of Bell, Wölfflin and Greenberg, have also been explained in this chapter as being structural approaches. All these examples of a formalist approach to the understanding of visual culture have been explained in terms of structures. They have been explained in terms of the ways they use the internal structures of visual culture as a support on which to base their understanding. Bell, Wölfflin and Greenberg were all concerned with the shapes, lines, colours and textures of paintings. They were concerned to demonstrate how these formal aspects could be used to understand paintings. Hebdige and Polhemus were also concerned with the formal qualities of visual culture. While the structuralist sympathies of their approaches were not developed to the same extent, they were concerned to show how fashions and clothes could be understood in terms of the communicative strengths of shapes, lines and so on. Hebdige charts how fashion items like winkle-picker boots, drainpipe jeans and leather jackets, for example, are chosen and combined into ensembles. This might be described in

terms of the paradigmatic and syntagmatic relations discussed in Chapter 7, above. Both Hebdige and Polhemus are concerned with how the internal structures of visual culture, what might be called ensembles, create and communicate meanings. To this extent, then, they are both following a structural approach.

Further reading

Meyer Schapiro and Ernst Gombrich have both written essays on style that have not been dealt with here. Schapiro's essay was published in *Anthropology Today* (1953), edited by A. L. Kroeber. Gombrich's essay was published in the *Encyclopaedia of the Social Sciences* (1958). Both are excerpted in Donald Preziosi (ed.) (1998) *The Art of Art History: A Critical Anthology* (Oxford: Oxford University Press).

Ted Polhemus followed up his *Streetstyle* with *Stylesurfing*, updating his concern with fashion and style into the 1990s. Other people trying to understand design in terms of style include Stephen Bayley, in his (1979) *In Good Shape: Style in Industrial Products 1900–1960* (London: Design Council), Peter York, in his (1980) *Style Wars* (London: Sidgwick and Jackson), and Bevis Hillier, in his (1983) *The Style of the Century* (London: Herbert Press).

From the Marxist, or social history of art, tradition, Nicos Hadjinicolaou, who was discussed in Chapter 6, has a chapter in his (1978) *Art History and Class Struggle* (London: Pluto), which discusses style as a form of visual ideology. As noted in Chapter 6, he prefers the term 'visual ideology' to 'style'. Arnold Hauser, also discussed in Chapter 6, investigates Wölfflin's notion of style, and the notion of an art history without names, in his (1958) *The Philosophy of Art History* (London: Routledge and Kegan Paul).

And Mike Featherstone develops the notion of style as it overlaps with the notion of lifestyle and consumption in his (1991) *Consumer Culture and Postmodernism* (London: Sage). His chapters on lifestyle and consumer culture and on the aestheticisation of everyday life cover art, advertising and fashion, for example.

Chapter 9

Conclusion

Hermeneutics and structure

This book has sought to introduce some of the methods which have been used to understand visual culture. It has tried to show what are the main concepts and methods used by various approaches to the understanding of art and design. In order to do this, Chapters 1 and 2 investigated what has been meant by understanding. Chapter 1 made the very idea of understanding into a problem. In everyday life, the possibility of understanding is not in question. Similarly, most current works on visual culture, and on art and design, do not ask the question as to what understanding is. They are not interested in whether understanding is an activity, or in what sort of activity it might be. Most approaches, and most works dealing with those approaches, are not concerned with questions of what understanding is, what it is that we do, or what it is that happens, when we understand something. Chapter 1 was an attempt to raise these questions and make them relevant to the project of understanding visual culture.

Chapter 2 put a series of potential answers to these questions into their respective historical and philosophical traditions, and attempted to show how the conceptions of understanding that are most useful in the understanding of visual culture had been sharpened and had developed from a scientific notion of understanding. These conceptions, born in the humanist and epistemological revolutions of the sixteenth century, were those of the social sciences. The social sciences saw the phenomenal successes of the natural sciences and wanted to emulate

them. One way that the social sciences thought that they could do this was to adopt the same approaches as the natural sciences, stressing objectivity, and the role of facts, for example. This chapter tried to describe how the approaches of art history and design history had developed out of approaches adopted by the study of history and how, in turn, historical approaches had developed out of more general social scientific approaches. Chapter 2 also argued that there are two major traditions, the structural and the hermeneutic, each of which provides a distinct and separate set of answers to questions regarding the nature and characteristics of understanding.

It was argued that each of the approaches to be explained in the following chapters could be located on a spectrum which had the individual at one pole and structure at the other. Some strategies were seen to favour the individual human subject or consciousness as the basis for understanding visual culture. Other approaches could be seen to favour structures as the basis for understanding visual cultures. Yet other methods seemed to use elements from both. Each approach's place on this spectrum, then, could be explained in terms of its using either the individual, or structure, or a mixture of both, as the basis for understanding visual culture. For example, expressionist accounts were seen to favour the individual (expressive) human subject as the basis for understanding visual culture. Semiological and iconological approaches were seen to favour structure, whether narrative, conceptual or syntagmatic. And feminists were shown to use both the individual (the 'personal') and structure (the 'political') to understand visual culture. The sequence of chapters adopted by this book is in part an attempt to reflect something of this spectrum. The individual consciousness and its world-view seems to be most favoured by the hermeneutic tactics of Baxandall and Hebdige, dealt with in Chapter 3. Gombrich's account of expressionist approaches and the feminist approaches of Chapters 4 and 5 seem to make equal use of structure and the individual in their accounts of understanding. And the formalists of Chapter 8 can be seen as stressing the role of as pure a structure as it is possible to describe.

However, the conclusion to this book will be used to argue that all the approaches explained so far have, or utilise, elements of both structural and hermeneutic traditions in order to understand visual culture. It will point out that all the examples covered so far (even those that seem to tend toward a hermeneutic, or individual-based, approach) posit a structural element to understanding. And it will argue that all the examples covered so far must also admit a

hermeneutic element or moment to their account of understanding. Following Paul Ricoeur's suggestions to the effect that structural analysis and hermeneutic understanding are mutually conditioning (1974: 56–61), this conclusion will briefly argue that all the approaches covered so far are made up of both hermeneutic and structural components.

In Chapter 3, the work of Baxandall and Hebdige was used to show how the individual could provide the basis for an account of understanding. In this chapter, the various individuals of these authors' accounts, the fifteenth-century business men and the twentieth-century Mods, for example, formed the bases for the understanding of visual culture. It was the individuals, and their horizons, or life-worlds, that formed the basis for the understanding of visual culture in these accounts. However, it can be argued that Hebdige uses both structural and hermeneutical approaches in his essay on the Italian scooter. Hebdige begins his account of the 'gender of machinery' by quoting from Lévi-Strauss's essay on totemism and from *The Savage Mind* (1988: 85). It is interesting that this latter is one of the texts that Ricoeur uses to argue his case that structural and hermeneutic moments of understanding each make the other possible (Ricoeur 1974: 33). One may argue, then, that in making use of the structuralist's account of totemism (in which people use systems of objects and the differences between them to represent groups of people and the differences between them), Hebdige is showing how understanding visual culture is made up of structural, as well as hermeneutic, elements. The account uses the hermeneutic in so far as it uses the individual to explain meaning and it is structural in so far as it uses structure to explain meaning.

Chapter 4 concentrated on expressionist accounts of understanding visual culture. This approach involved the curious idea that there is a 'natural code' of equivalences between shapes, lines, textures and colours and the feelings and emotions that the artist or designer was trying to express in their work. The individual was the basis for understanding on this approach in so far as it was the individual's consciousness, or unconsciousness, that was being expressed in their choice of shape, line, colour and so on. However, as Gombrich convincingly showed, it was only because these shapes, lines, colours and so on were coded, or existed in a structure, that they could be understood at all. The volume of the string quartet, the bold of the typeface and the brushstrokes of the artist only made sense, were only understandable in the context, or structure of volume, typography and so

on. The bold of a typeface did not simply express the individual typographer's feelings: it only made sense in the context, or structure, made up of plain, italic or gothic typefaces, for example. What at first seems to be an approach which tends towards, or favours, the individual and hermeneutic pole of the spectrum, turns out to need an account of structure as well. Gombrich effectively argues that one needs to understand the structures in order to understand the artist's or designer's expressions.

In Chapters 5 and 6, which dealt with gender-based and class-based accounts of understanding visual culture, feminism and Marxism, the situation was slightly different. It was different because these approaches explicitly acknowledged that a mixture of the individual and the structural was needed to understand visual culture. Penny Sparke, for example, was seen to explain her gender-based approach to understanding visual culture in terms of both the 'personal' and the 'political' (1995: vii). She connected her search for a 'personal style' that would 'represent' her 'emerging identity' to the 'political agenda' which was also emerging in the 1960s (ibid.). The gender-based understanding of visual culture, the fashions and clothing of the 1960s in this case, is based on a mixture of the hermeneutic and the structural. The class-based approach to understanding visual culture, investigated here in the forms of Marxist and 'social history of art' approaches, also depends on a mixture of hermeneutic and structural traditions. Marx's observation, to the effect that it is not man's consciousness that determines his social being, but that it is his social being that determines his consciousness (1970b: 21), may be taken as ascribing equal importance to both individual consciousness and economic, or class, structures. This quote does not say that consciousness is unreal, or illusory. It says that consciousness is a product of class society. What human subjects think and understand (including what they think and understand about visual culture) is a product of their economic position: consciousness is a product of the individual's position in economic and class structures.

And it was in these chapters (as well as Chapter 3) that the reflexivity of understanding, the way in which what one is produced by what one understands (see Giddens 1976: 19–20), was made clear. In these chapters, life-world, class and gender identity were seen to be constitutive of understanding in the examples that were chosen. In this sense, one's understanding of visual culture was seen to be productive of oneself. To adapt what was said in Chapter 3, one is one's understanding of visual culture. Although this is not the place to do it, these

ideas may be developed along the lines described by Giddens. What he calls the 'reflexive project of the self' is a form of self-creation by means of understanding and communicating the 'biographical continuity' of one's past (1991: 54). In this project, the self is the product of a reflexive grasping, or understanding, of the past. Clearly, the understanding of history, including the history of art and design, will be a part of this project and, to this extent, the reflexive understanding of visual culture is a part of the creation of one's self.

Chapters 7 and 8 might appear to deal with approaches which favour, or tend towards, the structural, given that they deal with semiological and formal accounts of understanding. They might even be thought to have, or leave, no room for hermeneutical approaches and the individual, proposing in some cases that the individual is a mere effect of structure. The structuralism of Chapter 8, for example, in which the formal elements of visual culture (such as shape, line, colour and texture) are held to be the basis for understanding, might be thought to be as near as an approach can get to a purely formal structure. Structuralism has often been accused of over-emphasising the structural, the formal, and of having nothing to say about content. Bell explicitly says that we need 'nothing from life' in order to approach visual culture. He says that we need nothing but a sense of form and colour and a knowledge of three-dimensional space (1958: 28). However, it must be said that structural approaches, including the semiological, are describing the structures of something. The structural approaches of Chapters 4 and 5, feminist and Marxist approaches, were describing the structures of something. In these cases, they are describing the structures of gender and class. Consequently, they cannot be purely formal, or empty structures. Similarly, Bell and the other formalists are describing the structures of something. They are describing the structures of shapes, lines, colours and so on. These are structures in which colours relate to other colours and to shape, texture and so on. Thus, even these structural approaches have to relate eventually to something that the individual can relate to: they are never describing empty or pure structures.

All the approaches considered in the preceding chapters, then, wherever they may appear to be located on the pole between hermeneutic and structural approaches, may be described as containing aspects from both poles. While it is to simplify and condense his argument considerably, it is not incorrect to suggest that Ricoeur is trying to describe this situation in his essay 'Structure and Hermeneutics'. He argues here that structural analysis is not possible 'without a

hermeneutic comprehension' and that hermeneutic comprehension is impossible without structure, without 'an economy, an order in which the symbol signifies' (1974: 60). Hermeneutic understanding is only possible if the items to be understood are recognised as existing within structures, 'wholes which limit and link their significations' (ibid.). And structural understanding can only happen if the meaning of the items to be placed into structures, or wholes, has been grasped: hermeneutic meaning here is the 'ground upon which structural homologies can be discerned' (ibid.). The example which probably illustrates this argument most clearly is that provided by Gombrich, covered in Chapter 4. Gombrich suggests that understanding the artist's use of colour, for example, depends upon the spectator knowing the selection of colours the artist had to work with. It depends, that is, on the spectator's knowing the structure. Similarly, one cannot understand the structure unless one understands each of the different items, or elements, making up that structure.

Both of these traditions, the structural and the hermeneutic, then, are necessary to the understanding of visual culture. Each of the approaches covered in this book has both structural and hermeneutic aspects: each, to a greater or lesser extent, stresses first the individual pole and then the structural pole of the spectrum. It makes no more sense to argue, with Janet Wolff for example, that structural approaches are 'immoral' because they are 'anti-humanist' and do not give 'primary importance to the dignity of the individual' (1975: 50) than it does to argue that hermeneutic approaches are 'immoral' because they are individualistic and lead to the indignities and exploitation of private enterprise or capitalism. Both individual-based, or hermeneutic, traditions and structural traditions are necessary to the understanding of visual culture and all the approaches covered in the present volume have been seen to contain elements of both traditions. These arguments may go some way to supporting the claim of W. J. T. Mitchell, which was noted above, in the Introduction, that the study of visual culture is, or should be, interdisciplinary. If approaches which might appear, or which consider themselves to be, purely structural or purely hermeneutical, are in fact made up of elements of both, then they are always already interdisciplinary.

Finally, Ricoeur provides an interesting, and distinctly unsettling, perspective on the matter of whether, and to what extent, the approaches to understanding visual culture that have been introduced in this volume are scientific. Ricoeur characterises structural approaches to understanding as being concerned with an (uncon-

scious) structure of differences which exists independently of the observer (1974: 55). The hermeneutic approaches to understanding are described in terms of their conscious recovery of meaning by an interpreter who tries to enter the hermeneutic circle, or horizons, of the one she or he is trying to understand (ibid.). Ricoeur's description of the structural account of understanding bears certain resemblances to the description of the natural sciences found in Chapter 2 above. The structures, like the facts of natural science, are held to exist independently of the observer. It is significant that, for Ricoeur, structural anthropology is a science. Indeed, he says that the 'triumph of the structural point of view is at the same time the triumph of the scientific point of view' (ibid.: 83). Ricoeur argues that structural anthropology is a science precisely because the relation between the person, or subject, who is trying to understand, and the structures which they are trying to understand, is 'objective, independent of the observer' (ibid.: 34). If all the approaches introduced here contain both structural and hermeneutic elements of understanding, then, to that extent, they are all scientific on Ricoeur's account. This, of course, opens up the possibility of returning to and re-considering the debates covered in Chapters 1 and 2. Unfortunately, however, as fascinating, attractive and complex a prospect as it is, here is not the place to being the exploration of this perspective and it will be left as another lacuna, a project to be undertaken and developed elsewhere.

Bibliography

Acton, M. (1997) *Learning to Look at Paintings* (London and New York: Routledge).

Adams, L. S. (1996) *The Methodologies of Art: An Introduction* (New York: Harper Collins).

Ash, J. and Wilson, E. (eds) (1992) *Chic Thrills* (London: Pandora, Harper-Collins).

Attfield, J. (1985) 'Defining the Object and the Subject', *Times Higher Education Supplement*, 1 February, p. 26.

——(1989a) 'Inside Pram Town: A Case Study of Harlow House Interiors, 1951–61', in Attfield, J. and Kirkham, P. (eds) (1989).

——(1989b) 'FORM/female FOLLOWS FUNCTION/male: Feminist Critiques of Design', in Walker, J. A. (1989).

Attfield, J. and Kirkham, P. (eds) (1989) *A View from the Interior: Feminism, Women and Design* (London: The Women's Press).

Baker, S. (1985) 'The Hell of Connotation', in *Word and Image*, vol. 1, no. 2 (April–June).

Banham, R. (1960) *Theory and Design in the First Machine Age* (Oxford: Architectural Press).

Barnard, M. (1993) 'Economy and Strategy: The Possibility of Feminism', in Jenks, C. (ed.) (1993).

——(1998) *Art, Design and Visual Culture* (Basingstoke: Macmillan).

Barthes, R. (1967) *Elements of Semiology* (New York: Hill and Wang).

——(1973) *Mythologies* (St Albans and London: Granada).

——(1977) *Image, Music, Text* (Glasgow: Fontana/Collins).

——(1983) *The Fashion System* (Berkeley and Los Angeles: University of California Press).

Bauman, Z. (1978) *Hermeneutics and Social Science: Approaches to Understanding* (London: Hutchinson University Library).

Baxandall, M. (1972) *Painting and Experience in Fifteenth-Century Italy* (Oxford: Oxford University Press).

——(1985) *Patterns of Intention: On the Historical Explanation of Pictures* (New Haven and London: Yale University Press).

Bell, C. (1958) *Art* (New York: Capricorn Books, G. P. Putnam's Sons; reprinted by arrangement with Chatto and Windus).

——(1992) Excerpts from *Art*, 'The Aesthetic Hypothesis' and 'The Debt to Cézanne', in Frascina, F. and Harrison, C. (eds) (1982).

Bell, J. (1999) *What is Painting? Representation and Modern Art* (London: Thames and Hudson).

Berger, J. (1972) *Ways of Seeing* (London: BBC and Penguin Books).

Berlin, I. (1969) 'A Note on Vico's Concept of Knowledge', in Tagliacozzo, G. (ed.) and White, H. (co-ed.) (1969).

Bhabha, H. (1994) *The Location of Culture* (London and New York: Routledge).

Bierstedt, R. (1978) 'Sociological Thought in the Eighteenth Century', in Bottomore, T. and Nisbet, R. (eds) (1978b).

Bottomore, T. and Nisbet, R. (1978a) 'Structuralism', in Bottomore, T. and Nisbet, R. (eds) (1978b).

Bottomore, T. and Nisbet, R. (eds) (1978b) *A History of Sociological Analysis* (London: Heinemann).

Buckley, C. (1986) 'Made in Patriarchy: Toward a Feminist Analysis of Women and Design', *Design Issues*, vol. iii, no. 2, pp. 3–14.

Carr, E. H. (1961) *What is History?* (Harmondsworth: Penguin Books).

Caughie, J. (ed.) (1981) *Theories of Authorship: A Reader* (London: Routledge).

Chaplin, E. (1994) *Sociology and Visual Representation* (London: Routledge).

Clark, T. J. (1973) *Image of the People* (London: Thames and Hudson).

——(1984) *The Painting of Modern Life* (London: Thames and Hudson).

Conway, H. (1987) *Design History: A Student's Handbook* (London: Routledge).

Crowther, P. (1983) 'The Experience of Art: Some Problems and Possibilities of Hermeneutical Analysis', in *Philosophy and Phenomenological Research*, vol. xliii, no. 3 (March), pp. 247–62.

Dant, T. (1999) *Material Culture in the Social World: Values, Activities, Lifestyles* (Buckingham and Philadelphia: Open University Press).

Davey, N. (1999) 'The Hermeneutics of Seeing', in Heywood, I. and Sandywell, B. (eds) (1999).

De Certeau, M. (1984) *The Practice of Everyday Life* (Berkeley and Los Angeles: University of California Press).

Douglas, M. and Isherwood, B. (1979) *The World of Goods: Towards an Anthropology of Consumption* (London: Routledge).

Doy, G. (1998) *Materialising Art History* (Oxford: Berg).

Eagleton, T. (1983) *Literary Theory: An Introduction* (London: Basil Blackwell).

Eco, U. (1976) *A Theory of Semiotics* (Bloomington: Indiana University Press).

Fernie, E. (ed.) (1995) *Art History and its Methods: A Critical Anthology* (London: Phaidon).

Forty, A. (1986) *Objects of Desire: Design and Society, 1750–1980* (London: Thames and Hudson).

Foucault, M. (1977) *Language, Counter-Memory, Practice: Selected Essays and Interviews*, edited with an Introduction by D. F. Bouchard (Oxford: Blackwell).

Frascina, F. and Harris, J. (eds) (1992) *Art in Modern Culture: An Anthology of Critical Texts* (London: Phaidon).

Frascina, F. and Harrison, C. (eds) (1982) *Modern Art and Modernism: A Critical Anthology* (London: Harper and Row).

Freud, S. (1963) *Civilisation and its Discontents* (London: The Hogarth Press and the Institute of Psychoanalysis).

——(1985) *Art and Literature*, Penguin Freud Library, volume 14 (Harmondsworth: Penguin Books).

Fry, R. (1925) *Vision and Design* (London: Chatto and Windus).

Gadamer, H.-G. (1975) *Truth and Method* (London: Sheed and Ward).

——(1976) *Philosophical Hermeneutics*, translated and edited by David E. Linge (Berkeley and Los Angeles: University of California Press).

Geertz, C. (1973) *The Interpretation of Cultures* (London: Fontana).

Giddens, A. (1976) *New Rules of Sociological Method* (London: Hutchinson University Library).

——(1978) 'Positivism and its Critics', in Bottomore, T. and Nisbet, R. (eds) (1978b).

——(1991) *Modernity and Self-Identity* (Cambridge: Polity Press).

Giedion, S. (1948) *Mechanisation Takes Control: A Contribution to Anonymous History* (Oxford: Oxford University Press).

Gombrich, E. H. (1963) *Meditations on a Hobby Horse* (London: Phaidon).

——(1979) *Ideals and Idols* (London: Phaidon).

Greenberg, C. (1982) 'Master Léger', in Frascina, F. and Harrison, C. (eds) (1982).

——(1986) 'Abstract Art', in *Clement Greenberg: The Collected Essays and Criticism*, volume 1, edited by John O'Brian (Chicago: University of Chicago Press).

——(1993) 'Modernist Painting', in *Clement Greenberg: The Collected Essays and Criticism*, volume 4, edited by John O'Brian (Chicago: University of Chicago Press).

Greimas, A. J. (1990) *The Social Sciences: A Semiotic View* (Minneapolis: University of Minnesota Press).

Hadjinicolaou, N. (1978) *Art History and Class Struggle* (London: Pluto Press) extracted in Frascina, F. and Harrison, C. (eds) (1982).

Hauser, A. (1951) *The Social History of Art*, 4 volumes (London: Routledge).

Hawkes, T. (1977) *Structuralism and Semiotics* (London: Methuen).

Hebdige, D. (1979) *Subculture: The Meaning of Style* (London and New York: Routledge).

——(1988) *Hiding in the Light* (London and New York: Comedia, Routledge).

Heywood, I. (1997) *Social Theories of Art: A Critique* (Basingstoke: Macmillan).

Heywood, I. and Sandywell, B. (eds) (1999) *Interpreting Visual Culture: Explorations in the Hermeneutics of the Visual* (London: Routledge).

Hine, T. (1995) *The Total Package: The Evolution and Secret Meanings of Boxes, Bottles, Cans and Tubes* (Boston: Little, Brown).

Hodges, H. A. (1969) 'Vico and Dilthey', in Tagliacozzo, G. (ed.) and White, H. (co-ed.) (1969).

Holub, R. C. (1984) *Reception Theory: A Critical Introduction* (London: Routledge).

Jameson, F. (1971) *The Prison-House of Language* (Princeton, NJ: Princeton University Press).

Jay, M. (1993) *Downcast Eyes: The Denigration of Vision in Twentieth-Century French Thought* (Berkeley and Los Angeles: University of California Press).

Jenks, C. (ed.) (1993) *Cultural Reproduction* (London: Routledge).

——(1995) *Visual Culture* (London: Routledge).

Kamenka, E. (1969) 'Vico and Marxism', in Tagliacozzo, G. (ed.) and White, H. (co-ed.) (1969).

Larrain, J. (1979) *The Concept of Ideology* (London: Hutchinson University Library).

Lavin, I. (ed.) (1995) *Meaning in the Visual Arts: Views from the Outside* (Princeton, NJ: Institute for Advanced Study).

Leach, E. (1969) 'Vico and Lévi-Strauss on the Origins of Humanity', in Tagliacozzo, G. (ed.) and White, H. (co-ed.) (1969).

——(1973) *Lévi-Strauss* (London: Fontana Press).

——(1977) 'Michelangelo's "Genesis": Structuralist Comments on the Paintings on the Sistine Chapel Ceiling', *Times Literary Supplement*, 18 March, pp. 311–13.

Lévi-Strauss, C. (1966) *The Savage Mind* (London: Weidenfeld and Nicolson).

Linge, D. E. (1976) 'Editor's Introduction' to Gadamer, H.-G. (1976).

Llosa, M. V. (1990) *In Praise of the Stepmother* (London and Boston: Faber and Faber).

Locke, J. (1975) *An Essay Concerning Human Understanding* (Oxford: Oxford University Press).

Lunt, P. K. and Livingstone, S. M. (1992) *Mass Consumption and Personal Identity* (Buckingham and Philadelphia: Open University Press).

Margolin, V. (1995) 'Design History or Design Studies: Subject Matter and Methods', *Design Issues*, vol. 11, no. 1.

Martin, R. (1998) 'A Note: Gianni Versace's Anti-Bourgeois Little Black Dress (1994)', *Fashion Theory*, vol. 2, issue 1, pp. 95–100.

Marx, K. (1954) *Capital: A Critique of Political Economy*, vol. 1 (London: Lawrence and Wishart).

——(1970a) *The German Ideology*, edited and with an Introduction by C. J. Arthur (London: Lawrence and Wishart).

——(1970b) *A Contribution to the Critique of Political Economy* (Moscow: Progress Publishers).

——(1977) *Karl Marx: Selected Writings*, edited by David McLellan (Oxford: Oxford University Press).

Mirzoeff, N. (1999) *An Introduction to Visual Culture* (London: Routledge).
Mitchell, W. J. T. (1995a) 'Interdisciplinarity and Visual Culture', *Art Bulletin*, vol. LXXVII, no. 4 (December), pp. 540–4.
——(1995b) 'What is Visual Culture?', in Lavin, I. (ed.) (1995).
Mulvey, L. (1989) *Visual and Other Pleasures* (Basingstoke: Macmillan).
Nead, L. (1986) 'Feminism, Art History and Cultural Poltics', in Rees, A. L. and Borzello, F. (eds) (1986).
Palmer, R. E. (1969) *Hermeneutics* (Evanston: Northwestern University Press).
Panofsky, E. (1955) *Meaning in the Visual Arts* (Harmondsworth: Penguin).
Parker, R. (1984) *The Subversive Stitch: Embroidery and the Making of the Feminine* (London: Women's Press).
Partington, A. (1992) 'Popular Fashion and Working-Class Affluence', in Ash, J. and Wilson, E. (eds) (1992).
Peirce, C. S. (1955) *Philosophical Writings of Peirce*, selected and edited with an Introduction by Justus Buchler (New York: Dover Publications).
Pevsner, N. (1960) *Pioneers of Modern Design* (Harmondsworth: Penguin).
Polhemus, T. (1994) *Streetstyle: From Sidewalk to Catwalk* (London: Thames and Hudson).
Pollock, G. (1988) *Vision and Difference: Femininity, Feminism and Histories of Art* (London and New York: Routledge).
——(1992) *Avant-Garde Gambits, 1888–1893: Gender and the Colour of Art History* (London: Thames and Hudson).
Preziosi, D. (ed.) (1998) *The Art of Art History: A Critical Anthology* (Oxford: Oxford University Press).
Rees, A. L. and Borzello, F. (eds) (1986) *The New Art History* (London: Camden Press).
Ricoeur, P. (1974) *The Conflict of Interpretations: Essays in Hermeneutics* (Evanston: Northwestern University Press).
Roberts, J. (ed.) (1994) *Art Has No History!* (London: Pluto Press).
Roth, L. M. (1993) *Understanding Architecture: Its Elements, History and Meaning* (London: Herbert Press).
Said, E. (1979) *Orientalism* (London and New York: Routledge).
——(1993) *Culture and Imperialism* (London: Chatto and Windus).
Saussure, F. de (1974) *Course in General Linguistics* (Glasgow: Fontana/Collins).
Schapiro, M. (1998) 'Style', in Preziosi, D. (ed.) (1998).
Simmel, G. (1971) *On Individuality and Social Forms*, edited and with an Introduction by D. N. Levine (Chicago: University of Chicago Press).
Sparke, P. (1986) *An Introduction to Design and Culture in the Twentieth Century* (London: Allen and Unwin).
——(1995) *As Long As It's Pink: The Sexual Politics of Taste* (London: Pandora, HarperCollins).
Stark, W. (1969) 'Giambattista Vico's Sociology of Knowledge', in Tagliacozzo, G. (ed.) and White, H. (co-ed.) (1969).

Steele, V. (1999) 'The Corset', *Fashion Theory*, vol. 3, issue 4, pp. 449–74.

Swingewood, A. (1986) *Sociological Poetics and Aesthetic Theory* (Basingstoke: Macmillan).

Tagliacozzo, G. (ed.) and White, H. (co-ed.) (1969) *Giambattista Vico: An International Symposium* (Baltimore: Johns Hopkins Press).

Tickner, L. (1976a) '. . . and they sewed fig-leaves together', *Spare Rib*, no. 45 (April).

——(1976b) 'Fashionable Bondage', *Spare Rib*, no. 47 (June).

——(1976c) 'The Attraction of Opposites', *Spare Rib*, no. 49 (August).

——(1976d) 'Why Not Slip into Something a Little More Comfortable', *Spare Rib*, no. 51 (October).

——(1977) 'Women and Trousers', in *Leisure in the Twentieth Century* (Design Council Publications).

Vasari, G. (1963) *The Lives of the Painters, Sculptor and Architects*, vol. 3, in 4 volumes, edited with an Introduction by William Gaunt (London: Dent; New York: Dutton).

Veblen, T. (1992) *The Theory of the Leisure Class* (New Brunswick and London: Transaction Publishers).

Vico, G. (1968) *The New Science of Giambattista Vico*, unabridged translation of the 3rd edition (1744) with the addition of 'Practic of the New Science', translated by Thomas Goddard Bergin and Max Harold Fisch (Ithaca and London: Cornell University Press).

Walker, J. A. (1989) *Design History and the History of Design* (London: Pluto).

Walker, J. A. and Chaplin, S. (1997) *Visual Culture: An Introduction* (Manchester and New York: Manchester University Press).

Walsh, W. H. (1960) *Philosophy of History: An Introduction* (New York: Harper Torchbooks).

Williams, M. (2000) *Science and Social Science* (London and New York: Routledge).

Winch, P. (1958) *The Idea of a Social Science and its Relation to Philosophy* (London: Routledge and Kegan Paul).

Wolff, J. (1975) *Hermeneutic Philosophy and the Sociology of Art* (London: Routledge and Kegan Paul).

Wölfflin, H. (1950) *Principles of Art History: The Problem of the Development of Style in Later Art* (New York: Dover Publications).

Wright, L. (1989) 'Objectifying Gender: The Stiletto Heel', in Attfield, J. and Kirkham, P. (eds) (1989).

Index

Italic numerals indicate that an illustration appears on the page.